Adobe Premiere Pro CC

by John Carucci

Treading Red Carpets for a Living

D1127685

for dummies

A Wiley Brand

Adobe Premiere Pro CC For Dummies®

Published by: **John Wiley & Sons, Inc.,** 111 River Street, Hoboken, NJ 07030-5774, www.wiley.com

Copyright © 2022 by John Wiley & Sons, Inc., Hoboken, New Jersey

Published simultaneously in Canada

No part of this publication may be reproduced, stored in a retrieval system or transmitted in any form or by any means, electronic, mechanical, photocopying, recording, scanning or otherwise, except as permitted under Sections 107 or 108 of the 1976 United States Copyright Act, without the prior written permission of the Publisher. Requests to the Publisher for permission should be addressed to the Permissions Department, John Wiley & Sons, Inc., 111 River Street, Hoboken, NJ 07030, (201) 748-6011, fax (201) 748-6008, or online at http://www.wiley.com/go/permissions.

Trademarks: Wiley, For Dummies, the Dummies Man logo, Dummies.com, Making Everything Easier, and related trade dress are trademarks or registered trademarks of John Wiley & Sons, Inc., and may not be used without written permission. All other trademarks are the property of their respective owners. John Wiley & Sons, Inc., is not associated with any product or vendor mentioned in this book.

LIMIT OF LIABILITY/DISCLAIMER OF WARRANTY: WHILE THE PUBLISHER AND AUTHORS HAVE USED THEIR BEST EFFORTS IN PREPARING THIS WORK, THEY MAKE NO REPRESENTATIONS OR WARRANTIES WITH RESPECT TO THE ACCURACY OR COMPLETENESS OF THE CONTENTS OF THIS WORK AND SPECIFICALLY DISCLAIM ALL WARRANTIES, INCLUDING WITHOUT LIMITATION ANY IMPLIED WARRANTIES OF MERCHANTABILITY OR FITNESS FOR A PARTICULAR PURPOSE. NO WARRANTY MAY BE CREATED OR EXTENDED BY SALES REPRESENTATIVES, WRITTEN SALES MATERIALS OR PROMOTIONAL STATEMENTS FOR THIS WORK. THE FACT THAT AN ORGANIZATION, WEBSITE, OR PRODUCT IS REFERRED TO IN THIS WORK AS A CITATION AND/ OR POTENTIAL SOURCE OF FURTHER INFORMATION DOES NOT MEAN THAT THE PUBLISHER AND AUTHORS ENDORSE THE INFORMATION OR SERVICES THE ORGANIZATION, WEBSITE, OR PRODUCT MAY PROVIDE OR RECOMMENDATIONS IT MAY MAKE. THIS WORK IS SOLD WITH THE UNDERSTANDING THAT THE PUBLISHER IS NOT ENGAGED IN RENDERING PROFESSIONAL SERVICES. THE ADVICE AND STRATEGIES CONTAINED HEREIN MAY NOT BE SUITABLE FOR YOUR SITUATION. YOU SHOULD CONSULT WITH A SPECIALIST WHERE APPROPRIATE. FURTHER, READERS SHOULD BE AWARE THAT WEBSITES LISTED IN THIS WORK MAY HAVE CHANGED OR DISAPPEARED BETWEEN WHEN THIS WORK WAS WRITTEN AND WHEN IT IS READ. NEITHER THE PUBLISHER NOR AUTHORS SHALL BE LIABLE FOR ANY LOSS OF PROFIT OR ANY OTHER COMMERCIAL DAMAGES, INCLUDING BUT NOT LIMITED TO SPECIAL, INCIDENTAL, CONSEQUENTIAL, OR OTHER DAMAGES.

For general information on our other products and services, please contact our Customer Care Department within the U.S. at 877-762-2974, outside the U.S. at 317-572-3993, or fax 317-572-4002. For technical support, please visit https://hub.wiley.com/community/support/dummies.

Wiley publishes in a variety of print and electronic formats and by print-on-demand. Some material included with standard print versions of this book may not be included in e-books or in print-on-demand. If this book refers to media such as a CD or DVD that is not included in the version you purchased, you may download this material at http://booksupport.wiley.com. For more information about Wiley products, visit www.wiley.com.

Library of Congress Control Number: 2022933151

ISBN: 978-1-119-86749-4

ISBN: 978-1-119-86721-0 (ebk); ISBN: 978-1-119-86722-7 (ebk)

SKY10033527_031222

Contents at a Glance

Table of Contents

Introduction

Nonlinear editing programs like Adobe Premiere Pro CC have changed the game when it comes to making movies so much that it's easy to take it for granted. Anyone with an Adobe Creative Cloud subscription and a dream can make a movie and show it to an audience that spans the globe. But it wasn't always like that. Not that long ago, making a movie depended on a tabletop full of editing equipment with a severe lack of forgiveness. There was no *undo* in this world. Actually, there was its own version — it was called the *do-it-over*.

As for editing costs, the passion of putting a movie together in the last millennium could make you broke faster than an online gambling site. Unless you were fortunate to be working in the industry, and had access to state-of-the-art equipment, chances are you were making quality sacrifices. So, without a suitcase filled with cash, putting the finishing touches on your movie project was as far off as a walk-in membership to a snooty country club. Even if you could afford the most basic equipment, the disparity between the consumer and professional level was far beyond a professional-quality movie. Instead of providing the look of a Hollywood movie, the end-result would be of significantly lesser quality.

Nowadays, that glass ceiling has been broken and all that should matter is how well you shot and edited your movie. Nonlinear applications like Premiere Pro CC are leading the way by allowing average Joes access to professional-style editing tools. Video content creators have access to the tools to create a real movie — be it long, short, really short (looking at you TikTok) or anything in between.

Premiere Pro CC puts the creative power at anyone's fingertips. Not even Nostradamus could have imagined the power in the hands of the average user, who was long on passion and short on accessibility, to now make a movie with limited resources and deliver to a potentially wide global audience.

About this Book

I'm making no allusions that this book is the oracle to understanding everything about Premiere Pro. To adequately cover every feature, function, and technique, in addition to tips, workarounds, and other tricks, I would need far more than a few hundred pages. Rather, this singular *Adobe Premiere Pro CC For Dummies* serves as a reliable resource to familiarize you with the software and get you editing quickly.

So, what exactly does that mean? It means you get the dollar tour of the workspace with the basics of setting up your project, importing various types of content, and

making magic in the Timeline — otherwise known as the place to arrange your movie assets. This is what's important when dipping your toe into Premiere Pro.

If you're not sure how important editing is to the filmmaker, just check out some classic films like the shower scene from Alfred Hitchcock's *Psycho*, or the Odessa Steps scene from Sergei Eisenstein's seminal 1925 film, *Battleship Potemkin*. Brian DePalma paid homage to that classic scene in the 1987 film, *The Untouchables*.

Versatility is the name of the game with Premiere Pro. Much like the special way you take your latte at a particular coffee chain, Premiere Pro is quite versatile. Plus, making a movie with it won't get your name spelled wrong on the cup. So, whether you're capturing a documentary with your new Sony F7 professional camcorder system, using your Canon 5D (of any mark you choose), a consumer-level camcorder, or more than likely, your smart phone, you can easily ingest that footage and begin making a movie after a quick perusal this handy guide.

How this book is organized

Reading this book should make you feel like living in the no commitment zone. That means you will not have to read it cover to cover; instead, you'll consume the information that you need and apply it with hands-on ease.

Premiere Pro CC For Dummies is divided into five parts, each detailing an aspect of preparing, editing, and delivering your movie. Depending on your level of understanding and your needs, you may prefer a particular area over another. Feel free to read it start to finish if that's your thing. But chances are you want to spend more time editing. So also feel free to jump around.

PART I: Getting Familiar with the Adobe Premiere Pro Universe

Think of this set of chapters as the appetizer to the big meal — you know, if the big meal were a pro-quality movie. Complex in what it can do, yet easy to learn, Premiere Pro CC essentially consists of a collection of individual windows called panels that together create its powerful interface. This section prepares you with a swift overview of setting up your workspace and customizing it for your needs.

PART II: Gathering Content

With features and functions that transform old school linear video editing from the suite to a nonlinear powerhouse on your laptop or desktop computer, the following chapters explain fundamental techniques for bringing content from a

variety of sources into the workspace. These include the previously mentioned collecting, managing, and organizing movie assets.

PART III: Editing Your Masterpiece

If the past sections were the appetizer, then think of the following chapters as the main course. Whether you're a beginner looking to make a short video, a working professional looking to understand the program's newest and most powerful features, or anyone in between, this group of chapters takes you through the ins and outs of editing your movie with sublime simplicity.

PART IV: Finishing Off Your Project

Now that your movie is edited, it's time to give a quality control once-over and export it as a movie file. After that, you can upload it to a social media site with your sights set on viral video victory. Maybe festivals or public showings are in the cards — then you could have a full house. Sharing your movie through a file transferring service is another option, or you could go old school by transferring to a DVD (or an even *older* school, like transferring to videotape) if that's your thing. Whatever you choose, your movie is ready to live outside the program.

PART V: The Part of Tens

The *For Dummies* version of the top ten list provides insight into tools and techniques that take your Premiere Pro moviemaking skills to the next level. And by including a trio of lists, think of your progress increasing three times as much.

Icons Used in the Book

What's a For Dummies book without icons pointing out pertinent information that quickly gives you what you need and lets you get on your way? Here's a brief description of the icons used in book.

REMEMBER

This icon marks a generally interesting and useful fact — something you may want to remember for later use.

TIP

This light bulb points out helpful suggestions and useful nuggets of information.

When you see this icon, you know that techie stuff is nearby if you're not feeling very techie feel free to skip it.

TECHNICAL
STUFF

The warning icon alerts you of lurking danger. With this icon I'm telling you to pay attention and proceed with caution.

WARNING

Beyond the book

In addition to what you're reading right now, this book comes with a free access-anywhere Cheat Sheet that includes tips to help you use Adobe Premiere Pro CC. To get this Cheat Sheet, simply go to www.dummies.com and type Adobe Premiere Pro For Dummies Cheat Sheet in the Search box.

1

Getting Familiar with the Adobe Premiere Pro Universe

Chapter **1**

Perusing the Premiere Pro Landscape

Way back in the early 20th century, the only way to edit a videotape package was to put it together in linear order. You know, the first scene first, then the second, blah, blah, blah. Nowadays, Adobe Premiere Pro lets you randomly drag clips (parts of a movie file) around and put them in any order you like. This is known as *nonlinear editing.* The really cool thing is that you can shuffle clips around as many times as you like until you're happy with the results.

As with any software, learning how to navigate the Premiere Pro features is extremely important. This chapter introduces you to the Premiere Pro workspace, including the panels, tools, and libraries.

In the workspace, various configurations of panels allow you to control various aspects of making a movie: audio mixing, controlling effects, and managing project assets. One of the key panels here is the timeline, which is the place you arrange, and often rearrange your clips to make your movie.

Understanding What Premiere Pro Can Do

Premiere Pro brings the creative power of post-production moviemaking from the editing suite to the convenience of your computer screen. *Tape-to-tape editing*, *film splicing*, and *workprint* are a few of the antiquated terms now in the rear-view mirror thanks to nonlinear editing.

That's quite a contrast from the way things used to be. For years, putting a movie together involved a series of steps that had to occur in sequential order. Imagine splicing pieces of film from different reels and putting them together and then realizing that you missed an entire scene. That's not a good feeling, and you get little forgiveness for skipping parts of the order.

Premiere simplifies the process of telling stories visually by making it more affordable, more flexible, and allowing you to change your mind and experiment with placing clips in the timeline without penalty. Change your mind and see how it plays out without any worry. You also don't get your fingers sticky with film cement, and you won't get cut with a razor blade. While the software is intuitive, it's important to have a lay of the land to fully understand its potential.

Premiere Pro lets you to place elements in a *timeline*, a long panel that appears at the bottom of the screen where you add video clips. The order in which you add the clips doesn't matter; you can drop in the last scene first, and the first scene later on, or in any other combination. It still plays out in linear fashion, regardless of when you add the clips. Yet, while Premiere Pro is intuitive, it's important to have a lay of the land to fully understand what the software can do.

Dissecting the Workspace

Premiere Pro makes you feel like a video-editing superhero whose special powers transform your movie project from appalling to appealing. Not quite as cool as x-ray vision or web-slinging, but producing effective, clean edits is a power in its own way.

REMEMBER

Before you can create an award-winning masterpiece, you need to get familiar with the workspace. C'mon, even Batman had to know his way around Gotham City, right? So think of yourself as Batman (your choice on which actor. . .okay, Christian Bale, no wait, Robert Pattison, or go old school with Michael Keaton or Adam West). No matter. You should learn your way around Premiere Pro so when you see the Bat-Signal — or most likely a text message on your iPhone — to edit an important package, you intimately know the Premiere Pro tools and functions

that are at your disposal. The following sections give you an overview of what you see when you open Premiere Pro.

Breaking down the interface

The Premiere Pro interface looks overwhelming at first glance because so many choices make it hard to focus on anything specific. Yeah, there's a ton of great stuff; it's just a matter of focusing on what's necessary. I'll address the points of contention, taking it from the top — of the screen, that is, where you'll find nine menu headers whose deep nesting make it feel like "bursting" nest syndrome. Consider the overwhelming screen real estate, shown in Figure 1-1.

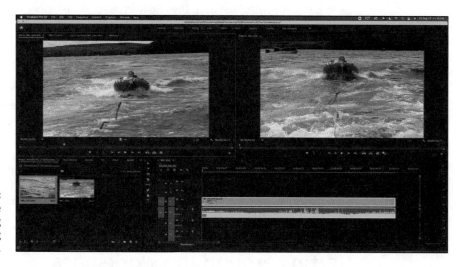

FIGURE 1-1:
Premiere
Pro showing
the editing
workspace.

While complex, the workspace actually makes sense. You just need to look at it as a series of individual components that work together as a single entity. The Project panel (lower left in Figure 1-1) shows the ingested movie files, and the timeline (lower right in Figure 1-1) has an edited clip. On top, the Source Monitor panel shows clip content while the Program Monitor panel plays out clips on the timeline.

Ingesting and Editing

Ingesting refers to transferring your video content from the camera of card into Premiere Pro. Editing is the means of putting that ingested content into some cohesive order.

REMEMBER

REMEMBER

The screen is far less scary when viewing the workspace as individual sections, or panels, each with its own special function. Although the panels have specific functions, they all work together. For example, the Projects panel stores your assets and sequences that you could drag into the timeline and then view on the Program Monitor panel before deciding to color-correct the video by making a selection in the Effects panel and fine-tuning it in the Effect Controls panel.

Understanding the panels

The panels in Premiere Pro are stylish, functional, and easy to navigate once you get the hang of working with them. You can click on one panel and interact that action with another panel. So, you can be in the Projects panel, select a clip, set its In and Out points, and drag the clip into the timeline. Once there, you can click on the clip, activate the Audio Meters, and make adjustments to the sound. Need to be more focused? Then for precise work, fill the screen with a single panel by highlighting it and pressing the accent key.

While each panel is a stand-alone, they all work together to create your video. It isn't necessary to understand every panel to do great work. The more you know, the more you can do, but you can easily get started by simply learning how a few panels work.

TIP

When you click in a particular panel, the area becomes activated, as indicated by a blue borderline. This allows you to perform whatever task that panel offers. For example, when selecting the Timeline panel, you can move clips around, change their length, or delete them altogether.

Getting around the workspace

Unlike a lot of software that folks use (I'm looking at you, Office 365), you can customize where different elements of the Premiere Pro interface live. Think of the interface of what you see on the screen, and the workspace, the particular way they are arranged.

Timeline on the bottom, monitors on top enjoys popularity; but so does the reverse. And even then, some users tuck the timeline to get a better view of the Project panel. Other users like a deep timeline to see multiple audio and video channels. Still others keep it compact so they have more monitor real estate. It's all about freedom of choice, and Premiere Pro makes it like a buffet where you get to choose what fills your plate and how much.

Some users may opt for one of the preset workspaces found at Windows ⇨ Workspaces. Again, it's all about personal choice, and Premiere Pro makes the available choices unlimited. Any time you choose, you can toggle between various layouts (see Chapter 3 for more information) to perform specific actions to get the job done.

REMEMBER

The panels operate independently depending on the one you highlight. Navigating to a particular panel is just a matter of clicking on it (a blue borderline lets you know it's active). The pull-down menus supplement the workflow by providing you with another way to access an action or effect, or to provide more choices.

Having a Panel Discussion

With Premiere Pro, most of your work will be done in three panels:

>> The **Project panel** where your video resides

>> The **Timeline panel** where the clips are placed

>> The **Program and Source Monitor panels** that shows the playback

When you're getting familiar with Premiere Pro, you need to know what each panel allows you to do when you're editing video. When you move into a new house, you need to understand the layout. Otherwise, it may take opening a closet door or two before you find the bathroom. In the following sections, I walk you through these primary panels in Premiere Pro.

Knowing the Project panel

Think of Premiere Pro as an office building, and the Project panel as a large office space with several rooms leading off of it. This panel, shown in Figure 1-2, holds media assets like your movie clips, still photos, and audio files, as well as all the sequences you've created. The panel is much like a self-contained room where the pieces are organized, and is completely customizable regarding size and display.

You can also control how panel information displays on the bottom of the palette. The *palette* allows you to view the contents as icons of various sizes, or view each element and its vital stats in list view Freeform view allows you to also make minor changes. The functions are found in the bottom-left corner of the panel.

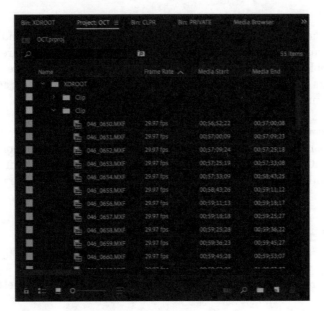

FIGURE 1-2:
The Project
panel.

Here's how the views compare:

» In **List view**, the Video and Audio Info shows vital stats, when you scroll horizontally, like frame rate, clip duration, and In and Out points. Audio Info shows duration, compression, and format. Navigate this information by using the slider on the bottom of the panel. Switching from these views at your leisure is fairly simple.

» **Icon view** shows mini thumbnails of clip content, and comes in handy when you need to quickly find the right clip in a busy folder.

» **Freeform view** lets you to organize footage, like the Icon view, but with a little more oomph. It's perfect if you're a visual thinker, and the thumbnails help you find the right asset. You can preview thumbnails, set In and Out points, and reorder your clips directly in the Project panel. This view allows you to drag clips and group them in different order than either Icon or List view. It's the most flexible, but takes up the most space.

The Project panel has a few other nifty features that will come in handy as you create a video.

» The **Search field** atop the panel lets you find specific clips. This comes in handy when you are working with lots of clips.

>> The **New Bin** feature allows you to tidy up the Project panel by creating a bin, naming it, and dragging files into it. You can make a bin by clicking in the panel and selecting New Bin, or you can go through the File menu (File⇨ New⇨Bin).

Everything in this Panel or subsequent bins can be used in a sequence (for more on sequences, see Chapter 5), or not at all.

Spending some time with the Timeline panel

TIP

The magic happens in the Timeline panel, as clips are dragged, probed, and prodded (and that's just to get started) while you create the right order to construct your movie. Think of this panel as the queue for what plays on the screen. In the meantime, you can change the order of the clips, and trim, tweak, or expand them to get them right. This is also where you turn audio and video tracks on and off to affect what plays back. And you can also make adjustments to audio levels directly in the timeline, as shown in Figure 1-3. While the timeline acts as the panel that you perform your edit, the individual edits within the timeline are the sequences.

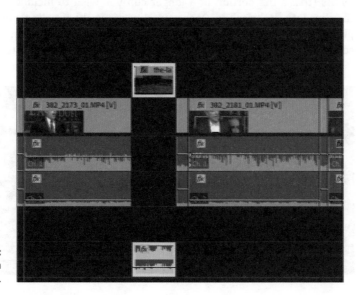

FIGURE 1-3:
Video clips in the timeline.

Consider the following:

>> The Timeline panel is the staging area for your video and audio assets to play out in chronological order.

>> You can create additional video and audio tracks to support effects, mixing, and layout.

>> You can trim or expand video or audio clips directly in the Timeline panel.

>> Tracks can be enabled or disabled to allow you to focus on a specific clip in the sequence.

Making the most of the Source and Program Monitors

Think of the Source and Program Monitors as a dynamic duo that allow you to see what you're doing. They're like the twin TV sets of your Premiere Pro workspace. While each panel performs a different task, they basically accomplish the same function. You can view your clips in the Project panel through the Source Monitor, where you can decide if they're going in the timeline, and then set In and Out points (that's the portion of a longer clip you wish to include) before dragging the clips into the timeline. Once your clips are in the timeline, you can view their playback in the Program Monitor, which plays the content in linear order. As you can see in Figure 1-4, the monitors in each panel share similarities.

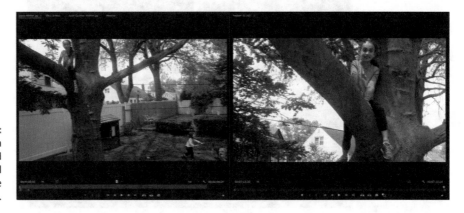

FIGURE 1-4:
Monitors from the Source and Program panel shown side by side.

TIP

Use the Source Monitor to preview clips by double-clicking their icon, or filename if that's your preference, in the Project panel. Both monitors play and pause when you tap the spacebar.

The bottom of each panel displays buttons that resemble traditional playback controls, including the right-pointing triangle that signifies playback. But these buttons do more than just play the clip. They allow you to *scrub* the video (take a quick look through it), look at it frame-by-frame to make precise adjustments, add markers, insert, and much more.

Grasping the Effects and Effect Controls panels

Just like Batman and Robin, the Effects and Effect Controls panels are two individual panels that go together. The Effects panel, shown in Figure 1-5, offers six folders that include video and audio presets, effects, and transitions. Among these functions are a myriad of correction tools. These include audio levels, color correction, scaling, and numerous other issues.

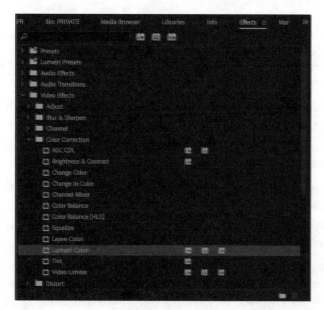

FIGURE 1-5:
The Effects panel.

After you make your selection, the Effect Controls panel, shown in Figure 1-6, displays the applicable settings to fine-tune the effect, as opposed to nesting a bunch of other effects that are not applicable. This makes it less confusing to adjust settings, as you have dedicated controls that only deal with that particular effect.

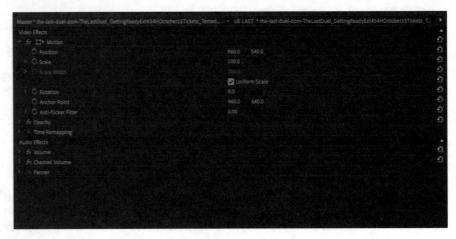

FIGURE 1-6:
The Effect
Controls panel.

Here is a breakdown of the folders, and some of the subfolders in which particular effects are nested, in the Effects panel.

>> **Presets:** While the folder is populated with some effects such as Bevel, Mosaics, and Lens Distortion Removal (also found in Effects bins), this is also where you can save adjusted effects you've used in the past, so that you can easily use them again.

>> **Lumetri Presets:** After applying color correction to your footage, you can save the correction preset in this folder, and then apply it to a similar clip later.

>> **Audio Effects:** This folder contains a healthy selection of controls that can enhance or alter the audio quality of your video clips.

>> **Audio Transitions:** These include several crossfade options to smooth the transition between two audio clips.

>> **Video Effects:** Color correction, blurs, and borders are just a few of the powerful video effects at your disposal in Premiere Pro.

>> **Video Transitions:** This folder provides a series of transitions ranging from Dissolve and Zoom to Slide and Wipe. The latter three were popular in the *Star Wars* series, while Dissolve is used most frequently.

Feeling out the other panels

If Premiere Pro were a baseball team, the previously mentioned panels would be in the starting lineup. But let's not forget those players coming off the bench. You know, the ones acclimated to more defined roles. That's pretty much the same for the remainder of the Premiere Pro panels.

Here's a brief description of the other panels.

>> **Audio Mixer panel:** The virtual version of the studio mixer lets you make critical adjustments to audio, with each track in the timeline individually controlled in the mixer. Each sequence offers a separate mixer that only affects only that sequence, so be sure to select the correct one. With this panel, shown in Figure 1-7, it's easy to alter audio levels, add effects, mix tracks, and directly record audio.

>> **Audio Meters panel:** One of the most useful tools in your setup, this VU (Volume Units) meter shows the audio level of clips in the timeline.

>> **History panel:** Consider this panel the visual version of the Edit ➪ Undo function, as it shows you all the actions performed since the project was opened. That could refer to everything you've done since reopening it from the previous session. This comes in handy after you've made a series of changes to your sequence that you're not satisfied with and you wish to revert to a previous state in the current work session. Like the Undo function, it automatically resets when you close and reopen the project.

>> **Info panel:** As a tab in the Project panel, the Info panel shows information, such as track arrangement and duration, about the currently selected item in the Project panel or timeline.

>> **Marker panel:** Markers come in handy when you need to find a specific part of a video clip. Maybe it's the best take, a poignant expression, or some embarrassing moment; marking them is as simple as hitting the M key. This helpful panel lets you see the markers in an active clip or sequence and make comments for description purposes, as well as change the color coding.

>> **Essential Graphics panel:** Offers an accessible place to find specific titles and motion graphics available through the program, and enables access to Adobe Stock to download some others. More about this useful panel in Chapter 14.

>> **Media Browser panel:** This nifty feature allows you to browse and preview files on all drives connected to your workstation or server. It provides direct access to all assets while you're editing.

>> **Metadata panel:** This is where properties of each clip are stored, including file size, format, creation date, and clip duration. Through this panel you can add other vital information such as location, scene info, or whatever else you need for optimal organization.

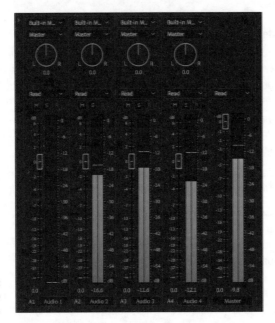

FIGURE 1-7:
The Audio
Mixer.

Using the libraries

Adobe products communicate incredibly well with one another. Premiere Pro kicks it up a notch through a new feature, the Library panel, which provides the ability to add and share media between Creative Cloud (or CC) apps such as Photoshop, Illustrator, InDesign, and others.

Library assets are shared through cloud access, making this feature invaluable for workgroups. Think of the Library panel as an interface for moving image files between applications on the same server.

At this point, the Library panel has limited use for video editing. Still, more intense projects that require enhanced titling, grabbing Adobe Stock images, or the need for grading by a colorist make it a useful tool.

Tooling Around the Toolbar

Back in the day, editing your 8mm film required a tabletop full of clutter that included an editing console with an illuminated viewer, a splicer, glue, and the essential lint-free gloves. Now many of those tools reside in a slim panel that generally lives next to the timeline.

Here's what the toolbar, shown in Figure 1-8, has to offer.

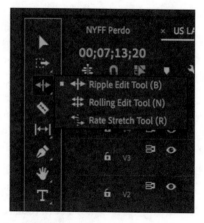

FIGURE 1-8:
The toolbar and all it has to offer, including the Ripple Edit tool.

>> **Selection tool:** This tool lets you grab and move clips in the timeline. In addition, you can expand and contract clips by rolling over their edges and grabbing to push or pull them. To activate this tool, you click on its icon or press the **V** key.

>> **Track Select Forward/Backward tool:** This tool grabs all the clips to the right (or to the end of the timeline) of the selected clip and allows you to move them. In the Backward mode, it selects all clips to the left (or closer to the beginning) of the clip. You click on the icon to activate the Forward tool, or hold down on the icon to choose the Backward tool. You can quickly access these tools by pressing **A** or Shift-**A**, respectively, to toggle between them.

>> **Ripple Edit tool:** Trim a clip by grabbing its edges and pushing or pulling to show more or less of the clip while preserving edits of adjacent clips. You can trim the clip, and the rest will "ripple," hence its name.

>> **Rolling Edit tool:** This tool is nested with the Ripple Edit tool, so you access it by holding the mouse button while selecting the Ripple Edit tool. The Rolling Edit tool works like the Ripple Edit tool, but it lets you move the Out point of the first clip and the In point of the second, thus allowing you to adjust both clips in a single swoop. The keyboard shortcut is **N**.

>> **Rate Stretch tool:** Also nested with the Ripple Edit tool, this tool lets you change the clip speed without affecting In and Out points. You quickly access it by pressing the **R** key.

>> **Razor tool:** Defined by its "old school" razor icon, this tool does pretty much what it says. Basically, you move over the desired area of the clip you wish to separate, and click on it. You can then use the Select tool to select the clip, and then delete it, copy it to paste it somewhere else, or move it. The letter **B** acts as the keyboard shortcut.

>> **Slip tool:** This tool provides a little more control than the Razor tool when it comes to trimming a clip by letting you change the In and Out points in the timeline as you move over it. This is great for making precise frame-by-frame adjustments, while maintainign the time span between clips.

» **Slide tool:** Slip Slidin' Away as this tool is nested with the Slip tool. The Slide tool is similar to the Slip tool, but will close the gaps after you click on them. The shortcut is **U**.

» **Pen tool:** Resembling the nib of a fountain pen, this handy tool lets you add key points that you can then raise or lower audio levels. It comes in handy when you have audio levels with a wide range that need corrections at specific places in the clip — just make points and raise and lower the area between the points. Obviously, the shortcut is **P**.

» **Hand tool:** This pretty much does what you imagine, and that's moving up or down the timeline. **H** raises this one.

» **Zoom tool:** Nested with the Hand tool, the Zoom tool also does what you expect by bringing up a magnifying glass. Clicking it expands the size of the clip in the timeline to allow you to make more precise adjustments. Type **Z** to access.

» **Type and Vertical Type tools:** These tools let you add both horizontal and vertical text onscreen, depending on which one you select. Click on the video, and it will add a Text layer. The shortcut is **T**, although there's not a shortcut to the Vertical Type tool — you just press and hold the **T** in the Toolbar.

» **Identifying your needs**

» **Working with your computer platform**

» **Knowing your user type**

Chapter **2**

Understanding the Premiere Pro Workspace

The moment you set foot in a theme park, you get one of those maps that sort of lets you know the lay of the land. After initial perusal, you end up finding your own way, reverting to the map every now and then to locate the soft-serve stand or find the bathroom.

Premiere Pro is not much different, restrooms aside. In fact, the content on the screen almost resembles a theme park map — you know, if it were called Premiere Pro Land. This chapter provides information for getting around the workspace, which defines the particular way your panels are arranged, and how to make the most of it.

What you do with this information depends on how you will use it. Some users keep it simple, opting for the default setting. Others may resize certain portions of the workspace to maximize their screen real estate. Users more comfortable with the software may select a more specific preset workspace.

Look at the numerous Premiere Pro users on YouTube and you will see practicality, and individuality, at its finest. That brings up the question, "What kind of user are you?" Let's look at the choices.

Identifying Your Needs

Whether you're editing short videos around your latest passion, working on your moviemaking skills, producing a music video, or feeding the beast for your YouTube channel, there's a good chance Premiere Pro will work for you. Within this democracy, serious users can play by their own rules and reach a sizeable population with everything from a short film to a feature-length documentary. Videographers and aspiring filmmakers can also share their vision.

Working with your computer platform

REMEMBER

When it comes to the creative arena, there's no such thing as a cookie-cutter solution, and that begins with your computer choice. Premiere Pro doesn't discriminate between computer platforms, but it does expect them to be robust enough to meet its minimum requirements to make sure it runs effectively, or even runs at all. So, whether you're a Mac maven or a Windows wonder, you will benefit from the power and ease of the program.

Are you a Mac?

TIP

Or do you just "think different"? Apple has come a long way since those early ad slogans (if you're unfamiliar with them, perhaps you'd enjoy a trip down memory lane on YouTube). Maybe you're a former PC user taking a bite from the Apple. Mac aficionado? Then chances are you'd rather fight than switch when it comes to your machine of choice. And for good reason. If you walk out of the Apple store with a computer, you can start your movie not long after you plug it in and download Premiere Pro.

I'm not saying that's not possible with a PC too; it's just not as likely. And that has nothing to do with the integrity of the machine; rather, it's because so many manufacturers make them using a potpourri of similar parts and different components as opposed to Apple, which is the sole maker of Macs. And when you add those lower-priced models aimed at web users, it's obvious that not all computers are suited for Premiere Pro.

Sleek and powerful, and with built-in software too, the Mac acts like a professional machine in the hands of anyone who chooses to tap its keys. And if you just bought one, you've already met the first requirement for moviemaking.

Here's the current Apple lineup.

>> **iMac series:** This popular all-in-one desktop computer, shown in Figure 2-1, includes enough computing power to edit 4K or HDR video right out of the box. Currently available in three screen sizes — 21.5-, 24-, and 27-inch — with a few configurations of the new M1 processor, these aesthetically pleasing models are serious editing machines.

>> **Mac Pro:** The big Kahuna in its tall aluminum tower looks more like an art installation than a robust machine. But don't let its visually aesthetic presence fool you. This is a powerhouse loaded with an Intel Xeon processor that includes up to 28 cores. Yikes! But it's not light on the pocket, and the monitor is a separate purchase. It's a durable workhorse for serious moviemaking and hardcore effects, yet for anyone breaking in, it is a bit costly.

>> **Mac Mini:** There was a time that the Mac towers were the only game in town when it came to serious moviemaking software, and they were usually tied to expensive turnkey editing solutions. Now, instead of a tower, one choice resembles a white cigar box. The Mac Mini is a serious player, and it thrives with Premiere Pro. Beware, as its size and name are all that's diminutive. Now running the M1 process, this line includes a healthy array of high-speed connections, you can attach fast-running hard drives, additional monitors, and other peripherals to these versatile machines.

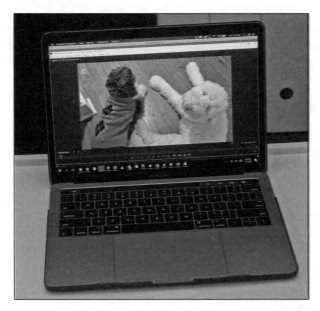

FIGURE 2-1:
Premiere Pro running on a Mac.

>> **MacBook Pro:** On the portable side, it's hard to have a more dedicated machine than the MacBook Pro. The Mac version of the laptop brings the power of a Macintosh to the field for capturing and editing video anywhere. Available in 14- and 16-inch models, all with Apple silicon, each one has a few configurations in terms of processer speed and hard drive size, including the new Pro or M1 Max chip with 10-Core CPU. And if you plan on staying put, adding an external monitor, keyboard, and mouse provides a desktop feel.

>> **MacBook Air:** These are powerful, agile computers that weigh next to nothing and fit easily in a small bag. Available with a 13-inch screen, and new M1 processor, the Air series lives up to it moniker, weighing in at less than an airy 2.8 pounds, making it a serious mobile contender.

Or are you a PC?

That title seems grammatically awkward, at least if you are reading the "PC" as a stand-in for political correctness. Instead, I am referring to the acronym's initial meaning, personal computer, or one that runs the Windows operating system. Not everyone is a Mac fan, and both platforms are equally powerful. Some users feel PCs are better suited for their needs — you know, like gamers, accountants, and programmers. PCs range in cost from cheap to very expensive. Just ask any avid gamer about the massive computing needs required to make it through Forza Horizon 4.

Hypothetically, if you took a group photo of the entire Mac-user nation on one side, and PC users on the other, the PC side would have about ten times the number of users. More people own PCs, plain and simple. But if you narrowed the groups down even further to include only computers that were built to handle video, the disparity between Mac and PC owners would narrow. Let's not worry about those debates. Instead, let's look at what you'll need to make a movie.

Naming PC models is a little harder

While it's easy to name all the current Macintosh models, which requires just a quick perusal of the Apple site, this isn't possible when it comes to the PC. Numerous manufacturers make them, so it's harder to isolate specific machines. Screen sizes on laptops and processers on desktop models also vary widely. Dell, ASUS, HP, and Lenovo are just four of the many manufacturers.

PC models come in the following types.

» **Desktop:** Towers are still common in one form or another. Various configura-
tions range from no frills to fully loaded. Better components include faster
processors, soundboards, and high-speed USB-C inputs.

» **All-in-one:** Becoming more common, the streamlined all-in-one models
feature fast processing power, HDMI connectivity, and a large screen in one
package. While the specifications and internal parts vary with each maker,
many models support video editing, including the Sony Vaio L-Series with
touchscreen technology and the HP TouchSmart. Their prices range from
$500 to $2,000.

» **Laptops:** Another wide swath of
the PC market includes the laptop,
shown in Figure 2-2, which enjoys
the same popularity and ubiquity
as the sport utility vehicle. But not
all PC laptops are created equal.
Some models excel, taking your
video editing to new heights, while
others clearly fall short of the
runway. That's why it's prudent to
check the specs for running
Premiere Pro before committing to
a model for editing your master-
piece. Because these portable
units are made by a variety of
manufacturers, basic components
and screen sizes differ widely.

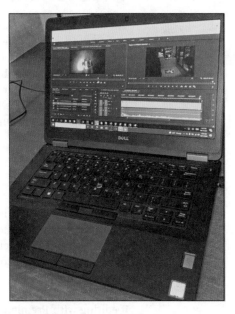

» **Touchscreen-based personal
computers:** Think the Microsoft
Surface Pro, which is essentially a
tablet that doubles as a laptop.
These hybrid devices are useful for
a variety of purposes, including
running Premiere Pro.

FIGURE 2-2:
Dell laptop running Premiere Pro

Operating the OS of each platform

>> **Mac OS:** Besides its famous Roman numeral moniker, the Mac OS these days is cutely named after national parks. The latest incarnation, Monterey, better known as OS12, offers a smooth, stable, and very cool work environment. Older versions, including 10.15, can run Premiere Pro CC.

>> **Windows:** Version 10 is the latest operating system for PC-based computers, and is required to run Premiere Pro CC.

The systems are not that far apart

REMEMBER

The term "separate but equal" applies here with the basic operation of Macs and PCs. In a way, they're like biscuits and cookies, or Labradors and Golden Retrievers. Yeah, they look the same, but each is still unique. Macs are generally more costly than the lower-end of the PC spectrum. Middle and upper range PC-based systems share similarities with Macs. If your PC current model meets the specs, then there's little difference between running Premiere Pro on either system, apart from your personal preference and a few changes to the shortcuts and keystrokes.

Look before you leap on your PC

Magicians and con artists thrive on the art of deception; they are successful at diverting your when the trick goes down. That's not insinuating manufacturers are misleading customers, but it's easy to believe that a PC model will work effectively with Premiere Pro. So, don't just look at the maker; rather, it's best to carefully evaluate the components.

If editing with Premiere Pro is in the cards, stay away from those PC models that look like a bargain; they are designed more for light duty and web-related activities. Instead, look for a machine with a fast processor like an Intel Core I-7 (or similar), high-res display, and a graphics card that can handle video playback at 4K resolution (about four thousand pixels), even if you're not editing it that way.

Expect the cost to be comparable to a Mac. And one more thing, ramp up on the computer's short-term memory, or RAM (see the section, "Random access memory," later in this chapter). Use the Premiere Pro CC specs listed below before picking a new computer, and try to pick a model that exceeds those requirements.

Understanding Workstation Requirements

WARNING

Not all computers are useful when it comes to making movies. Some are clearly better suited than others. For example, Macintosh computers running OS 10.11 are not compatible with making 4K movies in Premiere Pro — only macOS (versions 10.12 or later). Other programs may work, but the processing power doesn't rise to the occasion for making 4K, or even HD movies. The same applies to PC models that don't meet the application specifications.

But instead of concentrating on the negatives, let's look at the positives. Here's what you need to make movies with your computer.

TIP

>> **Use a relatively new model:** Some computers are clearly more replaceable than upgradable. While older computers may still be up for the task, some may lack certain functions or not include some important components — for example, a fast enough graphics processing unit (GPU) or adequate RAM capacity.

>> **Fast processor:** It's the brains of the operation. While many newer machines offer a fast enough processor, some may not be optimal for Premiere Pro. Other factors include the cache, RAM, graphics card, and other things that influence overall speed. If you're not using a newer machine, be sure that the one you are using exceeds the minimum requirements to run Premiere Pro.

>> **Large monitor:** When it comes to video editing, what you can get away with and what you need are two different things. Get as much real estate as possible on your desktop with the biggest screen you can afford. On a laptop, you're a bit limited, but you can still use a 15-inch external monitor. If the computer's screen is smaller than that, consider a second monitor.

TIP

>> **Sufficient RAM:** Less is not more here. Much like batteries or gaffer's tape, you can't have enough of the stuff. It's what lets you run your processor-hungry video-editing software while toning a picture in Photoshop and updating your Facebook status. Quite simply, the more the better, and because while HD movie files require a lot of memory, 4k needs even more, so you should buy as much as you can afford. Even HEVC files captured with your iPhone are RAM intensive. Premiere Pro requires a minimum of 8 gigabytes, but I would suggest at least 16 gigabytes to get better performance.

Determining if your computer is right

WARNING

Premiere Pro offers power and control over editing, but you need to make sure that your computer can support such a robust program. There's a good chance that if the computer is relatively new, and not a lower-level model, you'll be fine. But you still need to check specs. Here are the minimum requirements to ensure your computer is up to the challenge.

Windows

TECHNICAL STUFF

If you're running Premiere Pro on Windows, here's what you'll need:

>> Intel 6th generation or newer CPU — or AMD Ryzen 1000 Series or newer CPU

>> Microsoft Windows 10 (64-bit) version 2004 or later

>> 8 GB of RAM; 16 GB of RAM for HD media; and 32 GB for 4K media or higher

>> 8 GB of available hard-disk space for installation; additional free space is required during installation. (Premiere Pro will not install on removable flash storage.) But that's conservative, because you will need lots of extra storage for media and render files.

>> 2 to 4 GB of GPU dual-ported video RAM, or VRAM

>> 1280 x 800 display resolution

>> Audio stream input/output (ASIO) compatible sound card or Microsoft Windows Driver Model

>> 1 gigabit Ethernet

Macintosh

TECHNICAL STUFF

If you're running Premiere Pro on a Mac, here's what you'll need:

>> Intel 6th generation or newer CPU

>> macOS 10.15 (Catalina) or later

>> 8 GB of RAM; 16 GB of RAM for HD media; and 32 GB for 4K media or higher

>> 8 GB of available hard disk space for installation; additional free space is required during installation. (Premiere Pro will not install on removable flash storage.)

>> 2 GB of GPU VRAM

>> 1280 x 800 display resolution

>> ASIO-compatible sound card

>> 1 gigabit Ethernet

Breaking down the differences between Mac and PC

Premiere Pro works great on both the Mac and Windows platforms. Each provides a comfort level that's a matter of personal preference, much like the choice between air conditioning and a ceiling fan on a balmy day. For some, the intuitive nature of the Mac OS makes it the more desirable platform, though Windows users may argue that point, too. Aside from personal preference and some layout variation, there's little noticeable difference between the performance of Premiere Pro on either platform.

The Mac OS lives up to its reputation for being more user friendly, while a Windows PC offers more flexibility in price and adding custom peripherals.

Respecting the graphics card

TECHNICAL STUFF

Behind the scenes, this important computer component builds the screen image before your eyes pixel-by-pixel. The graphics card (GPU) is optimized for processing digital images. Think of it as a private contractor hired by the processor to build, rasterize, and redraw the screen image quickly and efficiently. In the case of video, it accomplishes this task at a rate of 30 or more frames per second. That means 30 individual images, or more, captured at a frame resolution of 1920 x 1080 pixels. Some video is captured at up to 240 frames per second and displayed at frame rates up to 120 fps. While most newer graphics cards suffice, it's a good idea to either add a second card to connect multiple monitors or see if the computer you're about to purchase offers the luxury of connecting multiple monitors. Here's where Macs have the edge. Out of the box, they're designed for multimedia use, and with only a few variations of each model, it's easy to determine if the graphics card is up to the Premiere Pro challenge.

PC models, as mentioned previously, are made by numerous manufacturers for a wide variety of uses. So, an inexpensive laptop that's designed for web use may not be ideal for video editing.

Needing GPU acceleration

WARNING

Premiere Pro re-creates high-quality video that plays smoothly on your computer when it meets the minimum requirements for hardware, memory, and operating system. Most of the time, the software helps process the workload, but when adding filters and graphics, video playback can sometimes be more than the program can handle. When that happens, a message pops up, saying, "This Effect Needs GPU Acceleration."

If you have a supported GPU, acceleration is handled by the graphics card. You can access it by going to File ⇨ Project Settings and selecting the Mercury Playback Engine (CL), as opposed to the one that reads Software Only. Only change to Software Only if you are having playback problems.

TIP

If you're not performing a lot of memory-intensive actions, then leave it to the software. Sometimes, when the hardware is selected, it can cause Premiere Pro to freeze or quit.

Random access memory

TECHNICAL STUFF

More is better when it comes to having random access memory, or RAM. Providing temporary storage and working space for computer-related tasks, the excess RAM translates to smoother operation with video playback when using Premiere Pro. Acting as the computer's main memory, RAM reads data from and writes data to the computer drives but only holds onto it while the computer is running. It's the kind of thing you can't have enough of, and that's the last superlative. Premiere Pro requires a minimum of 8 gigabytes, but it's better to have 16 or even 32.

More Hard Drive Space, Please

Hoarding goes beyond saving every newspaper and magazine from 1999; it also applies to virtual storage. Movie files, especially in 4K, take up a lot of space. Organization of your visual assets is important, but even if you're the most organized editor, video ingests take up a lot of room.

All of that data makes it necessary to invest in an extra hard drive. But this does more than keep your files in one place; it also affects performance for the better.

These drives come in several configurations.

>> **Internal drives:** Some CPUs let you add a second drive. Advantages include convenience and less desk clutter. Disadvantages are that internal drives require complicated installation and techno-surgery to remove when using a different computer.

>> **External drives:** Independent of the computer, these separate hard disks are available in various sizes and connections, with the solid-state drive being the newest choice. Benefits of the external drive include the ability to use them on different computers and to add new ones after they fill up.

>> **RAID Array:** An acronym of Random Array of Independent Disks, this group of hard drives connected to one another act as a single unit for increased capacity, performance, and redundancy, making it ideal for safely saving your movie projects. The RAID is a great option for your bigger projects.

Solid-state drives

TECHNICAL
STUFF

While it seems like the cost of an external hard drive has increased like lumber or gas prices, this increase has nothing to do with the dollar-to-gigabyte price point. Rather, it is based on the move to the solid-state drive (SSD), an example of which is shown in Figure 2-3. Not only is an SSD more stable, and has faster performance, but its lack of moving parts means that it will last longer. Self-powered and using a USB-C connection, these drives are superfast, making them perfect for video editing. Newer computers and laptops now include an SSD, which generally offers less capacity than its "spinning" HDD (hard disk drive) counterpart, but with more stability.

Conventional hard drives

TIP

While the SSD has no moving parts, the conventional hard drive is constantly in motion. Whether it's the internal drive in your computer, or an external accessory, these "spinning" drives save data using a revolving platter with a thin magnetic coating that translates binary information, those zeros and ones, into your video image.

Magnets that get too close to a conventional drive are like Kryptonite to Superman. If you get too close, data can become corrupted. But then again so can knocking it around. So handle them with kid gloves.

FIGURE 2-3:
Samsung
T7 Portable
SSD is only
2 x 3 inches.

Not all hard drives are created equal

WARNING

Visit any electronics store, and you'll see dozens of drives at a wide range of costs. Drive capacity, connection type, power source, and disk speed can all affect the cost of a conventional hard drive, though these days more computers are using solid state drives or SSDs — which, by the way, has no moving parts.

When it comes to standard drives (also known as conventional), not all of them are created equal. The average drive spins at 5,400 revolutions per minute (RPM), which is fast enough for most applications, but not always up to speed (pun intended!) when it comes to making movies. Sometimes it can feel like driving in the slow lane as everyone on the left zips past you. If you are using a standard drive, having one that spins at least 7,200 RPM will do the job. Faster ones go up to 10,000 RPM, but may be overkill.

Scratch disks

Scratch disks aren't actually disks at all; rather, they serve as the destination on your hard disks for temporary files, cache files, imported video, and other actions from the timeline (transitions, titles, effects, and so on).

Managing other computer components

If you have acquired the machine and the necessary requirement to run Premiere Pro successfully, congratulations! You're a few steps closer to editing your first movie project. But we're forgetting about few other things: the peripherals! Below you'll learn about what types of keyboards, mice, and ports work best for video editing.

Keying into keyboard types

While the standard version that came with your computer does the job, you may want to upgrade to one of the following.

>> **Dedicated Premiere Pro keyboard:** With color-coded keys and written instructions, a dedicated keyboard will familiarize you with shortcuts and keyboard actions. Plus, it looks pretty cool on your desk. They also handy when your wireless keyboard loses power or doesn't connect for some reason.

>> **Wireless:** Bluetooth models free up a USB connection and allow you to move the keyboard out of the way without tangling cables.

>> **Ergonomic:** Specialized keyboards designed to provide a more natural feel when typing can also reduce the causes of repetitive stress injury, better known as RSI.

Eeek, a mouse!

In nature, an upgrade to a mouse is a rat. For video editing, it ranges from a wireless mouse to a track pad and anything in between. Then, of course, there's the jog shuttle, shown in Figure 2-4, which transforms your desktop into an editing suite. A mouse is still a relevant tool with Premiere Pro, so finding a comfortable one is an asset. But the shuttle can help you zip through Premiere Pro with relative ease.

FIGURE 2-4:
The jog shuttle brings the control of an editing console to your desktop.

TIP

Reasons to use a shuttle control include the following.

>> **Easy scrubbing:** No scouring here, but it lets you move through the content more easily in forward or reverse.

>> **Preset application functions:** Instead of resorting to keystrokes for common functions, you can designate assignable functions.

>> **Included on some keyboards:** Keyboards designed for video editing sometimes include a shuttle control.

USB-C is the new black

Once upon a time, laptops, smartphones, and peripherals used a 'what's what' of cables and connectors. But now there's unity with a single cable that can handle it all, the USB-C connector. You can charge your phone, power your laptop, and transfer content faster than ever before. How fast? Using an SSD that can vary from 400–2800 MB per second when plugged into a USB 3.3 port, better known as a Thunderbolt on your Mac. Of course, these speeds depend on the transfer rate of the drive that you're using.

Looking at Capture Gear

Powerful editing tools like Premiere Pro allow anyone with a vision to channel their inner Thelma Schoonmaker. She's the Oscar-winning film editor behind Martin Scorsese's films, including *Raging Bull* and *Goodfellas*. But, before you can aspire to master the craft, you need to have great content to edit. That means great camera work, composition, and technical quality.

These days, that material comes from the widest range of tools to date. Everything from professional-quality 8K video capture cameras and broadcast camcorders to digital single-lens reflex (DSLR) and your smartphone can produce content for your movie.

Let's look at some popular devices and how they relate to the Premiere Pro landscape.

Smartphone capture

We've all heard an elder throw out a "colorful" metaphor like, "That happened before you were knee-high to a grapefruit," or a tale of the old days: "When I was your age, I walked two miles to school, uphill, both ways." Well, Premiere Pro got

its start long before the days of smartphones so in this case, the software application is the grandma or grandpa of the iPhone or Galaxy.

REMEMBER

Now, the video capture from your iPhone (seen in Figure 2-5) surpasses the video quality of your old DV camcorder. That kind of capability, along with the convenience of having it *everywhere* you go, has vaulted it to the most popular tool for capturing video. Just look on social media and you will see the dominance of the smartphone movie. And why not? You always have your phone, and so you can grab some video at any time, as shown in Figure 2-8. Want an example? How about the feature film *Tangerine*, which used smartphone content?

FIGURE 2-5:
The video capture mode used with an iPhone.

Transferring to Premiere Pro doesn't require downloading a media card, as the content can show up on your cloud server, so you can just import it to your computer.

Top-of-the-line video cameras

REMEMBER

Chances are if you're perusing this book, two factors are probably true: you're not digitizing from a VHS tape, nor are you using a higher-end video camera that captures 8K video. But in the off chance that you are, content captured with models from Blackmagic, Sony, and Panasonic and can be edited in Premiere Pro. But you had better make sure you have a super-fast graphics card to handle those edits, especially when adding effects. The pricey Radeon Pro SSG provides enough screen speed for those mega-large files. How much, you ask? That card, and similar GPU cards, can cost more than your entire computer setup. Still, the good

news is that Premiere Pro will support 8K footage from numerous native camera formats.

Broadcast video camera

In case you're wondering, the camera of choice for electronic news-gathering (ENG) crews is the bigger over-the-shoulder camera, which is optimized for rugged use. These cameras are versatile, durable, and can support a wide array of accessories for capturing video content on the go. Because they are designed for expeditious coverage, some of their proprietary formats are fast to download, but require a specific media card for video capture. Some newer models support Secure Digital (SD) cards, while others use proprietary formats such the XQD card used with some Sony high-end cameras, as shown in Figure 2-6.

FIGURE 2-6:
High-speed
XQD SD card.

Consumer-level camcorders

Less popular than they once were, consumer-level camcorders still play a role in amateur, student, or low-budget movie making. This group covers a wide range of options, from point-and-shoot models that capture HD video, which are very affordable, to more expensive ones that offer 4K video capture. While the less expensive range often lack the ability to support external accessories, the middle-to-higher-priced models let you add external microphones and camera lights, as well as have improved lens optics and provide a full array of manual camera functions. Camcorders in this class capture content on an SD card or record directly to the camera on a built-in hard drive.

Digital single-lens reflex

As one of the most liberating examples of image creativity, the digital single-lens reflex, or DSLR (shown in Figure 2-7), captures both still images and high-quality video. There are a lot of advantages to using this type of camera, including the ability to make high-quality video with a camera that arguably has the greatest cost-to-quality ratio. Much like your still photography capture, you have a wide range of interchangeable lenses that cover focal lengths from super-wide to ultra-telephoto.

FIGURE 2-7:
The Canon
6D DSLR
captures HD
video and
includes a
full-frame
sensor.

REMEMBER

Your still photo camera has a bigger image sensor than an expensive video camcorder. The more pro-oriented models match the size of a 35-millimeter frame, meaning that the same wide view you capture in your photos can make it to your movies. You can easily emulate the abnormally wide-view perspective of a filmmaker like Wes Anderson.

It's no secret that many movies and television shows have been shot using DSLR. Besides having the best bang for your buck, this class of camera stands out as being the most familiar to use, with video captured on an SD card and imported into Premiere Pro.

Point-and-shoot video options

Historically, 'point-and-shoot' covers a lot of ground; from the cheap instamatic camera of the 1970s to the discount store version of the 35mm, the point-and-shoot

camera provided some low-brow versatility. That tradition continues, although with more quality, and one of the options on many of the newer models includes HD video. But you get what you pay for: Quality and control are generally fickle, with limitations in optics, camera controls, and supporting accessories. While not the best option, a point-and-shoot camera can offer enough functionality to capture content for your movie.

Mirrorless camera

A successor to the DSLR, the mirrorless camera system is built with the same level of construction and is suitable for a wide range of professional applications, including 4K and HD video capture. Offering the same level of image quality, support for a wide range of accessories, and a complete array of camera functions, this newer camera technology offers a major difference from the DSLR: It excludes the mechanical mirror used to reflect the image into the viewfinder. That would be the *reflex* part of the digital single-lens reflex camera. The body is thinner and lighter than a DSLR and can support various accessories like a hot-shoe shotgun microphone (as shown in Figure 2-8) and interchangeable lenses. Some models can even fit in your pocket (that is, provided you have a jacket with a large pocket). The SD card captures video and easily transfers to Premiere Pro.

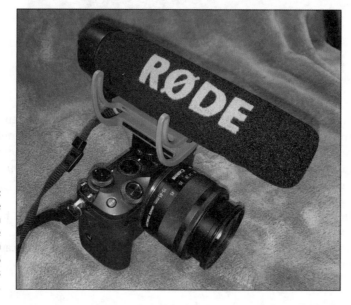

FIGURE 2-8:
A Røde shotgun microphone atop a Canon M6 mirrorless camera.

Going GoPro

The expression, *good things come in small packages,* covers the powerful and diminutive GoPro camera. This pint-sized, waterproof camera can attach to just about anything, it offers an ultrawide angle view, and it's controllable by your smartphone; on top of all this, it yields amazing results. The camera uses a micro SD card that can be ingested into Premiere Pro.

Card readers and capture devices

REMEMBER

Card readers and capture devices are almost like the VCRs of the modern day, minus the blinking-at-12:00 digital readout and any moving parts. A card reader, shown in the group photo in Figure 2-9, acts as the gateway between shooting scenes and getting them into your project. Card readers handle various memory card types, with the Secure Digital (SD) being the most popular. For example, the Panasonic P2 uses a dedicated reader, much like the Sony camera that uses the XQD card. If you're shooting in these formats, or others like them, you most likely have the proper hardware. But on the off chance that you don't, you can go old school and connect the camera to your computer and download the files.

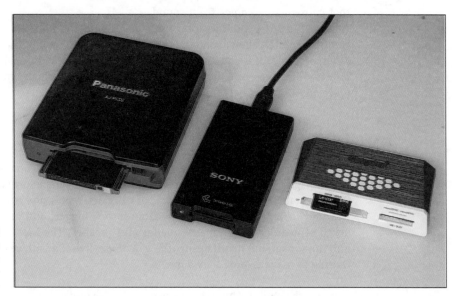

FIGURE 2-9:
The Panasonic P2, Sony XQD, and a multi-card reader.

Audio recorders

The notion of using a separate audio recorder, shown in Figure 2-10, the predecessor to the tape recorder, not only seems complicated, but also a burden. Who wants to add another device to the mix (no pun intended), then worry about synching up audio or matching levels? But it turns out that the rewards outweigh any inconvenience. Captured independently of the video, the audio easily comes together in postproduction. Another reason for using a separate audio source is that it gives you more control over audio level and equalization.

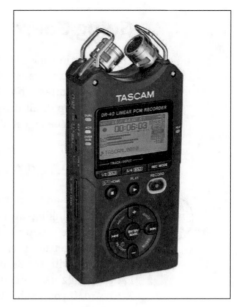

FIGURE 2-10:
Audio recorder for capturing audio independent of the camera.

REMEMBER

Movies are constructed by bringing various video and audio clips into cohesive form, and a big part of that construction comes from sound. Feature films depend on capturing audio separately, so even when your video camera captures audio, sometimes even high-quality audio, there are still limitations to its capture quality. Some situations require additional sound, be it for effects, voice over, or maybe additional dialogue replacement, known as ADR (for more on ADR, see Chapter 6).

Going to the videotape

It's hard to disagree with the notion that videotape has become scarcer than the yellow pages. The demise of both was imminent. Videotape formats such as Hi-8, DV, HDV, and even VHS, went the way of the video rental superstore. Their demise was inevitable as flash memory became faster, bigger, and more reliable. That led to camcorders being made smaller and cheaper. The tape camera has faded into the sunset, but its offspring, the videotape, lives on with yesterday's content waiting to make it into today's movie.

Here are the choicest lingering devices out there today.

>> **HDV decks:** These days, HDV decks are super cheap to pick up on eBay or some video outlet, and ideal for playing the last generation of videotape capture, the High-Definition Digital Video tape. They can also play a standard-definition DV tape. Often these decks used outdated technology like FireWire,

which was eulogized years ago. If transferring from an HDV deck, you will need a FireWire-to-Thunderbolt adapter.

>> **DV decks:** At one time, the digital video format leveled the moviemaking playing field by giving advanced users the power and affordability of serious equipment for that time. This format captured at a resolution of 720 x 480, which was great for the time, but now comes in undersized when viewed from an HD timeline. Upscaling will show some resolution loss, but it should be okay. One thing to keep in mind is that this material was captured in both 4:3 and 16:9 aspect ratios, the latter being the one most timelines edit in.

>> **Early video camera formats:** These include 8mm, Hi-8, and Digital 8, and they revolutionized home movies by offering the immediate gratification of watching your movie with sound on your television. Quite a departure from the nearly three minutes of silent capture provided by their predecessor, the Super 8 film camera. These videotapes are mostly played back using the original camera. While the content is irreplaceable, the quality is not.

TIP

If you plan to use old content, have it all digitized by a service; this way, it's ready to edit in Premiere Pro. Be aware that upscaling to HD will be as noticeable as chocolate pudding spilled on a starched, white shirt. Also, keep in mind that this footage uses a 4:3 aspect ratio, and may look weird (stretched out) when played in your 16:9 timeline, instead of showing areas of black on the side (known as *pillar-boxing*).

>> **VHS decks:** The once ubiquitous VHS format may still hold your old memories like school plays, family parties, and those early attempts at making your own short movie, but its minimal quality barely rivals the smartphone capture of a few years ago. At some point, you may want to transfer this legacy to a new format, and perhaps edit it in Premiere Pro. Unlike later video formats that took computer transfer seriously, there's not a digital throughput from your VCR without using a conversion box. These are found cheaply online but require a USB or FireWire adapter, depending on the device.

Defining Users

Here's an interesting factoid: Studies by social psychologists suggest that when the average person is asked about their proficiency in a particular area, they not only overestimate their ability, but tend to believe it, too. Nothing malicious about that theory, just an exposé of the pitfalls of being overconfident, and how it can affect your understanding of your true ability. Rather than examine your Premiere Pro proficiency level, let's take another approach and find the user group that best

defines you. Given the democratic nature of the software, it's possible to cover a wide swath of users. So, take a gander at some of these groups, and see what you can expect from this book.

Neophyte user

Completely new to nonlinear editing? Dabbled in some editing programs, or maybe heard about Premiere Pro, but never touched it, and now you want to? There's a good chance you're a little nervous about trying your hand at editing, but you want to make a movie and learn how to use the software. Well, you've come to the right place. Here, you'll get a down-to-earth explanation of the Premiere Pro landscape and how to navigate it to perform basic tasks. You'll start off by setting up your first project and then practice ingesting, moving clips, and playing them back. Next, you'll make simple, short edits consisting of a few clips. Before long, you will have the confidence to expand your horizons with your movie-editing prowess.

Intermediate

Could it be that you identify more with being a video editor than just dabbling in editing? It's just that the program you cut your teeth with is no longer the same, or maybe your new computer doesn't support it, and you want to migrate to Premiere Pro. If so, the front section of this book can bolster your understanding, much like reading a map in the pre-GPS days. Think of your journey as more of a re-acquaintance with the editing process that emphasizes the nuances of Premiere Pro. By the time you're done with this book, it will make you feel as though you have the resting heart rate of a marathon runner when it comes to making your movie.

Professional photographer

Photography and filmmaking were once far apart. It's not quite the relationship shared by oil and vinegar, but there was a time when photographers and filmmakers operated on two different planes of thought. Using film was the only thing they had in common. Now that the DSLR also includes a movie mode, photographers skilled at taking still images can make movies at an extremely high level with the same camera. Why not? Already comfortable with the camera, there's a dash of confidence. But the DSLR is more than a camera that has video capability; thanks to its CMOS sensor (the digital equivalent of the film plane), which is bigger than those on most video cameras, the quality factor also increases. Then there's the fact that you're a photographer, which means that you're probably comfortable with Adobe Photoshop, so the Premiere Pro environment will be familiar. So,

putting your masterpiece together should be as easy as driving home in the rain with the good windshield wipers. But it will require some understanding of lighting a video shoot as well as capturing audio.

Video enthusiast

So, you've been part of that group involved in video production for a lengthy part of your career. Maybe you worked in an editing bay and dabbled with tape editing. Did you come from the Final Cut Pro camp and want to translate your skills? Or were turnkey systems from Media 100 or Avid your thing? No worries. You know how to edit, but need to get used to the new software. If that's the case, then after a quick perusal of this book, you'll be making movies like a Premiere Pro.

Social media influencer

Putting videos up on social media is your thing, and now you want to fine-tune those edits to stand out more. Whether you are running a YouTube channel, amplifying your videos on Twitter, or interesting in wowing your TikTok followers, it all comes down to editing great video. Even if you have a limited understanding of Premiere Pro, this book will set you on your way to click heaven with its combination of power and ease.

Chapter **3**

Adjusting Premiere Pro to Suit Your Needs

M uch like the serenity that comes with manicuring your bonsai garden, setting up Premiere Pro provides its own Zen-like escape. Equating a productive sense of calm with such a complex program seems unusual — that is, until you realize the power and control it provides over your video content. And the power begins with the right feng shui of your Premiere Pro workspace after downloading and installing the software.

Setting Up Your Workspace

Some people walk into a department store, try on a blazer, pay for it, and walk out of the mall wearing it with confidence. Others prefer custom tailoring to feel content with what they're wearing. The same holds true for your Premiere Pro workspace. This includes everything from computer choice and loading software to setting workspace presets and making keyboard shortcuts a part of your workflow.

Subscribing and installing software

REMEMBER

Premiere Pro has always had a price point in line with other professional applications, which made it accessible to some users and cost-prohibitive to others. That's changed as Adobe has moved to a subscriber-based service, where customers can purchase licenses of Premiere Pro, along with other programs such as Photoshop and Illustrator, in the Creative Cloud.

Log on to the Adobe website at www.adobe.com and select the program you're interested in using (Premiere Pro in this case); then, after setting up a user account, you can download the software. The subscription is billed monthly and requires a one-year commitment. The good news is that you have seven days to try it out for free and decide if this is the right program for you.

Here are some aspects to consider:

>> Be sure you're prepared to subscribe for at least one year. Much like a traditional magazine subscription or gym membership, you're in for the duration. So use the trial period to make sure Premiere Pro works for your needs, otherwise it will be another subscription you will have to pay for like the five streaming services you no longer watch.

>> Check that your computer can support Premiere Pro before going to the trouble of downloading it (see Chapter 4).

>> And then get right into it. Mastering Premiere Pro is a marathon, not a sprint.

Feeling welcome

Premiere Pro welcomes you when you open up the program. This friendly space, shown in Figure 3-1, makes it easier for you to get started by offering several options. Create a new project, open an older one, or get back to your most recent project. There's also tutorial access and other helpful choices. You will not see this screen if you already have a project open.

Using workspace presets

REMEMBER

At the top of the program window, you see a list of preset workspaces designed around specific editing tasks. Besides the default Editing workspace, you can choose a preset suited for a specific task or project. You can change a preset by going to Windows ⇨ Workspaces, as shown in Figure 3-2, and looking over the choices. These choices can also be found at the top of your program window, with the currently selected one highlighted in blue.

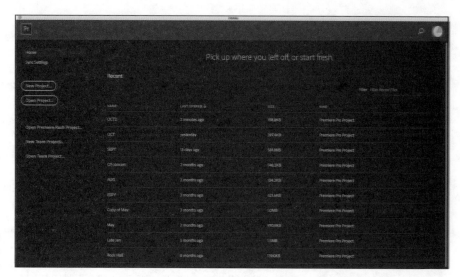

FIGURE 3-1:
The Welcome
screen.

Here's a basic description of each workspace.

>> **Assembly:** This is a useful workspace for beginning your project. It provides an intuitive layout for reviewing and organizing clips, especially when seeing them for the first time. Create separate sequences with scenes, interviews, and that extra footage for your movie, better known as B-roll that you can draw on later in the project. Basically, the screen is filled with the Project panel on one side so you can see all your files and organize bins and sequences. The top right toggles between the Source and Program Monitor panels, and a short timeline resides below it.

FIGURE 3-2:
The Workspaces pull-down menu.

>> **Editing:** Acting as the de facto layout, this is the place to do your heavy lifting, and tell your story. As for its arrangement, the Source and Program Monitor panels are on top, with the Project and Timeline panels on the bottom.

>> **Color:** This is the workspace for making sure that your footage looks tonally perfect. Rather than you having to manually load the effects and settings that control color, brightness, contrast, RGB curves, saturation, and stylized effects, this preset workspace puts them all at your disposal. You also can load the powerful Lumetri Color panel with its correction controls. (More on that in Chapter 10.) Closely resembling the Editing workspace, the Color workspace scales down those panels and adds the correction effects to the left.

>> **Effects:** This is very similar to the Color workspace, but with the panel listing choices beyond color correction. It also includes the Essential Graphics panel for adding text-based effects like lower-third graphics, animated text, movie style credits, and others.

>> **Audio:** As its name implies, this workspace optimizes tools for audio adjustment and enhancement. It includes the Essential Sound panel as well as the Audio Clip and Audio Mixer panels. You can even send audio clips to and from the Adobe audio-editing program, Audition, to enhance tracks.

>> **Learning:** This workspace is a bit redundant as it closely resembles the Editing workspace, just without the tabs to other panels. When you first activate this workspace, it displays some learning materials. These are helpful when you're getting started with Premiere Pro. This is a great workspace when you're just starting out and looking for an overview of the program.

>> **Graphics:** This is very similar to the Effects panel, but with the added option of the Adobe stock window and Adobe graphic templates. While many are free to add, others require a fee. You can click on the check box in the panel to look at either group, or both, if that's your pleasure.

>> **Libraries:** Sharing is caring with workspace. It allows you to share and access content from the current library, other libraries, and Adobe Stock. Activating this workspace prominently displays the Libraries and Project panel, so you can share content in and out of the program.

>> **Metalogging:** Much like the Assembly workspace, you wouldn't want to edit here, but this workspace offers better options when organizing and labeling your content. This is especially useful when you have a large amount of content that needs accurate descriptions so it's easy to find when you start editing. Clip length, resolution, frame rate, and other info that you input are at your disposal when tackling a massive project. Because this workspace defaults to the Overflow Menu, acccessing this workspace from the Program Window requires you to click the chevron on the far right. You can still access through the pulldown menu.

Edit workspace order

TIP

You don't always need to click the chevron for some preset workspaces. Instead, you can customize the Program Window order by going to Window ⇨ Workspaces ⇨ Edit Workspaces. Or you can click on the chevron and choose from pulldown menu.

Adding a clip description

TIP

Whether you are editing your own movie, or involved in a team effort, it's important to log shot information; that's easy to do in Premiere Pro. The Project panel displays properties information (this includes frame rate, video info, and audio info) on your footage, which comes in handy when selecting clips from a busy bin. That information isn't limited to properties; it also allows you to add your own descriptions and details. It doesn't matter what workspace you're in.

TIP

Inputting clip description notes may seem time-consuming, but it will pay you back in spades, especially in a busy project panel. After inputting information, you can easily find a clip by typing its name in the search box.

Here's how to add clip description notes. In the List view, just scroll across and click on the Tape Name, Description, Log Notes, or Scene field; the field becomes editable and you can start typing directly into it, as shown in Figure 3-3.

FIGURE 3-3:
Typed information in the Clip Description Notes field.

Customizing and saving your workspace

Regardless of the options and choices that Premiere Pro provides, you will surely be making little tweaks. Become the interior decorator of your workflow by selecting the one that works best for you. Maybe you like a hands-on approach when it comes to renovations, or maybe you're someone who seeks the convenience of bonded professionals. It's totally up to you.

Moving panels

REMEMBER

The word "moving" strikes fear in even the most lionhearted, unless, of course, it has nothing to do with changing your living space. But the workspace is another story. Moving panels can help to make your edits more efficient because all the panels are just where you need them and sized perfectly — plus, it's pretty easy. All you do is click and drag the top bar — that's where you see the name of the panel. Drag the cursor into another panel and you see a drop zone where you can drag the panel to. Made of multiple shapes, each individual section acts as a place where you can drag the selected panel.

» **Dragging a selected panel into the center of another panel nests it under that entire panel in that grouping zone.** For example, if you move the Program panel into the Source Monitor panel, it becomes part of the list of other panels included in that grouping. This refers to the menu of links atop the panel.

» **When you drag a panel to the sides of another panel, it this doesn't combine them or change the size of other panels.** Instead, it fills the space between the adjacent panels. Keep in mind that additional panels affect the size of those that are adjacent to them. If you drag to the top, near the menu bar, it will add that panel to the menu bar.

» **Dragging the panel all the way to the left or right of the Premiere Pro window results in the panel transforming to take up that entire half of the window.**

Saving your workspace

TIP

Customizing your Premiere Pro workspace increases your productivity and efficiency. But arranging it to your delight is only half the battle. If you really like what you've done, and you want to work in different presets and go back to the one you like, you need to save it as its own name, otherwise the change will affect the space you edited. Among the list of preset workspaces, like Assembly and Metalogging, you can have "Ed's Editing" or "Aubrey's Audio," or some other naming alliteration.

Here's how:

» To save a workspace, go to Window ➪ Workspaces ➪ Save as a New Workspace.

» To update an existing workspace, go to Window ➪ Workspaces ➪ Save Changes to this Workspace.

» You can go back to the default settings of a chosen workspace by going to Window ➪ Workspaces ➪ Reset to Saved Layout.

Hiding workspace presets

Some workspaces can really populate a panel. If you're seeing the chevron (that double arrow icon), then maybe you have too many choices. If things seem crowded, just remove a panel by clicking on it and closing it.

You can delete a custom workspace by going to the Edit Workspaces menu, highlighting the workspace, and clicking the Delete button on the bottom left.

Using a second monitor

Location, location, location prides itself on being the trifarious golden rule of real estate; perhaps, then, its virtual screen equivalent is the more direct "real estate, real estate, real estate." You can accomplish this goal with a larger monitor. Of course, that doesn't work with an all-in-one computer or laptop. If that's the situation, then simply add a second monitor and spread out. You can position your timeline and monitors on the main screen and place the Projects panel on the second monitor. This choice lets you see all your data and notes without losing screen real estate.

TIP

Make sure your graphics card can support a second monitor. Most new computers, especially Mac models, offer multiple monitor support. Macs allow you to connect external monitors via the Thunderbolt port or USB-C. Many models older and new support using an HDMI cable, though newer macs may require an adapter from its Thunderbolt to the HDMI on the monitor. Older Macs and PCs offer other inputs to connect. Some older monitors have a DVI input. Some have a VGA connector, and others a combination on one end or the other. For those cases, a DB15-to-DVI converter will let you connect.

Each computer platform, as well as its operating system, have slightly different methods for connecting a second monitor that should be included with the model and OS being used. As for basic requirements, consider the following:

>> **GPU speed.** Once again, newer computer models are fine with handling two monitors.

>> **Update drivers.** Make sure that you're using the latest graphics driver. Most of the time, your computer will alert you about updates.

>> **Consistent resolution.** To maintain screen continuity, be sure to match the resolution of your new monitor to that of your main monitor.

Using your iPad as a second monitor

TIP

Here's a way to make your iPad more useful. No worries about cables or connections either, as the Sidecar utility in the later version in Mac OS11 and higher, lets you add an iPad as a second monitor, as shown in Figure 3-4. You can also set up the Universal Control feature, on later OS versions, that allows you to use your mouse and keyboard. (See instructions with the version of Mac OS you're running.)

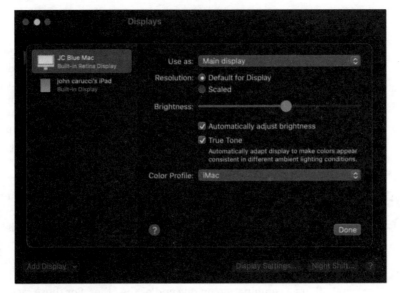

FIGURE 3-4: iPad being recognized in the Displays section of System Preferences.

TECHNICAL STUFF

Here's how you do it:

1. Go to Apple Menu ⇨ System Preferences.

2. Navigate to Displays. In the Add Display pull-down menu, on the bottom left, select your iPad.

3. Go to Display Settings and click. A new window will pop up. Select your computer as the Main Display. Choose Default for resolution. Click Done.

4. Arrange the monitors by dragging the smaller iPad icon to the right or left of the desktop icon, depending on which side you'd like your iPad display.

5. You can drag a panel across your screen onto the iPad screen and change its size.

Set up your iPad monitor

What you show on your iPad monitor becomes a personal choice. That's as simple as dragging the chosen panel from its center off screen to your iPad and rearranging the other panels. Some users may choose the Program Monitor to show the playback; others may opt for the Project panel to view vital parts of clips and assets in the folder, as shown in Figure 3-5, instead of the truncated view you get with the editing workspaces.

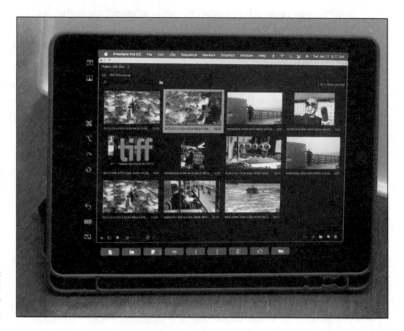

FIGURE 3-5:
Filling the iPad screen with the Project Panel.

Using a broadcast monitor

TIP

Regardless of your needs, using an external broadcast monitor to exercise some quality control is as important as using a food thermometer. Yeah, most of the time your final project is going to be all right without it, but that one time when it's not is all you'll remember. The same theory applies to using a broadcast monitor. This calibrated peripheral assures that your video looks great with accurate color and tone. Think of this extra screen as more of a high-quality television than a computer monitor that will render the movie as it will appear.

Here are some aspects to consider.

>> **Screen size:** Depending on the size of your editing station — or more likely, desktop — your requirements for monitor screen size will vary. A 17-inch broadcast-quality monitor offers a good compromise between screen size and portability. This matters when you are working in a smaller space. But as prices come down, you should purchase the largest model you can afford that will still fit on your editing desk.

>> **Screen resolution:** Newer monitors support the higher 4K resolution, but if you're on a budget, a 1080p-compatible screen (high definition) can suit your needs. Most monitors support a variety of input resolutions; just be sure to confirm compatibility.

>> **Connectivity:** Back in the day, Macs and PCs used a couple of different connectors on the video card port to add a second monitor. Nowadays, many more connectors exist on both the monitor and computer side. HDMI, BNC, Thunderbolt, DisplayPort, USB, and others are used to make sure your display is compatible when connected to the output port.

>> **Calibration:** Precise color and tone are the actual purposes for using a broadcast monitor. That's why it's important to make sure that color is as accurate as possible. Some monitors come with calibration software or can be adjusted by loading a calibration Look Up Table (LUT). This table profiles display performance over a variety of color points to reproduce the intended look on the screen.

Breaking down keyboard shortcuts

TIP

Running Premiere Pro requires a great deal of action with menu and panel selections, which helps you understand the program. But as you get comfortable with your workflow, you may find that keyboard shortcuts come in handy by allowing you to substitute a menu selection with a keyboard command. Almost every key using a modifier has a shortcut, so they're too numerous to list here. The shortcut is adjacent to its spot on the menu. But if you go to Edit ⇨ Keyboard Shortcuts, as shown in Figure 3-6, you can see all of the shortcuts, or better yet, use a shortcut to get there by typing Option+Command+K on Windows, or Ctrl+Command+K on a Mac. You can also customize the application with your own shortcuts.

FIGURE 3-6:
The Keyboard
Shortcuts
dialog allows
you to access
every shortcut
in Premiere
Pro, as well
as create
your own.

Personalizing keyboard commands

Premiere Pro offers so many keyboard shortcuts that it seems like you need a shortcut to the shortcuts. Actually, that's possible, because you can change the keyboard shortcuts to match your needs and workflow; you can also save them, just as you would a custom workspace. That means other users will still be able to use the default shortcuts or create their own set.

Here's how to create a custom keyboard shortcut:

1. **Search for the desired command.** Let's create a shortcut to export your movie. That shortcut already exists, but let's say you want a more practical one by simply typing an "**E.**"

2. **Type "export" in the search box under the left side of the keyboard map, as shown in Figure 3-7.** A list of shortcuts pops up that contain the word or part of it.

3. **Click the command and subcommand that brings up the panel you want.** In this example, you click on Export ⇨ Media to create the shortcut that brings up the Export panel.

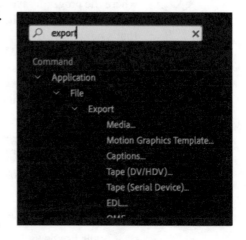

FIGURE 3-7:
The search field in the Keyboard Shortcuts dialog.

4. **Click on the "x" to right of the currently assigned shortcut.** You now see an empty box.

5. **Click inside the box and begin typing your new shortcut.** In this example, you simply type "**E**."

6. **Hit OK.** Now every time you're in the timeline and press the E key, it will launch the panel.

Single Key shortcuts

WARNING

While useful in dedicated situations, using a single key shortcut can trigger the action whenever you type it. So, use them sparingly or add a modifier.

Using a skin

TIP

The keyboard shortcuts can take some time to learn, but not as long as waiting for grapes to turn into a fine wine. So, while you're learning, you may want to purchase a keyboard skin that lets you see the shortcuts directly over the keys.

Setting your scratch disk

TECHNICAL STUFF

Whenever you edit a project, Premiere Pro uses disk space to store temporary information required for the project, called *scratch files*. Basically, it's a place where the program saves temporary data like captured video and audio, as well as preview files. By default, scratch files are stored where you save the project. But that's not always the best place for it. Ideally, you should use a separate hard drive to have enough space. With every choice, you will notice you can save in the same location as the project, or a custom location, generally an external drive.

Premiere Pro allows you to set scratch disks for the following:

>> **Captured Video:** Folder for video files captured from a camcorder or other source. Save on a faster external drive.

>> **Captured Audio:** Folder for captured audio files from another source.

>> **Video Previews:** Files created when you choose a video render option from the menu so that the video plays smoothly on the timeline.

>> **Audio Previews:** Files created when you render audio so it can play on timeline.

>> **Project Audio Save:** This is where the temporary files for autosaving your project are stored. It makes sense that this scratch should be saved to an external drive. Save on a faster external drive.

>> **CC Libraries Downloads:** The place you allocate for saving downloaded materials from various libraries and Adobe Stock.

>> **Motion Graphics Templates Media:** Location for saving selected motion graphics template.

Render files

REMEMBER

Render files are temporary files that help your video play smoothly on the timeline and are created when using special effects, corrections, and different file formats.

Pointing in the right direction

While it's not unusual to use the same computer for editing your movie and saving all your scratch files, it's not ideal. Just the same, if you had the time, space, and equipment you would isolate scratch files on separate drives. If you choose to do this, click the Browse button to the right of the setting you want to change, then navigate to the storage location you want it to use.

To specify where the program saves your scratch files, do the following:

1. Go to File ➪ Preferences ➪ Project Settings ➪ Scratch Disks.

2. Click the Browse button and navigate to your external hard drive.

3. Repeat Steps 1 and 2 for additional scratch disks.

Tweaking Program Settings

It's too bad that Premiere Pro doesn't have the equivalent of a sleep setting like those remote-control mattresses. It does, however, let you fine-tune your work-space when putting your movie together. The first step involves setting your preferences.

Setting preferences

REMEMBER

Just like getting your car checked out regularly, a little maintenance of setting preferences in Premiere Pro can help the software run more smoothly. Just go to Adobe Premiere Pro ⇨ Preferences (on a Mac) or Edit ⇨ Preferences (on a PC) to bring up the dialog. Some users have specific needs, while others get by with the default settings. You may find yourself somewhere in the middle.

Whether you stay with the default settings or adjust them to meet your specific needs, here is a rundown of what each Preference dialog controls.

- » **General:** This dialog lets you customize settings in a variety of areas, from projects and bins to tool tips and startup choices.

- » **Appearance:** This dialog allows you to alter and set the overall brightness of the interface, as well as control the brightness and saturation of the blue highlight color, interactive controls, and focus indicators.

- » **Audio:** You can select choices for audio that include waveform, scrubbing, and audio rendering. It's a good idea to check the boxes for "Play audio while scrubbing" and "Maintain pitch while shuttling," as this will allow you to hear sound while scrubbing through your video without it sounding like it's on helium. Also checking "Automatic audio waveform generation" lets you visually see the levels in the track.

- » **Audio Hardware:** This lets you choose microphone or line input, as well as the speaker for output. If you're plugging in speakers, leave this on the default setting.

- » **Autosave:** This automatically saves a copy of your project at a duration that you specify in a separate subfolder titled Premiere Pro Auto-Save, which is located in the folder containing your current project file. You can also back up to the Creative Cloud. It's a good idea to change the default setting from every 15 minutes to every five minutes, because you can lose a lot of your edit at 15.

- » **Capture:** This alerts you if the ingested footage has dropped frames, and if you want to abort capture when that happens. Unless you're ingesting tape, you can ignore this preference.

- » **Collaboration:** This comes in handy when sharing with multiple editors, as it provides alerts; otherwise, you can ignore it.

- » **Control Surface:** Provides a hardware control interface so you can control faders, knobs, and buttons on hardware devices like an audio mixer or MIDI device.

- » **Device Control:** This is another preference that deals with taking in content from an external device, like a video deck. You can ignore this, because even if you're using a deck, the default settings works fine.

>> **Graphics:** This refers only to the fonts used in the program.

>> **Labels:** This is another design preference. It lets you change colors for labels for assets, bins, sequences, and other stuff.

TIP

Give your labels accurate names so you can recognize them under the Label Defaults preferences, like the date of the shoot, type of shot, and so on. Click on the color bars to open the Color Picker window and customize your label colors.

>> **Media:** This offers a robust selection of choices for timecode, frame count, frame rate, and other preferences. If you leave the default settings as they are, you will not rue the day. Be sure to click Enable hardware accelerated decoding, and under Default Media Scaling, choose Set to Frame Size to simply image scaling.

>> **Media Cache:** This offers a preference for clearing out old or unused media cache files. Too many of these files will slow down performance, so being able to delete them automatically helps maintain optimal performance. Clearing them every month is a good practice.

>> **Memory:** This specifies the amount of random access memory (RAM) you reserved for Premiere Pro and other Adobe applications, such as Photoshop or Illustrator. It takes into the account the installed RAM and what you choose to reserve for those other applications. You can change the balance between these applications to increase for Premiere Pro . This preference also lets you optimize rendering for Performance or Memory. Most of the time, you will want Performance, so leave it on that setting. A good measure is to reserve 20 percent to other applications, so if you have 32 gigabytes of RAM, you can share 26 gigabytes with Adobe applications.

>> **Playback:** You can select the default player for audio or video, and set pre-roll and post-roll preferences. If you're using an external video monitor, be sure to check Enable Mercury Transmit. You can also access device settings for third-party capture cards.

>> **Sync Settings:** When running Premiere Pro on multiple machines, this option lets you synchronize general preferences, keyboard shortcuts, presets, and libraries to the Creative Cloud.

>> **Timeline:** In Premiere Pro, transitions, graphics, and still images have a default duration in either frames or seconds, which is the most common option. You can extend their time, of necessary. You also have the option of snapping the playhead to an edit point instead of moving past the cut for each clip. There are multiple ways to activate this function, so you can keep it in the default setting here.

>> **Trim:** When an edit point is selected in the Trim mode, you can make large trims by pressing the Trim Forward/Backward buttons. Specify how many frames under the Trim preferences, which is set at a default of 5. You can go up to 99 frames.

Optimizing performance

Premiere Pro can run smoothly and powerfully when putting your movie together. But the software will not run smoothy without you optimizing it. So, to get the software purring like a kitten, you can take steps to get the most out of Premiere Pro.

TIP

Stay up to date with Premiere Pro: It sounds obvious, but at some point, most of us ignore update requests, and before long, we're far behind the latest updates. Yeah, downloading them can sometimes be time-consuming, or at least slightly annoying. But updates and patches fix minor issues before they become major ones, enhancing performance and possibly even limiting crashes. And major updates are even more important, so do yourself a favor and run the latest version. Still, it's not a bad idea to wait a few days in case the update is still wonky.

WARNING

>> **Don't overload drives:** Your hard drive should never go beyond 80 percent capacity. It's that remaining 20 percent that allows Premiere Pro to run smoothly.

>> **Memories need memory:** Remember to allocate enough memory to run Premiere Pro smoothly. The more RAM, the better Premiere Pro will operate. Just go to Premiere Pro ➪ Preferences ➪ Memory and make sure you're using enough. The dialog shows how much you have, and you can increase it up to that amount. (See the section on preferences earlier in the chapter for more info.)

>> **Use a separate drive:** External hard drives add flexibility and space, and provide a place to store assets and set scratch disks without overwhelming your internal hard drive space. Storing your media assets on an external drive is like an insurance policy for your work.

Fine-tuning your setup

REMEMBER

Putting a movie together on your computer seems easy and convenient. But with all the magic and power, the interface is complex and busy. So many factors can challenge your mental well-being in Premiere Pro. But you can counter with a clean and ergonomic workspace that makes your layout as comfortable as possible. Of course, this means something different for each user, but here's a good place to start.

Customizing the Windows

Making Premiere Pro more effective also depends on elevating the user experience by arranging screen real estate. Frankly, the Premiere Pro workspace is daunting with all of its panels and controls, so it's necessary to make the layout more organized for your needs. Adjusting panels can make your workflow more efficient. But the already crowded space can make you feel like you're playing a game of whack-a-mole. Here are some ideas to tweak your score, or comfort level.

Doing the panel dance

TIP

The Premiere Pro interface requires moving stuff around whenever you want to do something different. It involves resizing panels and changing workspaces. It may involve modifying panel sizes, isolating them, and creating a workspace with your name on it. Maybe you want to shuffle preset workspaces to get the job done. Go to Window⇨Workspaces and select the one that matches your needs for the moment.

>> If you are organizing clips and creating bins before your edit, work in Assembly.

>> Bounce over to Editing to prep and drag clips on the timeline.

>> Corrections to audio clips and image tones are easily fixed in the Audio workspace.

>> When it comes time for tonal corrections, the Color workspace is the place to be.

>> Effects, Graphics, and Metalogging are also done under their dedicated workspaces.

Sizing the monitor

TIP

I'm sure you've heard that old axiom, "It's what's on the inside that counts." Well, that can apply to your Premiere Pro Source and Program Monitors. Sometimes the monitor size needs to be adjusted, and you can drag the panel edges to resize it, or click on the display to render it in full screen by highlighting the panel and pressing the accent (or backtick) key (the one between Tab and Escape).

What's inside counts

Making the monitor size work for your needs covers half of the equation; the other half involves referring to the content sized inside it. When dragging in a clip, anything different from the frame size of your sequence will appear bigger or smaller in the monitor, depending on its resolution. That means a standard-definition clip (640 x 480) will appear to float in the monitor, as shown in Figure 3-8. Conversely, a 4000 x 3000 still image will show an extreme closeup of a portion of the picture. You should also be sure that the monitor menu is set to Fit and not a percentage of the actual frame size.

FIGURE 3-8: Standard Definition video in an HD sequence before setting or scaling.

You can fix this problem with the Set to Frame Size function found under Preferences ⇨ Media.

SET A PREFERENCE

If you fancy these functions, you can make them part of the setup by going to Preferences ⇨ Media ⇨ Default Media Scaling, and choosing Set to Frame Size or Scale to Frame Size. The latter lets you scale clips further but puts a strain on your computer. The former resamples the image but degrades with further upscaling. One issue applies to image files that are not in the 16:9 aspect ratio, as they will either letterbox or pillar box in the frame.

Adjusting the timeline

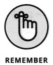

REMEMBER

Even if your editing sequence is as simple as using a video track with two audio tracks, you should still make some tweaks to the timeline to get the most out of it. Expand the video track so you see more of it by using the plus (+) key to expand and the minus (−) key to contract it.

Next, expand the depth of the video tracks (for example, to see the thumbnail) by using the shortcut Command+[plus key] on a Mac, or Control-+[minus key and plus key] on Windows; to make it smaller, use Command+[minus key], or Control+[minus key]. You can increase the depth on audio tracks by using Option+[plus key] on a Mac, or Alt+[plus key] on Windows; using the minus key (−) decreases it.

Modifying the Project panel

You can import clips into the project either by right-clicking inside the panel and selecting Import, or by going to File ⇨ Import. Once you import clips, they show up in the panel as assets. In the spirit of reducing clutter, it's a good idea to create one or more bins to organize your assets by going to File ⇨ New ⇨ Bin.

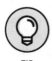

TIP

You can display your assets in the List or Icon view, which you can change using the icon at the bottom of the Project panel. List view shows clip information, while Icon view creates the classic look, a series of thumbnails. Hover over the clip, and you can scrub through it for a quick look. If you click on the clip, you can manually scrub through more accurately in the Source monitor, set In and Out points, and drag the clip into the timeline.

In this mode, the clip also displays some important information. If the filmstrip icon shows color, then the clip was already dragged into the timeline. Placing your cursor over it will tell you how many times it was used. This is useful when using a longer clip that contains several scenes.

Freestyling with Freeform

Why bother arranging your clips in the timeline when you can easily do a rough arrangement in the Project Panel? Accessed from that stacked-looking icon at the bottom of the panel, this relatively new way of viewing your assets (introduced in 2019) lets you organize your clips, set In and Out points, and stack similar types of shots on top of one another. You can also move clips around and create a storyboard that you can drag them into the timeline.

Consider the following:

>> Work in an enlarged view. Changing to the Assembly workspace, the project panel occupies nearly half the screen. You can also maximize the panel to full-screen by selecting and clicking the backtick key.

>> Adjust thumbnail size using slider on the bottom of the panel.

>> Clean-up the screen by right-clicking and using Align to Grid.

>> Categorize the order of your movie by moving thumbnails, and dragging the ones you need in order you want them to play.

Understanding the Audio Mixers

Great audio solidifies great video, and much like fine-tuning your video clips, it's necessary to make sure your audio levels for each channel are just right. You can manage audio quality using the Audio Track Mixer and Audio Clip Mixer. While they look alike, have similar names, and both tweak audio levels, each one is different.

The Audio Track Mixer allows you to control the levels in each audio track as a whole, as well as make an overall change to the audio levels. The virtual mixing board has sliders for controlling each track and shows activity in the meters. Add additional tracks, and it generates additional sliders for each track in the mixer.

The objective here is to make sure that levels are not too high or too low — when the track levels peak into the red or show too little activity. Move the slider up or down to increase or decrease audio levels, respectively. As you change the level of a track, you see a numerical value beneath the slider change to reflect the new level. You can type directly into this field to change the audio level; inputting a negative number decreases the level. You also see this information on the timeline next to the changed track. The master control affects the overall level of the entire sequence while honoring the changes in the other channels.

Here's what you should know about the Audio Mixer, which is virtual version of the studio audio mixer that allows you to independently adjust the levels of each audio track.

>> **Track:** An individual clip of audio, either attached the video or separately as a music track or voiceover.

>> **Levels:** The intensity of the track's audio volume.

>> **Sliders:** Each track has a slider. When raised it increases levels, and when lowered decreases it.

>> **dB:** The unit used to measure sound (decibels).

>> **Appropriate audio levels:** While a more detailed explanation will be described further into the book, maintain audio levels between -6dB and -12dB for dialogue, and -16dB to -22dB for natural sound.

>> **Red indicator:** The light at the top of meters when audio levels exceed 0dB. the meter will peak in red. In other words, not good.

>> **Mute:** The ability to silence a track with a push of a button.

More on the sliders

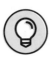

TIP

Let's take a look at those letters atop each slider: the "M," "S," and "R."

>> **M:** This mutes the track.

>> **S:** Solo-ing has the opposite effect. Click it to hear only that particular track, as it mutes the rest.

>> **R:** This one lets you record directly onto the track.

Above the master control is another control that simply says "Read." But when you click on it, you see a list of choices, as shown in Figure 3-9.

>> **Off:** If you've added keyframes, Off ignores them.

>> **Read:** The default state plays back every audio channel based on the values you set in either the master or individual tracks.

>> **Latch:** This records level changes during playback while you hold it. Let it go and it remains where you left it.

>> **Touch:** This records level changes during playback as long as you hold it. Let it go and it returns to the default for the remainder.

>> **Write:** This lets you record keyframes on your timeline with the slider to raise or lower levels during playback. It overwrites previously recorded levels. This mode records as soon as you hit the spacebar.

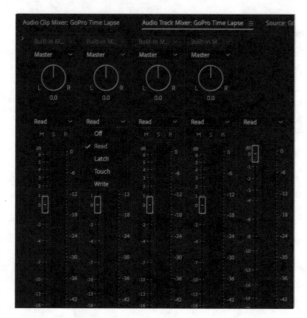

FIGURE 3-9:
The
Automation
Control
pull-down
menu.

Audio Clip Mixer

What sets the Audio Clip Mixer apart is that instead of controlling the levels on the entire track, it makes changes to the specific clip under the playhead. The mixer works the same way with functions and controls, including the number of tracks on the timeline represented as tracks in the panel. The only difference is that the levels change in the track from clip to clip.

2
Gathering Content

Chapter **4**

Sorting Out the Elements of Video Production

P utting together your movie shares similarities with working on a jigsaw puzzle. Both have numerous pieces that need assembly, and although moviemaking generally has fewer pieces than a puzzle (which can have hundreds or even thousands of pieces), both can be so intense that getting all of the elements together can be a struggle.

But fear not! Assembling and editing your movie in Premiere Pro begins with understanding how each piece of the process works with the other pieces. This means that knowing the basics of camera work, understanding file formats, and knowing how to perform video capture all become part of the bigger picture.

Defining Digitized Video

Back in the day, video editing consisted of recording excerpts from one tape to another to assemble the sequence in the order it should play. Movies were assembled in linear order, joining strips of film together to construct a scene. One difference between traditional and digital production is that the traditional editor could see the image in succession on a couple of feet of celluloid because it existed

physically. A digital video clip is not tangible, made up of binary code, hence the operative word *digital*.

The original movie file is indestructible and resides in a single place on your hard drive. So, while the movie clip generated by the program can be dragged, dropped, trimmed, copied, and cut, it has no effect on the original. But that also means you can't play your edit outside of the Premiere Pro timeline until its exported. When you export a movie from your timeline, the software renders your timeline choices and the file components together to produce a self-playing movie.

Binary refinery

Your digitized movie is nothing more than a bunch of ones and zeros, what we call *binary code*. The bigger the file format, the more data it includes, and all those extra ones and zeros make the difference between producing the frame size between standard definition and high definition.

Let's look at the different formats.

Digital Video

Digital video, or DV, camcorders were once the kings of the consumer and prosumer market, providing the best quality for their era. Now the content they create comes in undersized. DV preceded the media card, and was recorded on tape. That meant the video played in real time as it was captured by the editing software. While DV is somewhat obsolete, Premiere Pro still lets you capture video live in the program. Specifics on that are addressed in Chapter 6.

TIP

A digital video that was captured as 720 x 486 will need to be expanded (have more pixels added) if your objective is to integrate those files into a high-definition project timeline — which, of course, is sized at 1920 x 1080 or at 1280 x 1080 pixels. If you don't expand the pixels, your video will appear as if it is floating in a sea of black. Even when the video is sized for the timeline, the *aspect ratio* (see the section "Dealing with aspect ratio," later in this chapter) will lead to *pillar boxing*, those black borders on the side of the video. The camera included a 16:9 aspect ratio mode, matching the frame size of HD, but not the resolution. Not many people who recorded video using DV took advantage of that mode because their televisions used the squarer aspect ratio of 4:3. As for the space, DV took up approximately 200 megabytes per minute.

High Definition is the flavor of the day

Chances are you're making a movie in the HD timeline, which uses a 16:9 aspect ratio, also known as *widescreen* (as shown in Figure 4-1), and a resolution of 1920 x 1080 (or 1280 x 1080, in some cases). Camcorders, DSLRs, GoPros, and smartphones all capture HD video now, so there are various ways to import it into Premiere Pro. While Premiere Pro offers numerous project choices, HD is the most popular one. Some HDV cameras used tape, which requires playback. Others used video cards ranging from proprietary formats to consumer formats like Compact Flash and Secure Digital. The file size is approximately 1gigabyte per minute.

FIGURE 4-1: This scene shown in the Program Monitor conforms to the sequence's 16:9 aspect ratio.

Fawning over 4K

With much of the big-screen TV market offering ultra high definition (UHD), better known as 4K, it's nice to know you can create content using the latest cam-corders, DSLRs, smartphones, and GoPros, too. Its huge file size (3840 x 2160) quadruples the resolution of HD. DCI creates a 4096 x 2160 file size. And with great resolution comes great file size. The huge file size offers some flexibility, especially if you don't plan on editing in 4K, by providing enough data to sig-nificantly crop the image to play in an HD timeline without any degradation. Of course, the process of downloading, adding effects, and exporting your movie will take considerably longer.

Vying with VHS

VHS tape, though quite uncommon these days, still pops up on occasion. Sometimes you just need to grab a clip from your younger years — you know, like that school trip to Washington, D.C. — from the once-ubiquitous video tape. You will need a VHS-to-USB adapter to record the footage directly into Premiere Pro. That's probably the only reason you would want to add such a low-resolution format to your movie. Remember, the quality is already low (approximately 480 x 360) when compared to HD. It may even be lower, since VHS preceded computer imaging. Imagine that playing in a 1920 x 1080 timeline! While the content can make an impact, you will notice the difference in quality.

Explaining Digital Video Fundamentals

Digital moviemaking as we know it today is the child of conventional filmmaking and broadcast video. Digital video capture has become the standard for some filmmakers, with the exception of Quentin Tarantino, Steven Spielberg, and Christopher Nolan, who shoot movies on film stock. Back in the conventional film era, you couldn't see the footage until the film was chemically processed. Conversely, broadcast video has always been more immediate, allowing you to see the results after recording. Early video quality lagged behind film quality. That technology eventually caught up, and in some ways, digital capture eclipsed it. The 4K capture from your iPhone, for example, is far superior to the once reigning champ of broadcast, the Beta Super Performance (SP) tape. Most feature films are captured using some form of UHD like 4K, or even 8K. So, how does digital video work, and what does it mean for Premiere Pro?

Understanding how video works

If you told someone in Salem, Massachusetts, back in 1692 that it was possible to record a scene and immediately play back what had just happened, you might have ended up defending yourself against accusations of trafficking in the dark arts. Video capture only seems supernatural, but a camera's ability to instantly record the world in front of it is not really magical; rather, it's a combination of physics and electronics leading to the instant appearance of a photograph or video, as shown in Figure 4-2.

Much like a conventional film movie camera, the video camera uses the same concept to provide a moving image. That is, it uses a lens to capture the scene as a series of individual frames, each representing a fraction of time. The audio is recorded alongside as a separate file synchronized with the video capture.

FIGURE 4-2:
The image
from Salem,
Massachusetts,
is ready
for viewing
immediately
after stopping
the recording.

Dealing with aspect ratio

Big-screen television sets are still referred to as wide-screen TVs, and it's a format we've become accustomed to, replacing the square-like picture frame of the old cathode ray–tube TVs from the past. The aspect ratio is the comparison between the height and width of the screen image. For example, your HD footage is captured at 1920 x 1080 pixels, which translates to 16:9; this means the length almost doubles the height. Tube televisions and old camcorders used an aspect ratio of 4:3, meaning the length was just slightly longer than the height, as shown in the standard-definition frame grab in Figure 4-3. Uncropped photographs are generally in a 3:2 ratio.

Frame rates

At the granular level, movies are a series of still images played in succession to create the illusion of motion. Thanks to a principle known as persistence of vision, the image lingers in our brain after it's passed on to the next image. The number of frames used to create that motion is referred to as the *frame rate*.

However, that number can differ. For example, motion pictures use a rate of 24 frames per second. Video uses about 30 frames per second. Why does this matter? Because Premiere Pro can adjust a timeline to accommodate a different frame rate. Still, it's best to create your project using the same frame rate the material was captured in. The timeline will accommodate multiple frame rates but will export them as the one chosen for the sequence. Sometimes you may notice judder, jumps, and jerkiness when mixing frame rates. At other times, it's possible that Premiere Pro will crash, especially on a system that is short tethering on

minimum requirements for running the software, or if other programs are open simultaneously.

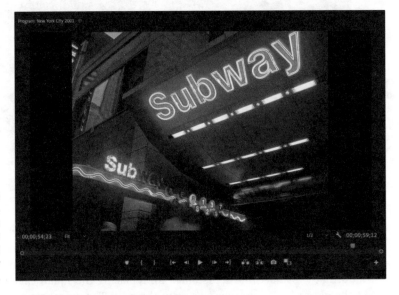

Understanding timecode

Timecode refers to the numerical assignment of every frame of video in chronological order. (You can also view the duration in either time or frames.) Think of timecode an identifier for each frame of video, much like house numbers on a street. Premiere Pro lets you use that timecode to track scenes, check duration, or jump to a specific place on the timeline by typing a specific time in the upper-left corner of the Timeline panel, as shown in Figure 4-4.

Understanding formats

Much like the streaming services on your Apple TV or Roku, many file formats are available. Premiere Pro can handle numerous video and audio formats, from QuickTime and Apple ProRes to WMV and WAV. That means it can support almost any file that you drag into the timeline.

Breaking down the best file types

After editing, the choices for exporting your self-playing movie will depend on your intention for the movie. It's a good idea to export an uncompressed file so

you have a lossless version for future use. But there are some variations discussed in Chapter 16 that you should consider, as creating a smaller compressed file offers even more options. For example, H.264 is the most popular file format, offering high resolution in a manageable file size; it uses the MP4 file extension. For high-quality purposes, the often-uncompressed QuickTime format works well.

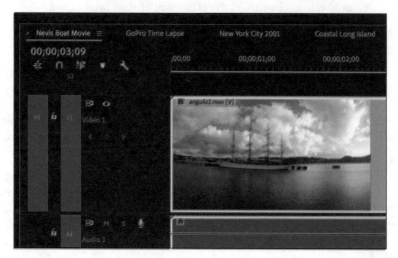

FIGURE 4-4: Timecode shown in the timeline.

Capturing Great Video

Do you know who leaves nothing to chance? A professional filmmaker, so neither should you. While this book serves as an editing guide, making sure you have the best possible content for Premiere Pro increases your potential for success. Great movies are made by hand, or in this case, by your hands. So, when shooting your own material, slow and steady wins the race. Every time something changes in the scene, or you move the camera, it's important to make adjustments.

Controlling the camera

Learning how to control your camera's functions will increase the potential for amazing content. Taking the time to accurately measure exposure (not too light, not too dark) white balance (color without a cast), and focus (the sharpness of the subject) outweighs the quickness of haphazardly shooting scenes, which may result in you having little usable material in postproduction. The extra time you take during each part of the process often makes a big difference.

REMEMBER

When it comes to technically perfect video, double-checking the basics means you don't have to go back and shoot additional footage. That's why movies are never shot in order. Sometimes the beginning isn't shot until the end, or the middle scenes may be amongst the first captured. In the 1973 Bruce Lee classic *Enter the Dragon*, the memorable opening scene was captured on the last day of shooting. So, the order in which you shoot each scene doesn't affect their order in the final movie, but it can affect the efficiency of your production.

Here's a breakdown of each function and how it will impact your shot.

>> **Shutter speed:** Unlike still photography, recording video uses a narrower range of shutter speeds; a standard shutter setting usually means 1/60 or 1/125 second. By using a higher shutter speed, say 1/250 second, you can more clearly capture faster-moving subjects that require crisp rendering. You can even use a lower shutter speed, like 1/15 second, if your camera permits, for a blurred effect.

>> **Aperture setting:** Videographers call it the *iris*, while photographers prefer the term *aperture*; this is the camera's main way of controlling exposure by letting light in.

TIP

Keep in mind that the reciprocal relationship between shutter speed and aperture.

>> **White balance:** This is the means of adjusting the color temperature of each scene by setting the camera's sensor to reproduce white without color bias. You can check your camera's instruction manual to find out how to set the white balance, but this usually involves pointing the camera at a white card. Without checking the white balance during the shoot, you will spend a much longer time editing for color correction, as shown in Figure 4-5. After a white balance is taken, the same scene has a more accurate color balance, as shown in Figure 4-6.

>> **Manual focus:** Years of evolution in focus technology takes a knee when shooting movies. That's because autofocus does not play well with shooting movie scenes, wandering off to whatever moving objects pass through its sensor. Here's where manual focus has its moment, staying on the subject and never drifting back and forth at every shiny object that comes its way. When using a zoom, you can set the lens to zoom all the way in, focus, and then pull out for effective focus. This is how the pros get a grasp on focus.

FIGURE 4-5:
The camera
was fooled
by the blue
light of early
evening.

FIGURE 4-6:
A quick white
balance
created some
offsets to the
cool lighting.

Arranging the scene

I always say that you should compose to create visual prose. How you fill the frame determines the strength of each shot, and before long, the overall tone of the movie. The more you consider what happens in that rectangular world, the better your movie will look. Remember, the audience will never be aware of anything more than the visuals they see on the screen. You have the power to influence them, depending on how you frame the shot.

UNDERSTANDING RECIPROCITY

The democratic nature of exposure provides a reciprocal balance between the amount of light that comes into the lens and duration that the lens stays open. Reciprocity defines the balance between shutter and aperture in regard to creating exposure. When you open the aperture of the lens, say from F5.6 to F4, you need to then limit the duration by one stop, going from 1/30 to 1/60 to "balance" the exposure.

REMEMBER

» **Look before you leap:** Before pressing the record button, check the framing of elements in the scene. Make sure everything is right before you record.

» **Don't forget the Rule of Thirds:** Having a subject that is dead center in the frame rarely looks good. By dividing the frame into thirds like a tic-tac-toe board, you can prevent this faux pas. The subject should appear on the points of intersecting lines. Figure 4-7 shows an example.

» **Watch for blocking:** Not only should the static elements be in place, but you should also make sure that your subjects move effectively through the frame. Use tape markers, paces (the number of steps), and other minor visual cues.

FIGURE 4-7:
Rule of Thirds.

Understanding shot lingo

Great filmmaking weaves a variety of shot types together to tell a story. While I discuss the basics in Chapters 5 and 6, following is a more descriptive list of shots. Naming the type of shot is more complex than imagined. The terms *wide*, *normal*, and *tight* are based on a relative comparison. Be aware, a 16:9 composition is quite wide.

Here's a more in-depth description of various shot types and their commonly used abbreviations.

» **LS (Long Shot):** Also called an extreme wide-angle shot, the long shot shows the subject in relation to their surroundings. Often this expansive view establishes the scene as the first shot. As far as the main subject is concerned — the actor or actors — it's not always necessary to include them. An expansive shot of the landscape with few identifiable subjects qualifies for this type of shot.

» **VWS (Very Wide Shot):** Although not as expansive as a long shot, this is still pretty wide in the frame. It can also work as an establishing shot.

» **WS (Wide Shot):** Also known as a full shot, this is the next logical step in the wide world of shots, but in this case, the shot isn't very wide. The subject is clearly seen, usually from head to toe. A wide shot is frequently used to set up the medium and close-up.

» **MS (Medium Shot):** Otherwise known as the normal shot, this one shows a more pronounced view of the subject than a wide shot. For example, when a person is in the shot, they are usually shown from the waist up.

» **Two Shot:** This arrangement shows the interaction between two subjects in conversation or confrontation. Sometimes it shows them as full figures, and other times from the waist up.

» **MCU (Medium Close-Up):** Think of this as the close-up for people who don't like close-ups. This shot shows the entire face and neck with the upper portion of the chest. With objects, it's relative to the size and distance, but the subject is dominating the frame.

» **CU (Close-Up):** This is pretty close, and some people may not like you coming this close to them to get the shot. The close-up usually refers to a frame showing the subject from mid-chest up. It shows the head, hair, and face without showing pores and blemishes.

» **ECU (Extreme Close-Up):** This shot gets right in there to show detail on inanimate objects, or a range of emotions on the human face. Of course, it may also be the shot that gets you hit over the head with an inanimate object when attached to a human face that doesn't approve.

>> **POV (Point of View):** This shows the scene from the subject's point of view. It makes for great editing fodder because it make sthe viewer feel like they're in the middle of the scene.

>> **CA (Cutaway):** If you watch reality television, you are familiar with those shots that have little to do with the story. Maybe it's the subject's home, some random inanimate object, or a city or village scene. Some even get creative and show a time lapse. On a red carpet, it could be the other television crews shooting the star, or photographers taking pictures. Whatever the content, the purpose of the cutaway is to inform the viewer of the subject matter as well as serve as a buffer to reflect the passage of time.

>> **CI (Cut In):** This shows details that are essential to the subject, like an actor cracking their knuckles, picking up a glass, or tapping their fingers.

Lighting the scene

From torches used at the dawn of civilization and gas lanterns from more than a century ago, to filament-based bulbs of the twentieth century and the changing colors of an LED light panel, the most basic function of light is to keep us from walking into things when in otherwise dark surroundings. Somewhere along the line, a light bulb went off over someone's head with the idea that photographers and filmmakers should use light more creatively, much in the way that a painter uses paint to set the mood and atmosphere. But having the right light at sundown or buying a sophisticated light kit does not guarantee success any more than expecting that a carton of milk will miraculously turn into a fine cheese. More important than having the right materials is knowing how to use them.

Waiting for the sun

Having the sun at your back when shooting proves that you only need a single, powerful light source to bathe the subject in intense, colorful illumination. But shooting your movie at the same time every day won't guarantee that the shot looks the same thanks to a variety of passive elements such as cloud cover or atmospheric conditions.

You can easily counter the unpredictability of natural illumination by using artificial lights. Just set them up and control them as you see fit to produce impressive results. Don't believe it? Next time you walk past a location for a movie or television series, notice the giant lights and reflectors on the set, even in the middle of the day.

So, whether you bring your own lights to the scene, take advantage of what's already there, or mix and match the light under your control with the ambient lighting (as shown in Figure 4-8), it's important to know its behavior and limitations.

FIGURE 4-8: Sunlight coming through the windows and reflected on the white walls, ceiling, and floor creates beautiful ambient light.

Communicating through light

The way you light your scene says a lot about what you're trying to convey. When it's done correctly, the audience hardly notices any individual effect. Instead, they absorb the movie, with all the elements working together to hold their attention, as shown in Figure 4-9. That's not to say the lighting shouldn't grab them, either. Consider the tinges of blue light that make Tim Burton's films so identifiable. Or notice the theatrical approach that director Elia Kazan takes in that iconic cab scene in *On the Waterfront*, where Marlon Brando mutters the classic line, "I coulda been a contender." These examples, and many others, prove lighting is an important partner in successful moviemaking.

On-camera video lights

Despite the above-average performance of cameras these days when it comes to handling low-light circumstances, plenty of situations occur when either the sun or a light kit is not at your disposal. Enter the built-in camera light, a continuous-powered light source that shares traits with the electronic flash unit. Many of these models use LED technology, which produces brighter output with more evenly balanced illumination, as well as more versatility. While they're not

perfect, built-in camera lights are manageable, providing you know their limitations and behaviors.

FIGURE 4-9:
Sometimes
great lighting
comes from
a variety
of sources.

Consider the following.

>> **Understand the nature of the light source:** Some lights offer a very narrow output, while others provide wider coverage. Intensity increases when the light source is closer to the subject and falls off the further away it's positioned. There's a sweet spot at around 7 to 10 feet that works for many situations.

>> **Balance with ambient light:** Once you establish a proper distance, adjust the light or camera setting so both the natural and built-in camera light match exposure. Many newer models have a dimmer control, making it easier to adjust. Others let you balance through camera-to-subject distance.

>> **Neutral density filter:** This is a filter that reduces the intensity of light entering the lens. This affects the captured image in a variety of ways by allowing you to control shutter and aperture combinations that can affect the level of depth of focus in the image or prevent overexposure in bright situations. The neutral density filter comes in a variety of strengths.

>> **Color temperature:** Some models let you change color temperature, from the 3200K of tungsten to 5600K daylight, so that you can balance the color of light between the source and ambient light.

>> **Use filters for more than correction:** Add a dose of color or go all the way by using a gel filter over the light — you know, light a blue filter to channel your inner Tim Burton.

The French call it mise-en-scène

That's a poetic way of visually conveying the intention of a scene — where the actors, props, set, and background are deliberately arranged. In this example, however, it involves not only the arrangement of different elements, but also the lighting in the scene. Sometimes this can be created in the editing process. One example is when the subject begins to visibly show anger, and it manifests with a cutaway of a train whistle blowing. Whatever it is, it's the kind of thing that can make your editing sing.

Here are some suggestions on how to enhance mise-en-scène elements in your footage.

>> Use cool, blue lighting to depict a subject's despair.

>> A subject looking up to the sky after a confrontation may suggest they are looking for guidance.

>> A subject walking out in the early morning can alert the audience to the start of something new.

» **Saving and opening projects**

» **Managing preferences**

» **Creating sequences**

Chapter **5**

Prepping Your Movie Projects

Ready. Set. Go! It's time to begin your movie.

Much like playing that first gig with your garage band, participating in a triathlon, or meeting the parents of your new partner, success with Premiere Pro comes from adequate preparation before the first clip is even imported. Otherwise, things may not go as well as hoped. It's no secret that poor planning often leads to poor production. I'm not saying that you need to stand in front of your whiteboard like a coach mapping out a game plan, but you will need to make sure Premiere Pro is locked and loaded for your specific needs. Taking the time to get it ready means the program runs smoother as you get set to edit your masterpiece, keeping your head clear for creative decisions, and not changing settings with every other move.

Starting Your Project

Think of a Premiere Pro project as the home base for your movie. It's the place where multiple sequences, your video and audio assets, and alternate ways to view them all come together. It's also a place where you can add metadata, color code your clips, or add any other visual cues to make your life easier. There's a lot here to unpack. And while its complexity seems daunting, it won't take long to get familiar with it and go on to a fruitful experience.

Creating a project

After opening Premiere Pro, you can either click New Project in the welcome screen or go to File ⇨ New ⇨ Project from the main menu. As shown in Figure 5-1, the program prompts you to name your project. After providing a catchy name, navigate to the specific folder you would like to save your project in. Before hitting OK, you should set scratch disks by clicking on the Scratch Disks tab to show the various places for saving data specific to the project, as shown in Figure 5-2. You can also do it at another time (see more information later in this chapter as well as Chapter 3). Scratch disks are especially useful because they provide space, which hold influence over your workflow — namely, where speed and performance are concerned. While there are different reasons for setting your scratch discs a certain way, the most basic is choose an external drive, as opposed the default, which uses the same location where the project file resides, which is usually on your computer.

Here are some suggestions for choosing optimal scratch disk locations for your projects.

>> **Captured Video:** This doesn't matter unless you're grabbing from tape. If you are, then you will need a drive with a lot of space.

>> **Captured Audio:** Same as for captured video.

>> **Video Previews:** This creates files that play video previews, which should be saved to the fastest drive with the most free space. Ideally, it would be an external drive with a lot of free space. If that's not available, be sure to have a space on your computer hard drive. How much? That depends on the size of your project. But having a 100 Gb free is a start, and up to 1Tb for a longer form project.

>> **Audio Previews:** Creates the audio previews for the project.

>> **Project Auto Save:** You can save on any drive, but keeping with the others on an external drive makes sense.

>> **CC Libraries Downloads:** This can reside on the same drive as the project.

>> **Motion Graphics Template Media:** This can also reside on the same drive as the project.

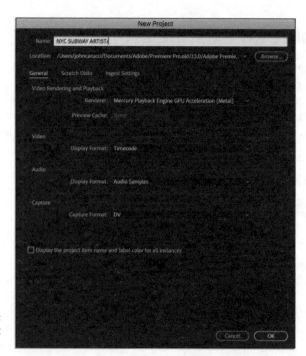

FIGURE 5-1:
New project
screen.

FIGURE 5-2:
List of scratch
disk locations.

Opening an existing project

Depending on your organizational skills, you may have multiple projects that you open and close. While earlier versions of Premiere Pro were restricted to having one project open at a time, the latest version allows for multiple open projects. That's actually not such a great idea, especially if the projects are completely different. So, unless the situation calls for it, stick to having a single project open at a time.

There are several ways to open a project file.

>> Go to File ⇨ Open Project.

Or

>> Use keyboard shortcuts — Ctrl+O for Windows and Command+O for Mac.

Or

>> Go to File ⇨ Open Recent, navigate to the project file, and click to open.

Tweaking the Settings

No two people are exactly alike, except for identical twins, and even they have minor differences. That also means that everyone's Premiere Pro project needs can be slightly different. Whether it's subject matter, movie duration, transition choices, or whatever else, it's important to present each aspect as perfectly as possible.

Project settings

Video editing requires a great deal of space, and not just because of the massive file size of the clips. There's a lot of background activity, too, like rendering clips, creating video previews, and generating temp files. So, before you jump into your project, make sure you have allocated enough hard drive space. How much? Well, that depends on the size of the project. But having around 32 gigabytes of free space for your media drive certainly makes for a good start for shorter pieces or limited content. More substantial projects benefit by more free space, It's not a bad idea to estimate the number of hours you plan to shoot in a specific format (HD, 4K) and multiply by the storage factor. Remember, if there's not adequate room on your drives, then the rest of the settings won't matter.

Elements associated with your projects are managed in the Project Settings under the following three tabs: General, Scratch Disks, and Ingest Settings. With a few exceptions, these are the same tabs and settings that you see when you create a new project. If you want to change those settings after you have created a project, go to File ⇨ Project Settings ⇨ General to access them.

Let's look at the General tab, which contains numerous sections that deal with capture and other aspects of your project. To make life easier, here are some suggestions.

>> **Video Rendering and Playback:** Most of the time, this section shows choices for the Mercury Playback Engine, with one using the Graphics Processing Unit (GPU) and the other depending on the processor. Unfortunately, the processor slows down when it comes to rendering, color correction, and playback. So, if you have the option, choose GPU Acceleration over software only.

>> **Video:** It's okay to leave Timecode selected in the pull-down menu. Other choices include Frames and several film-based options if converting movies is part of the workload.

>> **Audio:** Here's another one that you can mostly leave alone.

>> **Capture:** Unless you have connected a video deck to your computer, this setting has no effect. If you are using a video deck, then choose either DV or HDV, depending on which type you're capturing.

>> **Action and Title Safe Areas:** Lets you set the values for your title margins, when you actually use them. Leave it in the default setting.

Title safe margins

This is more of a remnant of the broadcast television days when TV sets varied in cropping the image due to overscan (when the picture is slightly larger than the screen) and curved corners. Looking like a box within a box, it allowed the editor to know where to maintain the most important parts of the image, as well as effective title location. They still come in handy for a variety of reasons, including precise arrangement of graphics and other screen elements, as seen in Figure 5-3.

Getting those preferences right

If you wanted to take a three-mile run in your dress clothes, you could do it. But you're clearly better off changing into sweats and cross trainers before that workout. That small effort improves the experience and makes it much more comfortable. Well, the same can be said for taking a few moments to set your preferences, as this will improve your overall experience.

FIGURE 5-3:
Image showing
title-safe area.

Preferences were partially addressed in Chapter 3, but let's look at some specific settings that can make editing a little smoother. As previously mentioned, if you go to Premiere Pro ⇨ Preferences (Mac) or Edit ⇨ Preferences (PC) and click on General, as shown in Figure 5-4, you see a healthy list of choices. Let's look at some key settings.

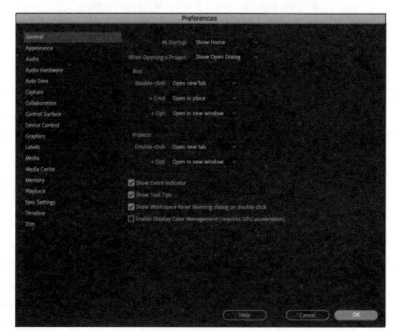

FIGURE 5-4:
The General
tab of the
Preferences
window, with
choices in the
left pane.

Timeline preferences

Under this section, shown in Figure 5-5, several check boxes allow for minor adjustments that might otherwise drive you crazy.

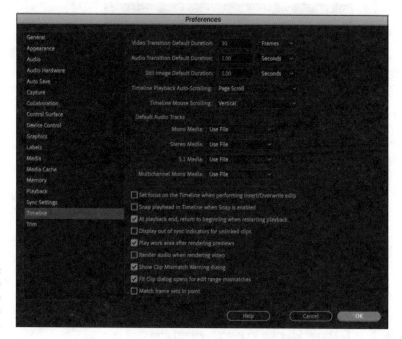

FIGURE 5-5:
The Timeline section of the Preferences panel.

>> **At playback end, return to beginning when restarting playback:** Do you want the playhead to automatically return to the beginning of the sequence? This function comes in handy when showing your finished work, but it can also be slightly annoying when you are working near the end of the sequence. It's the kind of thing that could make smoke come out of your ears. Because of this, perhaps it's best to manually move the playhead, so uncheck this box.

>> **Play after rendering preview:** When you check this box, after rendering a section, Premiere Pro will immediately play the clip. Once again, it's the kind of action that could possibly interrupt your creative flow, so uncheck this box.

Auto Save preferences

Under this menu resides the first line of defense for preserving your good mood. Why? Because it can automatically save your project periodically, thus avoiding the mishap of losing your timeline edits if the program crashes or the power goes out. At one time or another, everyone has experienced losing an unsaved

project, so it's such a relief that Premiere Pro can automatically save your files. Just make sure the Automatically save projects check box is checked, as shown in Figure 5-6.

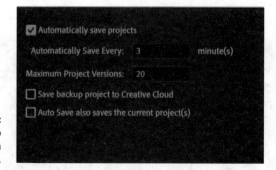

FIGURE 5-6:
The Auto
Save function
preferences.

Next, change the Automatically Save Every field from 15 minutes to something in the lower single digits. Why? How much work can you do in 15 minutes? The answer is way more work than you'd ever want to lose. And as one more protective measure, click the Save backup project to Creative Cloud option to protect your project if your computer or drives go down. Just make sure that you have an Internet connection and that it's fast enough, otherwise it's not going to do much good. In that case, an external drive is your best option.

Playback preferences

This menu provides the option to let the GPU share the workload when using an external monitor.

- » **Enable Mercury Transmit:** Checking this option ensures that the video plays using your video card, which speeds things up.

- » **Video Device:** This lets you precisely control devices, such as video decks and camcorders. If you don't have a camcorder or deck connected, don't worry about it.

Scratching the scratch drive surface

Somewhere between the storage of your ability of the hard drive and short term memory of RAM lies the scratch disk. This dedicated area on your internal and/ or external drives holds all the temporary files that are necessary to make your movie. By default, the scratch disk resides in the same folder as your project.

However, it's better if you use an external drive as a scratch disk to improve performance.

Following are some tips to maximize your scratch disk performance. (*Note:* If you only have one drive, you can leave all scratch disk options at their default settings.)

>> **Use the largest external drive you have:** Choose the drive that has the most space. Remember, bigger projects with lots of effects will require a lot of scratch disk space, as seen in Figure 5-7, which offers more than 800 Gb.

>> **Maintain your drives:** If using a conventional drive, defragmenting it occasionally can improve your scratch drive periodically, assuring tip-top performance. Defragmenting is also not recommended for any APFS systems (new Macs).

>> **Divide and conquer:** If using multiple drives, put your video files on the fastest, largest drive. Slower drives are fine for audio preview files, as well as where you save your project.

>> **Make sure the disk is connected to your computer:** It sounds logical, but sometimes you may have an external drive that's used part-time. That's not a good idea because Premiere Pro requires access to scratch disk files if the project is live, even when you close it. If you're going to use an external drive, make sure you have it connected until the project is completed.

FIGURE 5-7:
Using an external drive with a lot of space can assure a smooth editing experience.

WHY USE A SEPARATE DRIVE FOR SCRATCH DISKS?

It may sound like a flaw with your vinyl album collection, but it's actually a place, or set of places, to store temporary files that allows Premiere Pro to run smoother. Depending on the size of your project, the program requires varying amounts of drive space for the different kinds of temp files, but if you don't have enough memory space, an error message will pop up, and you will not be able to continue until purging your disk to add more space. Pointing these files to an external drive alleviates the problem.

Making a Sequence

The magic happens here. It's those steps you take to assemble your video, audio, and other assets in the timeline that make your movie. But not all sequences are created equal, with "created" being the operative word. Each sequence is specifically designed to handle a particular resolution and frame rate. You can create various sequences within the same project, although it's best to work with a single master sequence to create your video.

Setting each sequence

You begin the process by going to File ⇨ New ⇨ Sequence to bring up the New Sequence window, as shown in Figure 5-7. Before getting trigger happy and hitting OK, it's a good idea to check the details. The left side of the panel is filled with presets, and there are plenty, with regard to resolution and frame rate.

When you select a preset, information pertaining to it populates on the right side of the panel. Picking the correct one depends on your needs. Chances are you're working with HD material. If so, there are numerous choices, so you might want to match the codec you used when you started your project. It never hurts to pick a preset that matches your camera and the way you shot the movie, for example, HD or 4K.

One popular HD choice can be found by clicking the down arrow adjacent to DVCPROHD, and then the down arrow next to 1080i or 1080p to bring up the two options for each. Basically, i50 and i60 are advanced versions for PAL and NTSC (the two analog color systems for TVs; PAL is used in Europe and NTSC in the Americas) in HD form, resepectvely. Select DVCPROHD 1080i60, which is interlaced (this refers to the alternating lines of resolution that we used to see on our TV screen) and is consistent with U.S. Standard, known as National Television System Committee. If PAL is the standard for you, then select DVCPROHD 1080i50. Name your sequence and hit OK.

Making a custom setting

If you're not the cookie cutter type, or you have very specific needs, then you can take a walk on the wild side and make your own preset that's even named after you. Follow these steps:

1. **Bring up the sequence panel by going to File ⇨ New ⇨ Sequence.**

2. **Select any preset on the left.** It won't matter which one you pick, because you're going to change and save it anyway. In this example, you will try the top choice by clicking down arrows until you get to 1080 and select that option.

3. **Click the Settings tab.** The top of the Settings panel displays numerous choices. Scroll to the very top and select Custom, as shown in Figure 5-8.

4. **Select your Timebase.** This is a fancy way of saying frame rate, and is the second pulldown menu under the Settings tab, This option is critical, because it's where you get to decide if your movie has the fluid appearance of video at 29.97 frames per second (fps), or the more cinematic 24 fps of traditional film. Keep in mind that you can't change this number once you start editing.

5. **In the Video section, of the Settings tab, set the frame size.** This will more than likely be HD, at 1920 x 1080. But, if it's different for some reason, then you can enter that size. Then **choose the following options, as shown in Figure 5-9.**

 - Pixel Aspect Ratio: Choose Square Pixels.

 - Fields: Choose No Fields.

 - Display Format: Make this the same as the Timebase setting.

6. **For the Audio presets, use the default settings.**

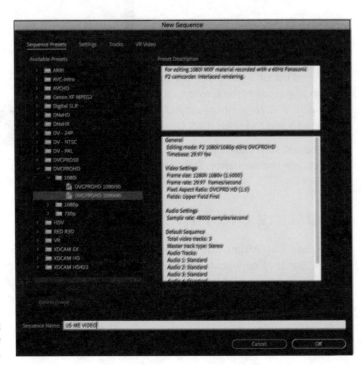

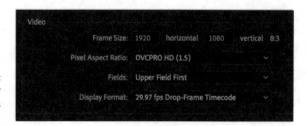

FIGURE 5-9:
Make your
video settings
here.

7. **Make the following changes to the Video Preview settings.** (This is critical because you don't want to bog down playback.)

- Choose the first option, I-Frame Only MPEG.

- Choose a resolution that matches the frame size of your sequence, so if it's 1920 x 1080, then pick that one. (Don't worry about checking any of the boxes below.)

8. **Click Save Preset.** A dialog pops up.

9. **Name the preset.** Click the Save Preset button and a dialog will pop up so you can name it, as shown in Figure 5-10. Now, whenever you need it, you can select. Click OK.

10. **The last step allows you to rename the sequence.** Satisfied? Click OK.

FIGURE 5-10:
Save Sequence Preset dialog.

Adjusting the Timeline

In the default position, the timeline shows enough information for you to get started. But is it enough to make detailed tweaks? No. The clips contain all the information dragged into the timeline. Sometimes these clips are either too long or too short. If you need to trim an extra frame or two, you need to zoom the frame (make it longer) so you have adequate space to cut it. It's especially helpful for longform video, where you want to see all the cuts in a single view. There are several ways to accomplish this.

>> **Use the slider:** On the bottom of the timeline, there's a slider on the lower left side; it's the one with the circular handles on each end. If you push a slider in, the timeline expands. Pulling out the sliders contracts the timeline.

>> **Use the menu:** Click on the wrench icon on the left side of the timeline, and in the menu that appears, select Expand All Tracks, as shown in Figure 5-11.

>> **Key it in:** Select the timeline and use the (+) key to expand it or the (–) key to contract it.

>> **Scroll to change the size of the timeline:** If you have a mouse with a scroll wheel, you can change the track length by holding down the Alt key (on Windows) or the Command key (on Mac) while scrolling up or down.

FIGURE 5-11:
Selecting the Expand All Tracks option.

Increasing the height of the video and audio tracks

By default, the video and audio tracks are quite narrow; these clips are like fat, colorful lines, and they do not show a thumbnail in the video track or waveforms in the video. Luckily, Premiere Pro offers a way to enhance the view. By now, it's clear that Premiere Pro offers numerous ways to accomplish the same task, and track height is no different.

Here's how to change the height of a video or audio track clip:

>> **Using sliders:** Located on the bottom and the right side of the timeline, as shown in Figure 5-12, these sliders let you zoom in on the timeline and change height. Pushing in on the slider increases the height of the video track, on the bottom, while pulling the slider out returns it to the default size, or even shorter. The side slider adjust track height as, pushing down increases track depth, while up decreases it.

>> **Using keyboard shortcuts to resize a track:** Holding down the Control key (Windows) or Command key (Mac) and pressing the plus (+) key increases the height, while pressing the minus (–) key makes it smaller.

>> **Resizing both audio and video tracks at the same time:** Looking to shave a second off your editing time? Holding down the Shift key and using the (+) and (–) keys makes both the audio and video tracks bigger.

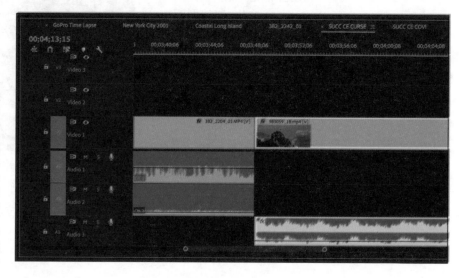

FIGURE 5-12:
Sliders to zoom the timeline and make the tracks longer and higher with the bottom arrow pointing to the length slider and the side slider changing height.

Fill the screen with a panel

Sometimes more is more, making it necessary to work with a single panel. For example, you can use the Project panel to add data or the Program Monitor to see your movie fill the screen. Maximizing an individual panel is as simple as selecting the panel and going to Window ⇨ Maximize Frame to enlarge, as seen in Figure 5-13, and Window > Restore Frame Size to go back to your grouped set of panels. You can also select the panel and use the accent key to toggle the panel size between isolated and grouped.

FIGURE 5-13:
Enlarging
the Program
Monitor lets
your edit fill
the screen.

Chapter **6**

Importing Media into a Project

While the previous chapter had more of a behind-the-scenes vibe for setting up your project, this one continues the conversation with a more upfront tone. Consider this chapter the next step in the construction of your movie project.

Now you will set up your Premiere Pro project through actions like grabbing files from your camera card, downloading iPhone clips from the cloud, and organizing additional assets like music and photographs in the Project panel. This is the buildup leading to that exciting moment when you drag that first clip into the timeline. The success of this process depends on how well you planned your project. So, if you're worried about the poor planning, poor production bug, step back into to the previous chapters and get your ducks in order. But if you're ready, then move ahead in pursuit of cinematic bliss.

Starting Your Project

Making movies can fall somewhere between simple and difficult. Narrowing the gap, both in theory and practice, begins with adequate preparation of your elements. So where do you start? The beginning works for me, and that requires importing media into your project before working that magic.

Ingesting media

Ingesting refers to the process of capturing your clips and assets into Premiere Pro, which you can do from a camera, a media card, cloud storage, or your hard drive. The objective involves getting these files from their various places and moving them to local storage so they are always accessible. Importing doesn't move the actual files; rather, it makes Premiere aware of them. Let's examine the various ways you can use to get that media into your project.

Your choices include the following.

>> **Adobe Bridge:** Use Bridge to locate video, audio, and photo files throughout your system and import them into Premiere Pro. (See the next section for more about Adobe Bridge.)

>> **Camcorder:** Many camcorders allow you to connect to your computer via USB and capture directly into Premiere Pro.

>> **Hard drive:** Saved files can be imported from your hard drive or an external drive into your project.

>> **DVD:** Grabbing files from a data DVD is as easy as finding them on your other drives. Importing from a self-playing DVD is not as easy, but with the proper software, you can easily extract sections.

>> **Recorded from Zoom:** Recording interviews over Zoom has become quite popular, and the files are easily importable.

>> **Photos from cameras or devices:** Plug in the device, search for the file, and import it into Premiere Pro.

>> **Downloaded from your smartphone:** Grab content from the cloud or plug in your smartphone, export it to a drive, and import it into Premiere Pro.

DVD PERMISSIONS AND PERILS

If back in the day, you made a self-playing DVD of videos from your 80s tribute band, and now want to use a portion for your movie, then go for it. On the other hand, if you're looking to extract a scene from a commercially sold DVD movie, then you need to seek permission if you plan on showing it in public. Without permission, you are in violation of copyrights and rights issues, and cannot use unless you have permission.

Adobe Bridge

If you have this digital asset management application on your computer, then use it. If you don't have it, consider downloading it. Adobe Bridge, shown in Figure 6-1, comes in handy when looking for video files saved on your computer, external hard drives, or whatever you have connected to your computer at the moment. Using Premiere Pro, navigate to the location, find your clip, and import it into your Project folder.

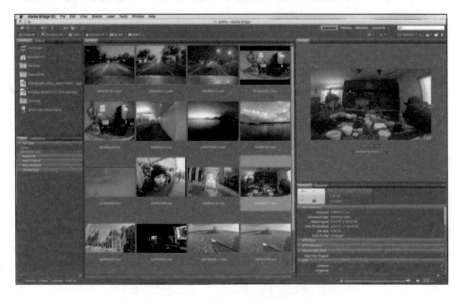

FIGURE 6-1: Adobe Bridge is designed for reviewing files, transferring between files, and digital asset management.

Transferring from a card reader

Depending on the camera, chances are you're capturing on a Secure Digital (or SD) card. Some older DSLR models use a Compact Flash (or CF) card. Many computers these days include a built-in SD card reader. If your computer doesn't have one, or

if you're using a CF card for video capture, you can easily use an inexpensive card reader, as shown in Figure 6-2.

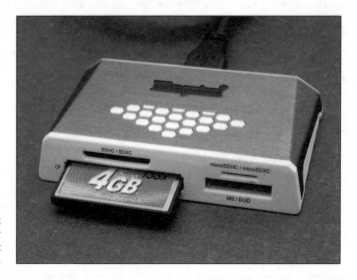

FIGURE 6-2:
Card reader
with Compact
Flash card.

WARNING

Remember to save the content to your hard drive first. While it's possible to edit directly from a media card, it's far better to transfer the entire contents of the card onto your hard drive or an external drive. Once it is imported, you won't have to worry about the content going offline when you remove the card.

**TECHNICAL
STUFF**

To transfer video, follow these steps:

1. **Connect the digital media card to your computer.** Whether using the built-in reader or an external card reader, pop in the card.

2. **Make sure the card is mounted.** In other words, check the Finder or directory; go to File ⇨ Import.

3. **Double-click on the card.** There you will see, numerous folder and files nested within the confines of the card. While there are some critical assets mixed with others that won't affect ingest, it's a safer bet to drag the main folder onto your local drive, or an external drive that stays connected. Once transferred, you can eject the media card.

4. **Import the content.** Here it doesn't matter as much that you import every nested folder, instead, finding the Clip folder should suffice. Select the clip or group of clips you want. The files populate your Project panel.

Editing directly from a card

Sometimes when you need a quick edit or to save time you can refrain from importing directly from the memory card. This is not an ideal situation. On the upside, you can edit quickly and not have to worry about having enough space on your computer hard drive. But it's also risky since the media only exists on the card, which can take your clips offline if removed or disconnected. If that happens, you can always put the card back and reconnect media. See Chapter 15 for more info on relinking those media clips.

To transfer video, follow these steps:

1. **Connect the digital media card to your computer.** Whether using the built-in reader or an external card reader, pop in the card.

2. **Make sure the card is mounted.** In other words, check the Finder or directory; go to File ⇨ Import.

3. **Import the clip.** If the card stays in the reader — in other words, if you don't remove or disconnect it — you can navigate to the clip folder, and either select the entire folder, or open it to find individual clips. Select the clip or group of clips you want.

Capturing tape from a camcorder

REMEMBER

Not all camcorders record on a media card or have the option of capturing video onto an internal hard drive. Think of it as a card that's not removable. So, as we compile another generation of digital capture, the DV and HDV tape fades into the sunset. While programs that help digitize videotape make the process easier, you can still capture content from your old camcorder directly into Premiere Pro. You may need a convertor. When connected, you can capture from the tape to your hard disk.

IMPORT AND CAPTURE

These terms are thrown around loosely when it comes to bringing content into your project, but like choosing almond milk over cream for your coffee, importing and capturing content for your project are both similar and different. *Capture* refers to creating new media, like something you recorded on a camcorder, while *import* points to a file on your drive brought into the project.

You can transfer that content into Premiere Pro through the camera's USB connection, as shown in Figure 6-3. After plugging it in, here's what you need to do.

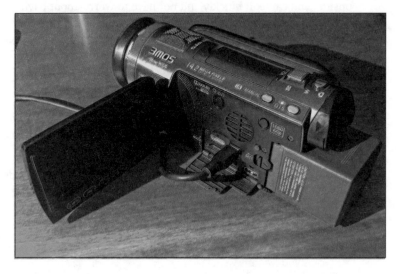

FIGURE 6-3: Connecting to an HDV camcorder.

1. **Go to File ⇨ Capture to bring up the Capture window.**

 On the right side of the window, you see the Clip Data section. Here's where you input all the names and descriptions.

2. **Type the tape name and clip name.** For most forms of capture, 'tape name' sounds antiquated, unless, of course, you're capturing from tape. You can name it whatever you want, including with the card name. In the next field, Clip Name, another important piece of information, especially when it comes to organization and searchability. Then you can add some metadata that differentiates the clip, such as the date or location of a particular capture.

3. **Save the capture.** At the top of the panel, click Settings to choose the location where you want to save the capture. Click Browse to navigate to the desired location.

4. **Locate and capture the footage.** Click back to the Logging tab. On the bottom of the dialog, click on the Play button. When you find the part you want to record, hit the Record button, and Premiere Pro begins capturing the content in real time. After the footage has been captured, click on the Stop button; the Save Captured Video pops up. You can add more information, and once you are satisfied, click on the OK button. The clip imports into the Project panel and is now ready to edit.

Downloading clips

REMEMBER

Internet clips can offer another avenue for gathering content for your movie. However, just because you can download a clip from the Internet doesn't mean that you have a right do so. Instead, look for content found on royalty-free sites, sent to you from a third party, or perhaps uploaded from another computer. Maybe it's some other situation that provides you with a clip you're allowed to use. It's all good because there are various methods for downloading online clips. Many of these clips are discussed in detail in Chapter 16. For now, let's look at the most common sources for downloads.

>> **Video transfer sites:** These range in cost from free to a few dollars a month. Depending on the size of your files, sites like WeTransfer, Redtail, and Dropbox provide a viable solution for moving big files from one place to another. Basically, you open the link sent via email and the file transfers to your Downloads folder.

>> **Over email:** While extremely limited in size (generally 20MB or less), it's possible to send and receive short, compressed movie clips over email. This is not the best option, but one that's useful in a pinch.

>> **Royalty-free sites:** There are some places where you can download generic clips for your movie without paying for them or trampling on anybody else's copyright licenses.

>> **Handout material:** Sometimes you can get permission to download handout materials, like electronic press kits (EPKs), which are popular when it comes to movie clips, or some other material you have permission to use.

Importing media

Adding clips and audio into your Premiere Pro project is fairly simple. You can either go to File ⇨ Import, and navigate to the file, or use a keyboard shortcut (Command+I on a Mac; Control+I on Windows). Or you can simply right-click in a blank area of the Project panel to bring up a menu, as shown in Figure 6-4, choose Import, and then navigate to the desired file.

REMEMBER

""Import" doesn't import the actual file, only the path and file name to where the media file is stored.

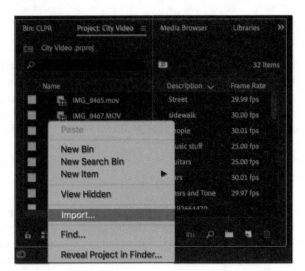

FIGURE 6-4:
Import menu.

Adding music and audio clips

REMEMBER

Music and sound are a big part of the success of your movie. Layering enhanced sound, adding effects, dropping in musical scores, or even using Additional Dialogue Replacement (ADR) are pretty much a necessity for great moviemaking. So much sound — including music, sound effects, and replacement audio — is added beyond what the camera records that seeing a motion picture without it would not hold your attention. Premiere Pro supports numerous tracks, so you can layer as many sound assets as you need for your movie.

Recording ADR

Additional Dialogue Replacement is the process of re-recording audio under controlled conditions to improve the audio quality or make changes to the voice of an actor.

Sound effects

REMEMBER

Sound effects play a big part in your movie and can make it zing. Breaking glass, rolling thunder, galloping horses, breathing, and honking horns are just a few of the sounds that are added to movies to make it all seem so real. Numerous free

websites offer common sound effects, from footsteps and wind gusts to whooshes and crashes. You can also peruse the Essential Sound panel in Premiere Pro to make corrections, as shown in Figure 6-5.

Adding a soundtrack

REMEMBER

What do movies like *The Godfather*, *Star Wars*, and *The Good, the Bad, and the Ugly* have in common? They all have soundtracks that most people can recognize after hearing a few notes. Chances are you will want to add some background music to your movie too. That's a great idea, but if you plan to show it online, or in public, you need to be sure the music is cleared. Music is copyrighted, which means the creator owns the exclusive legal right to its use; anyone who wants to use it must get permission, and often pay a fee. And guess what? Your favorite song might cost you more than you make in a year to use in your movie! Rather than take a chance with popular music, you can try royalty-free music from one of numerous sites, create your own, or commission your young Mozart-in-training to provide music for your project.

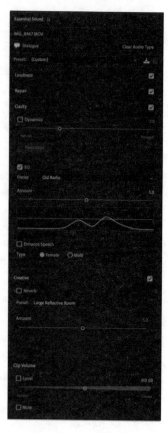

FIGURE 6-5:
Essential Sound panel.

Finding the right music

Sometimes you have control over picking the best piece of music, and other times it's based on some other reason or decided by another person. But that's only a part of the issue. The most important question you should ask is whether you have permission to use the music you are planning to use. Sometimes, the best song doesn't end up working out because you don't have the necessary permissions, or obtaining those permissions is cost prohibitive. Always confirm that there are no restrictions.

NO FREE LUNCH, ERR MUSIC

"Royalty free" does not necessarily mean free. It means that if you use content — music in this case — you won't have to pay royalties, or a usage fee every time the movie plays with the piece of music. Royalty-free music usually requires a one-time payment, or subscription to download the music clip.

So, to reiterate, remember the following points.

WARNING

>> **Get the necessary permissions:** Have you ever tried to view a YouTube video that was blocked for permissions violations? Using music without the proper permission can get you flagged on YouTube, or a social media site, and you will be forced to take the video down or even end up in Internet jail.

>> **Find out the restrictions:** How much can you use, and what limitations are there on where you can show it?

>> **Use the right tools:** Editing songs and pieces of music sometimes requires some tweaking, so use a tool like Adobe Audition, which works well with Premiere Pro.

>> **Make sure it works for the sequence:** Music works with your video for various reasons: it's appropriate for the scene, the lyrics add to the message, it works with the rhythm of the movie, and so on.

REMEMBER

Finding the right music can take hours at best, and days or weeks in more extreme situations. That's why it's a good idea to start listening as early as possible to make the right choice. Nothing is worse than being in postproduction and scrambling for the right musical piece.

Grabbing royalty-free music from the web

If there are no young composers available or you don't want to make your own music, here are a few online sites that provide royalty-free music for both commercial and non-commercial use:

>> **Audio Jungle:** With a nice selection of affordable music tracks, you can make time purchases of individual songs or subscribe with a monthly subscription. Besides music, there's also stock footage, SFX, photography, and 3D assets. You can preview content, and access it at www.audiojungle.net.

>> **Smartsound:** Includes a nice selection of music genre's, instrumentation, and mood. You can purchase individual tracks, collections of tracks, and subscriptions. You can preview content and access it at www.smartsound.com.

>> **Pixabay:** A unique community that you can join and share your assets, including music, video, images, and illustrations. All content is released under the Pixabay License. That makes them safe to use without asking for permission or giving credit to the artist -- even for commercial purposes. You can find out more information or join by going to www.pixabay.com.

Prepping still images for the timeline

REMEMBER

Documentary filmmaker Ken Burns made a career out of strategically using still images in his movies. Maybe you're not going to only use photographs, but at some point or another, you probably will use still images in your movie for a short film, documentary, family celebration, or something completely different. While Premiere Pro makes it easy to use your photos, there are a few factors to consider.

>> **Check the frame size:** Images not sized in conjunction with the sequence settings could be either too big or too small for the frame. More than likely, they will be so large that you will need to resize them by making the monitor view smaller. Set to Frame Size eliminates this issue, but if you're looking to move around the image, it's best to turn it off.

>> **Choose the file type:** While most images will work, there are several types that Premiere Pro does not support. CMYK images and Camera RAW files should be converted to PNG or TIFF before importing.

>> **Check the resolution:** For photos to be effective, they need a high enough resolution and level of sharpness. That's evident in the amount of horizontal and vertical pixels in the image, which should be more than 1920x1080 in an HD timeline, and around 3840 x 2160 for 4K. That's important, if you want to scale the image up, it should have enough pixel real estate.

>> **Crop to meet aspect ratio:** The dimensions of a standard photograph do not match the aspect ratio of an HD movie. You will need to crop the image unless you want to have pillar boxing, as shown in Figure 6-6. Cropping the image will remove a portion of the picture but fill the frame, as shown in Figure 6-7.

TIP

>> **Fit to the frame:** As mentioned, unless the image matches the sequence size of the frame, it's going to be either too big or too small. One easy solution involves the simple action of right-clicking and selecting either Set to Frame Size. A detailed explanation of this command can be found in Chapter 3.

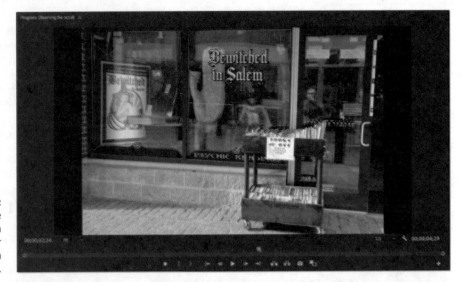

FIGURE 6-6:
This full-frame photograph leaves pillar boxing on the sides.

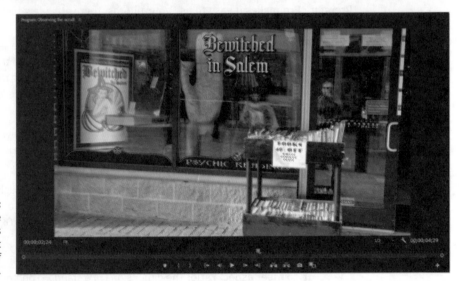

FIGURE 6-7:
Cropping the image fills the frame but loses some of the image.

Organizing Media

REMEMBER

Some of the success behind making great movies in Premiere Pro lies in techniques that have nothing to do with editing. Rather, it's about how well you organize the assets for your movie. Keeping your project folder lean and clean will be more efficient than if you have multiple timelines and sequences in the same project. It's simple logic. Assets that have nothing to do with your movie will slow down the process of putting your movie together. Conversely, structure and

organization lead to a more efficient and effective workflow and can make you a better editor.

Creating bins

TIP

You've heard the expression about putting things in different baskets? Well, Premiere Pro does it with bins, which are like baskets but resemble folders. It's like calling an elevator a *lift* or changing the pronunciation of aluminum — it's all the same. How you decide to organize is up to you, but one idea is to have a bin for video clips, another for audio, and perhaps one for photos. Or you can organize clips in separate bins based on subject, type of shot, or day of capture. The command is File ➪ New ➪ Bin, or you can click in the panel to bring up the menu.

Here are a few ideas:

>> Use a bin for each card download.

>> Use bins to separate your project into sections.

>> Use bins for photos, music, and clips.

>> Nest your bins (put bins inside of bins) based on content.

Color coding your bins

TIP

As mentioned earlier, the bins can behave as separate baskets that hold various elements of your project, and one great organizational tip is to color code them. Just right-click on the bin, navigate down to Label, and when the submenu pops up, choose a color, as shown in Figure 6-8. Now, each bin will have its own designated color in your timeline. This can help you keep track of an asset group, especially if you have many types of audio and video clips from different cameras and recorders.

Tagging with metadata

TECHNICAL
STUFF

Metadata is comprised of other bits of relevant information about your project. This includes basic information generated by either your camera or the software, like duration, frame rate, and audio info. The simplest way is to enlarge the panel. But you can also add additional information. Creating tags for project content like clips and audio can help streamline the editing process and make it easier to find content for your movie.

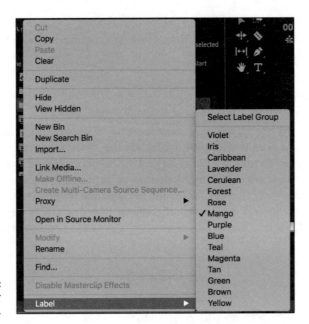

FIGURE 6-8:
Color
coding a bin.

Here's how to do it:

1. **Click on the panel menu icon on the top left of the Project panel and choose Metadata Display.** A dialog pops up, as shown in Figure 6-9.

2. **Add a new selection.** Click on the Add Property link in the upper part of the dialog.

3. **Name the content.** After the dialog pops up, enter a name. Tagging or Tags both work as appropriate names.

4. **Select the data type.** The pull-down menu offers four choices: Integer, Real, Text, and Boolean, as shown in Figure 6-10. Choose Text, as that will be the means by which you search for content.

5. **Click OK.** The content appears in the dialog and is selected.

PLAYING TAG FOR KEEPS

Take some time to think about the keywords you'll use. They should be descriptive, but not to the point where you have too many to keep track of. Some ideas include organizing by date, location, time of day, names, action, or type of shot. And make sure it's simple, like "night" or "crane."

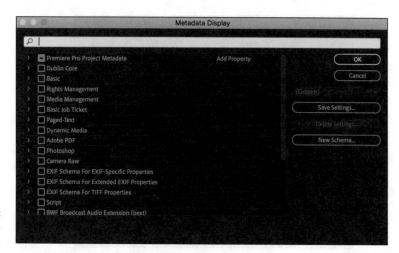

FIGURE 6-9:
Metadata
Display dialog.

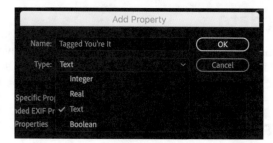

FIGURE 6-10:
Choosing a
data type
from the pull-
down menu.

Understanding data types

TECHNICAL
STUFF

You have four choices of data types. Here's what they do.

>> **Integer:** Looks for whole numbers.

>> **Real:** Searches for a decimal number.

>> **Text:** Allows you to search by name.

>> **Boolean:** Represents situations that can have two values, like Yes or No, or True or False.

Move it on over

The default spot for the newly formed tag area resides on the far-right side of the Project panel. It's beneficial to drag it over to the filename area, as shown in Figure 6-11, to make input smoother.

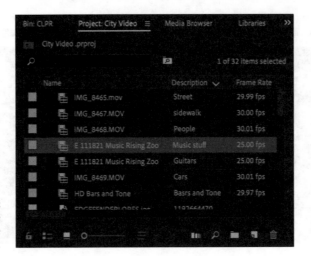

FIGURE 6-11:
Dragging the tag into a more visible area.

Entering data

While it takes time to enter this information, it's worth the investment. Simply click on the field and enter keywords. The time you spend with this data now will be well worth it later.

Bins versus tags

It's not a competition, as both methods can exist in the same project. There's even a way to combine tagging and bins in a single action.

Let's say you have inputted categories based on locations. For example, you've added keywords like "interior," "exterior," "park," or "river." Then you type "street" into the search field, and it brings up a group of images tagged with the name "street."

If you want to put this collection into its own bin, you don't need to drag it. Instead, you can easily organize the content in its own bin by clicking the folder icon next to the Search field, as shown in Figure 6-12, that says Create New Search Bin Query. When you click the folder icon, it automatically names the bin (with your tag) and places these items in the bin.

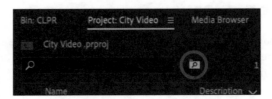

FIGURE 6-12:
Folder icon to create a bin from a search.

3

Editing Your Masterpiece

Chapter **7**

Preparing Your Video for Editing

I f someone is constantly keeping an eye on the clock or checking their cellphone, this could be a symptom of audience disinterest. Clearly, this is not something you want to happen when someone is watching one of your movie productions. In a perfect world, you would make an engaging movie to draw the audience into what's happening on the screen. Solving this problem begins with using the best possible assets.

The ancient Chinese proverb, "A journey of a thousand miles begins with a single step," comes in handy here. You should analyze your clips and trim them to a lean and mean state. This is one of the key components of making a powerful movie.

One aspect of moving the story along is economizing each clip so it makes its point without lingering. There are exceptions — like a longer opening scene, for example — but after that, the action needs to flow by using shifting angle and shot selection. How much of the clip you choose to show, and how well it plays off adjacent clips, are all contributing factors. Of course, some clips just won't make the cut due to some deficiency, like soft focus, unfixable audio, or weak composition. As you prepare to edit your movie, it's important to make sure you understand the content of each clip, and how to use it effectively to produce a compelling movie.

Getting the Lowdown on Your Clips

REMEMBER

Dragging video clips and other assets into a timeline shares the same premise as throwing a bunch of ingredients into a pot and calling it dinner. Even if safely cooked, this would not qualify as a culinary delight. That same idea applies to haphazardly assembling clips together and assuming everything will work out.

Successful assembly of your clips begins with familiarity. You should know what your clips are about and how to fix them. Some clips may need a little tweaking to reach the "sweet spot."

Video editing is a delicate balance between using enough of the clip but not too much that the viewer loses interest. When looking at your clips, start by trimming away the "bad" parts.

Analyzing clip details

Analyzing your clips for content, quality, and compatibility helps you get a feel for what you need to edit. That means watching each clip and taking notes. When you understand the content of each clip in detail, you can decide what stays and what goes based on its potential importance, and if you take copious notes, you can successfully plan your movie.

TIP

Here are some other aspects to check.

» **Scene interest:** This seems obvious, but sometimes it's easy to get emotionally attached to a scene that doesn't work for your movie. If it doesn't work, take my advice and kick it to the curb. Think of the uninteresting clip as a microcosm of your entire movie.

» **Sharpness:** Sometimes less-than-perfect clips can find their way into the edit. Is the desired portion of the clip not in focus from start to finish? Then don't include it. Case closed.

» **Audio quality:** Are the levels within range? Do they need tweaking? Maybe they are beyond repair because they're too low, and cannot be raised to acceptable audible levels. Or perhaps they're too high and create distorted sound. This problem is more complicated. You can use it if it's important, but only if you're willing to enhance it with audio dialog replacement (see Chapter 6).

REMEMBER

>> **Composition:** While subjective and arbitrary, some scenes clearly communi-
cate the message you're attempting to convey, as shown in Figure 7-1. Others
are more complicated. Then there are those that have no place in your movie.
If there's no way that a few sentences can justify the complexity of composi-
tion, then common sense can help. If the video makes you feel like some-
thing's not right, then nix it.

FIGURE 7-1:
Proper
arrangement
of the scene.

Keeping bins lean and clean

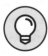

TIP

Avoid overloading your bins with clips that you don't intend to use for the movie.
As shown in Figure 7-2, overloading can make it harder to locate important clips.

Playing clips smoothly

Older, slower computers may display the clip as *juddery* (when the video stut-
ters a little as it plays). Sometimes, it's a capture issue, but more often it's your
computer. But that doesn't rule out the possibility of a capture issue where the
problem is the clip itself.

Name	Description	Frame Rate	Media Start	Media End	Media Duration	Video In Point
IMG_8465.mov	Street	29.99 fps	00;00;00;00	00;00;17;29	00;00;18;00	00;00;00;00
IMG_8467.MOV	sidewalk	30.00 fps	00;00;00;00	00;01;10;19	00;01;10;20	00;00;54;23
IMG_8468.MOV	People	30.01 fps	00;00;00;00	00;00;15;06	00;00;15;07	00;00;00;00
E 111821 Music Rising Zoo	Music stuff	25.00 fps	00:00:00:00	00:01:47:21	00:01:47:22	00:00:08:20
E 111821 Music Rising Zoo	Guitars	25.00 fps	00:00:00:00	00:08:19:18	00:08:19:19	00:03:17:18
IMG_8469.MOV	Cars	30.01 fps	00;00;00;00	00;00;19;25	00;00;19;26	00;00;03;20
HD Bars and Tone	Basrs and Tone	29.97 fps				00;00;00;00
EDGEFENDERLORES.jpg	1192664470					00;00;00;00
EDGEMRGUITARLORES.jpg	1052553516					00;00;00;00
IMG_5917.jpg						00;00;00;00
WORLD EDGE		29.97 fps	00;00;00;00	00;51;59;00	00;51;59;01	00;00;00;00
Wednesday night scenes						
US CFDA_2		29.97 fps	00;00;00;00	00;02;31;05	00;02;31;06	00;00;00;00
US CFDA		29.97 fps	00;00;00;00	00;05;52;02	00;05;52;03	00;00;00;00
u2.mp4		25.00 fps	00:00:00:00	00:02:28:22	00:02:28:23	00:02:01:12
SONY						
R4D_GSF_Home Segment_S		23.976 fps	01:05:10:00	01:08:15:21	00:03:05:22	01:07:42:05
R4D_BRoll_Jason Ross.mp4		23.976 fps	00:00:00:00	00:03:56:13	00:03:56:14	00:00:00:00
private						
Observing the occult		29.97 fps	00;00;00;00	00;00;04;28	00;00;04;29	00;00;00;00
JC NEWS CITY LIFE		29.97 fps	00;00;00;00	00;06;35;09	00;06;35;10	00;00;00;00
IMG_8466.MOV		30.00 fps	00;00;00;00	00;00;52;06	00;00;52;07	00;00;00;00
CLPR 01						
CLPR						

FIGURE 7-2:
An overloaded
bin.

Altering playback resolution

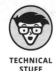

TECHNICAL
STUFF

The Mercury Playback Engine uses the power of your computer hardware to boost the performance level of Premiere Pro. RAM, GPU power, and hard drive speed work together to process the intense requirements of video production. Sometimes that's not enough, and your computer will have difficulty playing back every frame of video in your sequence smoothly. If you're having any playback issues with your video clips, then lower the playback resolution. Depending on how much you reduce the resolution, it will not reproduce every pixel, but performance will dramatically increase. You probably won't notice any drop in quality because 4K and HD video have higher resolutions than are displayed on monitors, because monitors are smaller than the original media size.

Knowing how far can you go

If you want to see how much, if any, quality is lost, play the clip at full resolution. Then compare it by playing at half, quarter, and eighth resolution to see if you notice any difference. If there's still a problem, then maybe it was a capture issue.

Changing playback resolution

TIP

On the bottom right of either the Source or Program Monitor, you see the Select Playback Resolution control, as shown in Figure 7-3. The playback resolution doesn't affect the export quality, it just helps the video play smoothly while you are editing. You may notice some degradation if you lower the resolution too much.

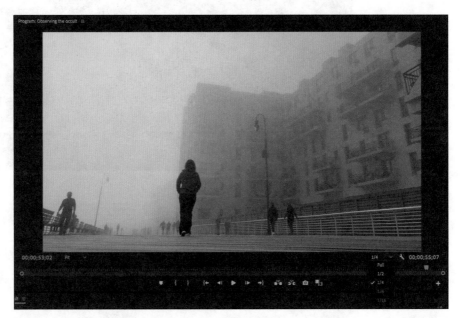

FIGURE 7-3:
Playback
Resolution
menu.

Working the In and Out Points

The In and Out points are perhaps the most important feature of Premiere Pro. They let you define the range you want include of a clip or sequence. Set an In point to choose the beginning of the section you want to include, and an Out point to represent the end of it. You set In points by pressing the "I" key, and Out points by pressing the "O" key.

Setting In and Out points

Double-click to open a clip in the Source Monitor. As shown in Figure 7-4, you can set an In and Out point. Afterward, you can either drag the clip into the timeline, or save it for later as it will retain the range settings. You can also set In and Out points in the timeline to determine what portion you will export.

FIGURE 7-4:
In and Out
points set in
the clip.

Here are some useful tips:

>> Although it's cumbersome, use the menu command to set In and Out points, by going to the Markers menu and selecting Mark In or Mark Out. Click on the brackets on the bottom of the Source Monitor panel.

>> Navigate clips in your timeline by using the down arrow to move toward the end, and the up arrow key to go back to the beginning.

>> To clear In and Out points, go to the Markers menu, as shown in Figure 7-5, and select which action you want to take.

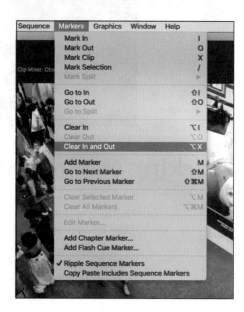

FIGURE 7-5:
Markers menu options.

ERROR MESSAGE WHEN DRAGGING CLIPS

Often, after dragging the first clip into the timeline, you will see an error message pop up, as shown in Figure 7-6. If you want to retain the settings you made when creating the project, then select Keep Existing Settings.

FIGURE 7-6: A common error message when dragging clips into the timeline.

Using markers

Looking through alternate takes, different locations, and other variables can produce a lot of clips, making it hard to remember where you saw the good parts. That's where markers come in handy. They allow you to flag areas and add comments so you can go back later and grab them. Premiere Pro lets you add as many markers as you need, either on the timeline or directly on the clip.

More than a bookmark

Adding markers to your clip does more than bookmark the good parts; it also retains metadata and your comments, which are readable throughout the Adobe Suite. So, if you decide that a clip works better for another Premiere Pro project, you can open it up with the metadata intact. You can even export markers as an HTML page by going to File ⇨ Export ⇨ Markers.

This feature comes in handy if you ever want to keep track of key parts in another program like After Effects.

Types of markers

Markers are a huge help when it comes to "fleshing out" the key parts of your clip and great tools for optimizing your workflow. However, too many markers can put you back to square one. You can choose different marker types, marker colors, names, and comments. Just hit the "M" key a second time to bring up the Marker window, as shown in Figure 7-7. Under the Options section, you see some radio buttons that allow you to choose the Marker type.

Here are some variations on the marker.

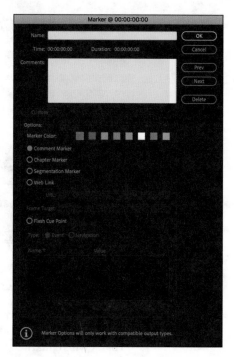

FIGURE 7-7:
Marker window.

>> **Get the necessary permissions:** There's nothing worse than getting flagged on YouTube, or a social media site, having your video taken down, and even ending up in Internet jail. No bars, just restrictions on your posts.

>> **Comment Marker:** A general marker that you can use to leave notes on your clip.

>> **Chapter Marker:** Useful for having Adobe Encore read the chapter marker when making a DVD or Blu-ray Disc.

>> **Segmentation Marker:** Makes it possible to define an entire segment of a clip to apply notes or a title for certain video servers to divide content into parts.

>> **Web Link:** Useful for video formats like QuickTime, which can use this marker to automatically open a web page while the video plays. When you export your sequence to create a supported format, web link markers are included in the file.

You can add a marker in several ways:

>> Click the Add Marker button at the top left of the timeline.

>> Right-click the Timeline time ruler and choose Add Marker.

>> Press the "M" key.

Making your mark

While markers help locate important sections, too many of them make it hard to keep track of why you added these sections in the first place, as shown in Figure 7-8. The good news is that there are several marker types. And to help differentiate between different types of markers, you can use different colors.

FIGURE 7-8:
Crowded
markers.

The Markers panel

The Markers panel shows you a list of markers, displayed in time order. The same panel shows you markers for a sequence or for a clip, depending on whether the timeline or the Source Monitor is active. When you click on the color, as shown in Figure 7-9, it brings up thumbnails that represent the mark. You can double-click a thumbnail to add information.

FIGURE 7-9:
Marker panel.

Modifying Clips

Sometimes you capture an entire scene as one long clip. Other times the camera creates a separate clip each time it stops and starts. The latter situation seems to be the norm with digital capture, meaning that you have a lot of clips to look at once they're ingested.

Scrubbing through the clip

It sounds like you are cleaning up your clip if you're scrubbing through it, but actually it's a technique for moving the playhead manually through the clip or timeline. It's a great way to quickly assess and locate the desired section. This can expedite the process, especially when watching the entire clip isn't necessary.

There are several ways you can scrub, each with their own virtues.

Grabbing the playhead and moving it with your mouse across the clip or timeline lets you move through the clip as quickly as you can move the mouse.

Using keys

The J, K, and L keys will scrub backward, pause, and forward, respectively. Each time you click on the key, you double the speed.

>> J: Moves the playhead backward

>> K: Pauses the playback

>> L: Moves the playhead forward

Using the arrow keys

When it comes time for precise placement of the playhead, perhaps for making a cut, you can use the arrow keys. Each tap moves the playhead by one frame.

Marking the scrubbed clip

If your project assets are shown in the Icon View, you can scrub through the clip to adjust the range with In and Out points, as shown in Figure 7-10.

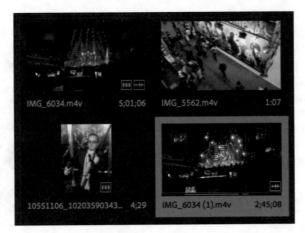

FIGURE 7-10:
In and Out
points shown
in Icon View.

Adjusting clip duration

Clip duration refers to its total length of time, and it's directly related to the rate at which the clip was recorded (for example, a clip that runs 45 seconds and was captured at a frame rate of 29.97 frames per second). Yet, while it refers to the real-time it plays back, it can also mean that the speed of playback was altered to speed it up or slow it down.

Why would you want to do this? One reason is to change speeds for the purpose of effect. You can speed the clip up in the timeline as a creative choice or turn it into a slow-motion sequence. But for now, let's look at methods you can use to adjust the clip at the rate it was captured.

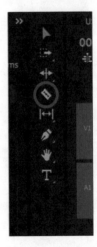

>> In the timeline, you can push in on the ends to the point you want the clip to start and stop.

>> Use the Blade tool, shown in Figure 7-11, to make cuts and then click on the extra parts and delete them. You can find this tool in the toolbox or by pressing the C key.

>> Set In and Out points in the Source Monitor and drag them into the timeline.

FIGURE 7-11:
The Razor tool
highlighted in the
toolbox.

Changing speeds

The quickness of time-lapse, the leisurely pace of slow motion, and everything in between are possible with your clips in Premiere Pro. To access these extremes, just go to Clip ⇨ Speed/Duration. You can also right-click on the selected clip and

choose Speed/Duration. In the dialog that appears (shown in Figure 7-12), you can alter the percentage of change regarding clip speed. Assuming that normal speed is 100 percent, changing it to 50 percent plays the clip at half the speed. Put in 200 percent, and it plays twice as fast. You may need to tweak the percentage to get the pacing right, but that's the fun of it.

Rate Stretch tool

This unique tool can solve issues on the timeline when you're short of footage, looking to make changes on a music beat, or looking to quickly change clip speed. The Rate Stretch tool alters clip speed without adding additional frames. You can access this tool by either pressing the R key or selecting it from the toolbox, as shown in Figure 7-13.

FIGURE 7-12:
Speed/Duration dialog.

Here's how to use it

After activating the Rate Stretch tool, you can expand or contract clips. If you grab the handle on one side of the clip and drag it out, this expands the clip and slows down the action. Conversely, if you push in, making the clip smaller, this plays the clip faster. How much depends on how much you drag the clip.

The control maintains the clip's In and Out points. Keep in mind, it just expands or contracts them, so it's not a Trim tool.

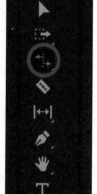

FIGURE 7-13:
Rate Stretch tool.

Reversing the action

You can reverse the action of the scene, which adds the potential for a really cool effect. It's fun for many situations, and when used strategically, it can help move your story along while engaging your audience. All you need to do is right-click on the clip and select Speed/Duration. When the dialog pops up, just click the Reverse Speed checkbox.

You can also change the rate at which the content was originally captured, by either speeding up the action or slowing it down. This effect works well with

linear action shots like diving into a pool, as shown in Figure 7-14, or walking on a crowded street.

FIGURE 7-14:
Backward capture of diving into a pool.

Understanding Clip/Speed Duration

Besides changing the speed of a selected clip, this function lets you alter the duration. Checkboxes let you Reverse Speed, Maintain Audio Pitch, and Ripple Edit. Time Interpolation lets you select various options to interpolate missing frames, as shown in Figure 7-15.

Rippling through the Ripple tools

These tools expedite your edit by saving steps when it comes to trimming clips and adjusting them in the timeline. Under normal circumstances, you may use the modifier keys (V for the Selection tool and C for the Razor tool) to cut, select, and delete to trim your clips. Well, the Ripple tools help you perform the same actions more efficiently.

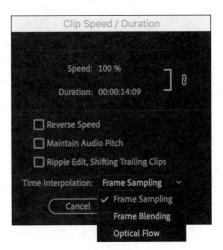

FIGURE 7-15:
Time Interpolation pull-down menu.

Ripple Edit tool

Located on your toolbar, the Ripple Edit tool looks like two arrows sticking out of a vertical line. You can also press the B key to select it. This tool expedites the editing process by saving time and extra steps when it comes to trimming clips in the timeline.

When you select a clip and edit point, observe how the cursor's brackets change direction as you move it toward a new clip, indicating which way you can trim it. When you shorten a clip, the adjacent clips snap to the new endpoint, letting you to make precise edits without affecting the rest of your project.

You can use this tool to trim clips without leaving a gap or to push adjacent clips later in the sequence. This comes in handy when you want to shorten or extend the clip move while preserving all edits adjacent to it.

The Rolling Edit tool

Similar to the Ripple Edit tool, the Rolling Edit tool trims the In point of one clip and the Out point of another, without affecting the combined duration of the two clips.

clips

» **Using markers to organize your project**

» **Adding a freeze frame to your movie**

» **Making three- and four-point edits**

Chapter **8**
Editing in the Timeline

N ow comes the part where you begin to construct the movie you plan on showing. The previous chapters described basic preparation of individual clips, but here the goal is to begin to make them work together as a whole unit. This is the fun part. If you were in grade school, it would be recess, but not quite lunch. That's coming up. Now, you get to pursue the creative side of assembling your masterpiece.

How intense is that masterpiece, you ask? That's up to you. It can be a couple of clips joined together to look interesting, a more sophisticated piece with multiple elements, or a full-fledged, all-out sight and sound experience with music, voiceover, and multiple layers. Name your poison, and Premiere Pro will meet your needs. But first things first, so let's look at the foundation of a successful movie.

Managing Your Sequence

Assuming you have started a project and saved it with a name that's not Untitled, you're ready to rock and roll. While in your project, create a sequence as described in Chapter 5. To reiterate, go to File ⇨ New ⇨ Sequence and when the dialog pops up, select the settings that work for you and type a name in the Sequence Name field. Hit OK, and it now becomes your project. The sequence will often be referred to throughout the text as the timeline, so keep in mind that they'll be used interchangeably.

Populating the timeline

As the song says, it's time to "put one foot in front of the other." As you drag each clip into the timeline, you build the magic of individual scenes working together as they become a movie. Think of the marriage of clips kind of like whistling a catchy tune. Yeah, it sounds good, but it sounds better when blended with other sounds, only instead of just hearing it, you're seeing it, too. Setting In and Out points, and marking your key areas, as discussed in Chapter 7, is an essential part of the process.

Adding clips

There are many ways to get your clips into the timeline. Deciding which method works best for you is partly based on the situation and a little on your personal preference.

Here are some ways to add clips:

FIGURE 8-1:
Insert and Overwrite buttons.

>> Drag the clip from the Source Monitor directly to the timeline. This is straightforward.

>> Use the Insert and Overwrite buttons on the bottom of the Source Monitor to add clips to the timeline, as shown in Figure 8-1.

>> Select the clip. Go to Clip ⇨ Insert, as shown in Figure 8-2. Or you can go to Clip ⇨ Overwrite.

>> Use the keyboard shortcuts of "," for Insert, and "." for Overwrite.

>> Hold the mouse button as you drag from the Source Monitor to the Program Monitor and select what you want to do when the choice pops up in the Program Monitor panel.

>> Copy and paste from one place in the timeline sequence, or another you have open, to the place you want to add it.

>> Poaching (just kidding).

Backing it up a bit

But there's an even easier way. When you start a new project, all of the panels are bare. So, after you import one or more clips into your project, you can drag the first clip into the barren timeline area, as seen in Figure 8-3, and Premiere Pro will automatically configure the timeline based on the clip settings.

FIGURE 8-2:
The Insert option on the Clip pull-down menu.

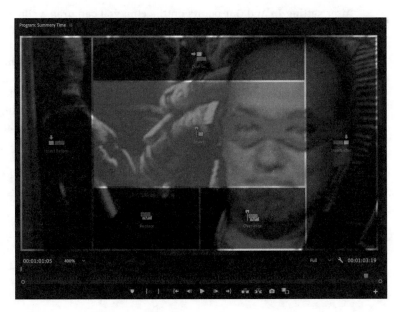

FIGURE 8-3:
The barrenness of panels in new project.

Moving clips

The beauty of nonlinear editing is that you can change the order of the clips at any time simply by dragging them around the timeline. You can also copy and paste them. But you must be careful not to overwrite a clip when you're making a change. Overwrite replaces the clip it dragged onto or copied on. So, unless your intention is to replace and not a clip, avoid overwriting. (See the section, "Source Patching and Targeting," later in the chapter.) As far as the process, if you think a clip that you previously dragged to the beginning of the timeline works better at the end, you can drag it, or copy and paste to the desired location.

Here are some techniques for moving video components:

>> Drag by mouse-clicking an individual clip, and place it in the linear order you want it to play.

>> Drag between clips: Hold the mouse button while dragging clips to a new location. If there's not enough room for the new spot, make space by selecting a group of clips and clearing the way. Then after you have enough room, using the same technique of holding down the mouse drag the clip to the desired location.

Dragging clips into the timeline

After setting In and Out points on the clip, you can drag a clip onto the timeline. But where it ends up can sometimes feel random if you're not careful. Ideally, you want the clip to occupy the first video track and the first two audio tracks, at least when beginning your edit. These tracks are denoted by the alphanumeric designation of V1 for the first video track and V2 if it's the one above it. So, drag it the first video track. And if you don't, just drag it down manually. Also make sure that the Track Targetting Control is properly set. (See Source Patching and Targeting later in the chapter.)

Adding clips through the Program panel

This method provides some control over the type of addition you want to make to the timeline. Drag the desired portion of the clip that you viewed in Source Monitor panel, and perhaps set In and Out points in the Program Monitor Panel to provide alternatives for dragging on the timeline. This method shows an overlay displaying six choices, each one a different way to add the clip to your movie, as shown in Figure 8-4.

>> **Insert:** Puts your clip in the timeline, at the position of the playhead, and moves the playhead to the end of the clip you just inserted, so you can add another.

>> **Insert Before:** Places the clip before the location of the playhead in the timeline.

>> **Insert After:** Places the clip after the location of the playhead in the timeline.

>> **Overlay:** Puts the dragged video clip in the next channel above any existing timeline clips so you can add a clip without affecting other clips on the timeline. This comes in handy for a variety of situations, including putting b-roll over dialogue, creating effects between two video clips, and adding a blend mode.

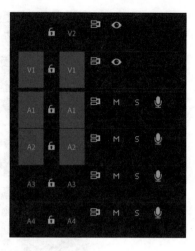

FIGURE 8-4:
Selecting the Overlay option.

>> **Overwrite:** Depending on where the playhead is positioned, and if you have a clip selected, this determines how the feature behaves. If the playhead is next to a clip on the timeline, it will overwrite that clip, but if the duration of the new clip is shorter, it will leave a shaded area that you can trim. On the other hand, if you select a clip in the timeline, it won't matter where the playhead is located; the action will simply overwrite the selected clip.

>> **Replace:** When you drag the selected clip onto the Replace icon, it replaces the footage selected in the timeline. For example, perhaps you have a detail shot of waves crashing into the rocks in the timeline and want to swap out with a stronger shot. Select the one in the timeline, and drag the replacement from the Source Monitor to the Replace section of the Program Monitor. It will replace the shot in front of the playhead.

Source Patching and Targeting

Source patching acts as the routing control for adding clips into your timeline by directing assets to specific tracks, and is represented by the blue boxes on the far left side of your timeline, as shown in Figure 8-5. Every track on the timeline has a number. You can toggle them on and off like a gatekeeper to the timeline by clicking. The highlighted tracks accommodate the clip, and you can click them on and off, so you can only add to the highlighted tracks. So, if you want your video and audio tracks to reside on the second video track and audio tracks 3 and 4, then make sure they are highlighted, as shown in Figure 8-6.

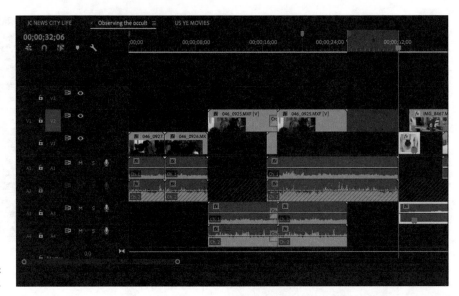

FIGURE 8-5:
Track targeting.

The other set of blue boxes to the right are called *target tracks*, and these let you select different tracks when pasting on the timeline. For example, if you want to copy a title graphic, and don't want to paste over a portion of the video, select a target higher than the one where your video resides. Just make sure the others are not selected or clip will paste to the lowest num-bered track.

		046_0928.MXF	29.97 fps
		046_0927.MXF	29.97 fps
		046_0926.MXF	29.97 fps
		046_0925.MXF	29.97 fps
		046_0924.MXF	29.97 fps
		046_0922.MXF	29.97 fps
		046_0921.MXF	29.97 fps

FIGURE 8-6:
Clicking the tracks that you want to add and seeing them in the timeline.

What you drag isn't always what you get

Dragging clips into the timeline should create a video track and an audio track. Recent versions of Premiere Pro use a single track for stereo, unless you want to separate into two audio tracks (see Chapter 13 for more info). Still, there are times when the clip has multiple tracks, but sometimes only a single audio track shows up, or less than the number of audio tracks contained in the clip. For example, some movie clips have four to eight tracks. How many show up on the timeline depends on the Track Targetting highlighted in blue. See the section, "Source Patching and Targeting," for more information. This controls the number of tracks that are imported into the timeline.

Fine Tuning Your Clips

Redundancy is a big part of assembling a movie; you are constantly going back and forth to the same places to make the movie better. While tonal issues will be discussed later, let's look at adjusting clip length. The following techniques will help you take your movie to the next level.

Trimming clips

When you watch your sequence, you may notice that some shots go on longer than warranted, while others are a bit shorter. You may notice that a clip is a few frames too long, or a few seconds. Maybe there's some errant frame. Not to worry. You can trim clips in your timeline using various trim tools and keyboard shortcuts to select and adjust edit points.

Here is a short list of tools for shortening clips.

>> **Push in the ends of the clips:** Using the Selection tool (V is the keyboard shortcut), you can trim the clip right in the timeline, by grabbing the end. When you do this, you see a red bracket with an arrow, and you can push on the clip to make it shorter.

>> **Use the Razor tool:** Go to the toolbox and select the razor blade icon (you can't miss it), or bring it up using the keyboard shortcut C. After making the cut, you can then select the area you want to discard using the Selection tool (press V to activate it). Then delete the area.

>> **Use the Ripple Edit tool:** This tool lets you extend or trim the clip without affecting adjacent clips. You can access it from the toolbox, or simply by hitting the B key. A full description of the Ripple Edit tools is available in Chapter 7.

>> **Use the Rolling Edit tool:** This one lets you make an edit between adjacent clips in the timeline by letting you shorten one clip while adding from the other, to retain the same frame count and overall sequence length. You can access it on the toolbox, or by pressing N.

ELIMINATING THE GAP

If you have a gap between clips in your timeline, either from adding clips or from changing the order, you can easily close it. Just click on the gap and hit the backspace or delete key.

Handling enough clip frames to trim

Clip handles represent the extra video before and after the key portion of the clip. And while they are essential when it comes to adding transitions, which will be discussed in Chapter 9, sometimes you will need some of those extra frames when trimming your clip — perhaps to finish a phrase that's off by a syllable in the initial In point. If you don't have that extra buffer, then it's not possible, so always be conscious when setting In and Out points and even before, during the shooting process. Remember, less is not always more.

Naming clips

Naming your clips allows you to recognize and easily search for them. If you need to change a clip's name, just click on the filename until it highlights in blue, as shown in Figure 8-7. Then type in the new name. Remember, changing clip names does not change them on your hard disk.

FIGURE 8-7: Changing clip names.

Expanding to see waveforms

Resembling the silhouette of a rugged landscape, as shown in Figure 8-8, these squiggly lines depict a visual representation. Besides looking cool, audio waveforms are a big help when you are making edits in your timeline. This is because you can know where the sound ends to make a clean cut, as it's obvious that the sound ends as the waveform dips. Sometimes waveforms are not visible, especially when the tracks are silent. But if you can't see them, click on the wrench icon on the top right of the timeline, and choose Show Audio Waveform in the menu, as shown in Figure 8-9.

Freezing frames

Combining a movie clip with a still image gives birth to the *freeze frame*. That's when the action stops while the rest of the movie continues. A common example of the use of a freeze frame is the opening of the situation comedy, *Modern Family*, where the last frame of the scene is frozen and ends up as the framed picture displaying the cast. Choosing your own freeze frame should include a frame that is clear and dynamic, as shown in Figure 8-10.

Here's one way to freeze a frame in your movie:

1. Position the playhead to select the exact frame you want to freeze.

2. Go to Clip ⇨ Video Options ⇨ Add Frame Hold, as shown in Figure 8-11. You can also right-click on the track to bring up this menu.

Depending on where the playhead is positioned, it makes a cut to the clip, with the latter part remaining frozen in the timeline.

FIGURE 8-8:
Waveforms in audio tracks on the timeline.

FIGURE 8-9:
Use the pull-down menu to select Show Audio Waveforms.

FIGURE 8-10:
A dynamic portion of the clip used as a freeze frame.

FIGURE 8-11:
Selecting the Add Frame Hold option.

Choosing Insert Frame Hold Segment

Another way to freeze your frame is to freeze a portion of the video for a few seconds and continue to play the rest of the clip.

1. Position the playhead to select the exact frame you want to freeze.

2. Go to Clip ⇨ Video Options ⇨ Insert Frame Hold Segment.

After selecting, Premiere Pro makes a cut to separate the frozen portion, and another to continue playing it.

Advanced Timeline Tricks

Less like a magic trick, and more like helpful effects, Premiere Pro offers some advanced techniques for helping to take your edit to the next level. Some are functional, some are efficient, and others are just cool.

More advanced clip movement

If you have a busy timeline filled with multiple tracks, then moving a group of clips can be complicated. You can select and drag the clips out of the way by holding the mouse over the group of clips.

Using the Track Select tool

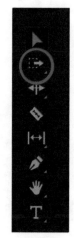

This toolbox feature lets you to grab a block of clips, and depending on which version you select, it grabs all the clips in front of (as shown in Figure 8-12) or behind where you place the tool. The Track Select tool comes in handy when you need to create an opening on a busy timeline for another clip. So, instead of selecting and dragging clips toward the back, you can do it in a single step.

Overwrite a clip with an adjacent clip

FIGURE 8-12: Track Select tool showing an arrow grabbing clips in front of it.

In the timeline version of survival of the fittest, you can easily replace a clip with a better one by setting the In and Out points in the Source Monitor panel of the clip you want to add. Then place the playhead on the clip you want to change, and either drag to overwrite it, or select the Overwrite button below the Source Monitor panel.

Considering the three-point edit

Regardless of whether you're working on a short film, feature documentary, or social media piece, the process of scouring through your clips looking for prime scenes remains the same. And as you drag these clips onto the timeline, you lay them out. You can position at the specific points on the timeline, for example at the top of each minute, sometimes leaving a gap until you can add a clip to the space. For making the added clip in these gaps work, three-point editing can help.

This technique lets you precisely position a clip into a sequence. Let's say you're making a music video and you want a particular clip, or set of clips, to correspond to the beat; you can easily fill the gaps with this technique. The same applies for adding a musical passage.

First, let's get to the point — or, more appropriately, talk about the points in three-point editing. When you add In and Out points for a clip and drag it onto your timeline, that's known as a *two-point edit*. The In is one point, and the Out is the second point. Three-point editing adds another point in the clip as either an In or an Out point.

If you have clips laid out on the timeline, and there's a gap, as shown in Figure 8-13, here's how you perform a three-point edit:

1. Zoom in on the timeline to give yourself some room to work on the clip.

 The In point and the Out point of the timeline gap represent a two-point edit.

2. The third point comes from the clip you want to add. After opening the clip in the Source Monitor panel, set either the In or Out point — in other words, the place you want it to either begin or end.

3. Before adding the clip to the timeline, check that your source patching is correct. If you're working on a music piece, make sure that you lock the audio tracks by clicking on the track lock on the left side of the timeline.

4. Because you have already set In and Out points on the timeline, and added an In point on the clip, you can just click the Overwrite button, and it displays a dialog that asks you to confirm options to fit the clip, as shown in Figure 8-14. Choose Ignore Source Out Point. This adds a clip from the In point until it fits, and disregards the rest.

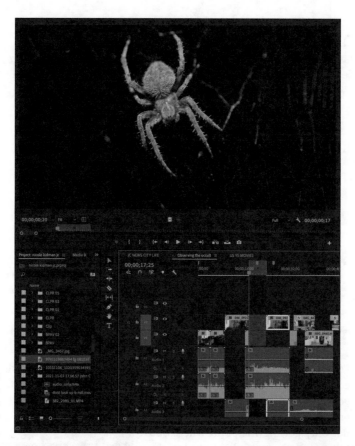

FIGURE 8-13:
Adding a clip to a gap for a three-point gap.

Back-timing edits

Great mystery writers often construct the end of the book so they can focus on getting to the twist or someone shouting, "I would have gotten away with it if it wasn't for you meddling kids." Well, the same premise works with video editing when adding a key piece of action into a fixed place at, or near the end of your movie. The Back-time edit focuses on where you want the clip to end. Examples that come to mind are catching a touchdown crossing into the end zone or that moment when graduation caps soar.

FIGURE 8-14:
Overwrite button, circled below the clip in the Source Monitor panel.

THREE- AND FOUR-POINT TIP

Make sure that you Overwrite and don't Insert. Selecting the latter will only move all the clips.

Here's how you perform a Back-time edit:

1. Zoom in on the timeline to give yourself some room to work on the clip. Set an Out point on the timeline where you want the action to end.

2. After opening the clip in the Source Monitor panel, set an In and Out points, with the latter showing the decisive moment.

3. Before adding the clip to the timeline, check that your source patching is correct. After a quick perusal, click on the Overwrite button, and the clip will end at the desired spot.

Trying a four-point edit

Following the same principle as discussed for the three-point edit, the four-point edit follows the same process, except that it adds an extra point, and that's when you select both an In and an Out point on the clip you want to add. So, you're not only getting the point where you want the clip to begin, but also the point where it should end. Sounds simple, right? Not so fast.

Four-point editing means that for the clip to fit precisely into the gap in the timeline, it must change its speed. For some situations, this won't matter; for others, it's crucial.

The difference between three and four-point editing lies in the Fit Clip dialog. If you select Change Clip Speed (Fit to Fill), as shown in Figure 8-15.

FIGURE 8-15:
Fit Clip dialog showing the Change Clip Speed option selected.

Making the right choice

There's a specific reason for using each of these options.

Reasons for a three-point edit:

>> It simplifies the process.

>> It lets you precisely pick footage, down to the frame, at the beginning, or end, and add it to the timeline.

>> Situations are dependent on either a specific beginning or end to a clip.

>> You need to expedite filling gaps on the timeline.

>> It helps you quickly make efficient edits.

Reasons for a Back-Time edit:

>> Provides a climatic end to an action.

>> Saves time on making an ending work.

Reasons for a four-point edit:

>> You need a defined beginning and ending for the clip.

>> Clip speed not a problem.

>> It allows you to intentionally make a slow-motion segment or speed it up.

Chapter **9**

Transitioning between Clips

Are you a *Star Wars* fan? If you are, then you're aware of the over-the-top transitional wipes between scenes. They're almost as distinct as the rolling text that opens each film in the franchise. And while there will be more on that "A long time ago in a galaxy far, far away. . ." jibber-jabber later in the book, for now, let's look at transitions as another vital piece of your visual storytelling, much like George Lucas used them effectively in his seminal space opera. That's not suggesting that bombastic elements between clips are right for your movie. Quite the contrary. But you can make subtler choices than the ones George opted for and make them just as powerful.

Acting as a buffer between clips, the transition kind of acts as a divider in your utensil drawer combined with wearing a dress-up accessory like a scarf or earrings. Only, instead of wearing it, they're producing an animated link between scenes that helps "accessorize" and further communicate your intention. For example, a long dissolve between scenes does more than smoothly transition one frame to the other; it can depict a passage of time between those scenes. And there are numerous other examples that can take your storytelling to the next level.

The relationship between two clips is also a transition, a hard cut, to be exact, and the most popular one of all. Just look at any movie or TV show, and you will see what I mean. But for now, let's look at making a transition for those scenes that require something other than a cut, which acts as a change in position of the scene. Dissolves can depict changes in time or place; and a wipe takes the story someplace entirely different. So, transitions are an essential tool for your visual storytelling.

Choosing Effective Transitions

REMEMBER

Knowing you can enhance the relationship between clips with something more expressive than a hard cut offers a creative choice and helps move the visual story along. Then you realize numerous choices and variations are at your disposal, and things get a little fuzzy, as shown in Figure 9-1, Which clip should you add? Or should you add one at all? These are competing questions, and worth pondering.

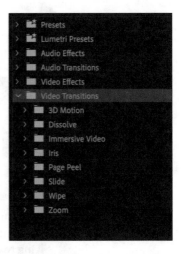

FIGURE 9-1:
Group of Transition bins.

Sometimes it's hard to pick the one that works for your scene, and haphazardly adding a transition doesn't always help the situation. In fact, it can hurt the flow of your movie. It's like regretting something you said, when you should have said nothing. Not picking a transition that makes your project sing, can lead to hearing the metaphorical sad trombone.

So, it's important to pick a special one or nothing at all.

TIP

Think about what you're trying to convey with the intention to not just "soften" the change between scenes, but also to make a statement. Partially hypothetical, and equally relevant, let's look at some reasons for using transitions to make your movie flow more effectively.

Perusing the transition palette

REMEMBER

After establishing the process of dragging clips into the timeline and assembling them in linear order as you play them out, it's obvious that some clips don't play well with others, leading to an awkward cut between clips. Sometimes these changes between clips will appear abrupt and disruptive for the audience to watch. These cuts need some help. It's much like cuff links that add pizazz to your shirt as they neatly emerge from the sleeves of your suit. Placing the transition on the cut line between those shots translates the cuts into something that can look better. Of course, transitions can't miraculously fix mismatched or problematic shots.

Why do you need transitions?

Transitions are a necessary component of the moviemaking process because they help tie your sequence together and enhance the relationship between clips and scenes.

Let's examine a few scenarios.

TIP

» **Helping to tell the story:** Visual storytelling yearns for economy, and one way to help create a quick visual message is to use transitions. They can help the audience understand concepts like passing time, with a long dissolve, as shown in Figure 9-2. Or perhaps they can jump ahead to another location with a Cross Zoom.

» **Fixing abrupt changes:** Whether it's the color palette, light ratio, or key objects in adjacent scenes that clash, a transition can help "soften" the blow. Adding a dissolve or wipe can help a movie flow more naturally, so it doesn't distract the viewer.

» **Separating similar scenes:** Talking heads, for example, can benefit from making a cut and dropping on a dip-to-white dissolve to create a flash for each new idea being spoken, as shown in Figure 9-3.

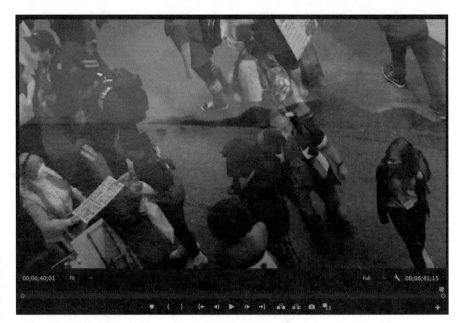

FIGURE 9-2:
The superimposition of two scenes in a long dissolve.

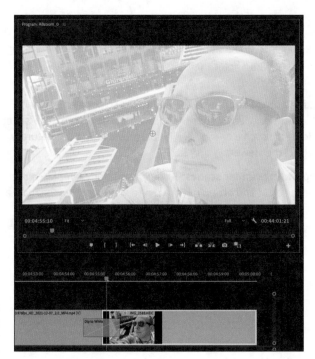

FIGURE 9-3:
White flash from dip-to-white dissolve.

» **Ending a scene:** Otherwise known as the fade-out, it's essentially a dissolve that goes to black, as shown in the sequence in Figure 9-4.

» **Beginning a scene:** You can use a dissolve at the beginning of a scene to fade in.

Grasping Transition 101

Transitions are used to move a scene from one shot to the next. Premiere Pro provides a list of transitions that you can apply to a sequence. A transition can be a subtle crossfade or a stylized effect and can help make your movie more visually appealing. But those should be the exception, not the rule. Most transitions are cuts, which essentially are two clips butted against one another. So, when using something other than a cut, do so sparingly.

FIGURE 9-4:
Sequence to a fade-out.

WARNING

Before you apply a transition, trim the clips because some of those extra frames are sampled. The more you trim, the more frames you can use in the transition. Sometimes there's not much, or any, to trim, so you also need to make sure you have enough frames (see the section "Using clip handles," later in this chapter).

Here's a brief description of the different transition bins.

» **3D Motion:** These include the elaborate Cube Spin, or Flip Over to provide a sophisticated animated transition between clips.

» **Dissolve:** This is home to the most used transition, and a bunch of variations.

» **Immersive Video:** These VR transitions work with footage that's been shot in the 360 rectangular mode. If your footage isn't shot for VR, then move along.

» **Iris:** This unique set of masking techniques helps focus attention on a portion of one clip as the rest of a scene comes into view. Several choices, including Iris Round (shown in Figure 9-5), are available.

» **Page Peel:** This is a pair of transitions that resemble a page turning or peeling away, as shown in Figure 9-6. It has its place, but use sparingly.

FIGURE 9-5:
Example of an
Iris Round in
mid-transition.

FIGURE 9-6:
Example of a
Page Peel in
mid-transition.

TIP

>> **Slide:** This includes a group of transitions that do what they say and slide from one clip to the other, such as the eponymous Slide, Split, and Push (shown in Figure 9-7).

>> **Wipe:** A wipe transition moves from one shot to another with a sliding animation. It makes it look like one shot is literally wiped away to reveal the next. There are more than a dozen choices, including a traditional sliding wipe, checkerboard, clock, and barn doors. Wipe transitions are great for grabbing your viewers' attention, but they can quickly become overwhelming if used too much.

>> **Zoom:** As mentioned earlier, dropping this one between two clips zooms into the end of the first clip and the beginning of the second before returning to normal.

FIGURE 9-7:
Example of
a Push in
mid-transition.

Setting default transitions

While the Cross Dissolve is the default transition (and for good reason), it's like vanilla ice cream: It goes with everything. But you may want something a little more special, and you don't want to go through the process of grabbing it from the bin.

So, if you have a new favorite, here's how you change the transition setting:

1. **Go to Window ⇨ Effects and expand the Video Transitions bin.**

2. **Select the transition that you want to make your new default.**

3. **Right-click the transition, and choose the Set Selected As Default Transition option.**

4. **Click it, and that will now be your default.**

Apply default transitions

You can easily apply a default transition to an edit point between two selected clips. The simplest method is to click on the cut between two clips and right-click. This brings up a menu, as shown in Figure 9-8. Select Apply Default Transitions, and Premiere Pro adds a cross dissolve, unless you've changed the default.

You can also place the playhead between the clips and go to Sequence ⇨ Apply Default Transitions To Selection.

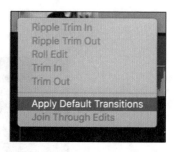

FIGURE 9-8:
Transition pop-up dialog.

Controlling transitions

REMEMBER

Most transitions provide the option to make them longer, and also enable you to control how much of the adjacent clips show the effect. You can drag the edges of the transition to equally extend it or shorten it over the two clips it's affecting. But there's much more you can do to make it perfect for the segment. For example, you can change the duration by double-clicking on the transition; the Set Transition Duration dialog pops up, as shown in Figure 9-9. Adjust the duration and click OK.

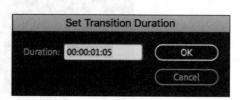

FIGURE 9-9:
Set Transition Duration dialog.

DEFAULT TRANSITION

The cross-dissolve acts as the default transition and is accessed by right-clicking on an edit point and selecting Apply Default Transition, control-clicking, using the keyboard shortcut Command-D, or using the Sequence ⇨ Apply Default Transition pulldown menu. You can alter duration by going to Preferences ⇨ Timeline.

If you want more control, you can adjust transitions through Effect Controls.

Here's how:

1. Highlight the transition by clicking on it.

2. Go to Effect Controls.

3. Adjust the duration, if necessary, by clicking in the Duration field and typing a different time.

4. Change the alignment in the Alignment drop-down menu. It defaults at Center, but you can change it to Start at Cut or End at Cut, as shown in Figure 9-10.

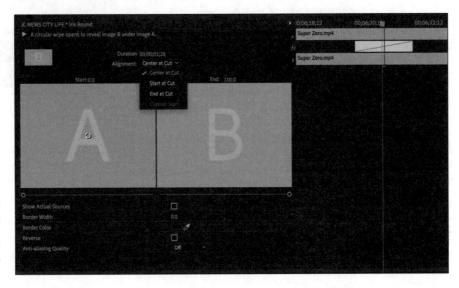

FIGURE 9-10: Changing transition effects in the Effect Controls panel.

REITERATING EFFECT AND EFFECTS CONTROL

As mentioned throughout the book, the Effect and Effect Controls panel go together like chips and salsa or moonshine and a mason jar. You pick the Effect in the first panel, and the specifics populate in Effects Controls where you can make changes.

Using clip handles

WARNING

For a transition to, well, *transit*, you need some extra frames before the In point and after the Out point for most transitions to sample frames before or after the cut. This extra space is known as the *clip handle*. So, if you want to create a dissolve between two adjacent clips, the end of the first clip and beginning of the second, each needs extra frames for the effect to work.

You can immediately identify if the clip you're using is at the last frame by noticing a tiny triangle on the top right (at the clip end) or top left (at the clip beginning), as shown in Figure 9-11.

But not just any frames will work. They should be consistent with the shot. Sometimes, when shooting a scene, you may incorporate another angle, subject, or location that can be sampled, that makes the transition seem awkward. If you see this during playback, you need to adjust the duration of the transition, or change its alignment (see the previous section, "Controlling transitions").

FIGURE 9-11:
Indication of a clip end.

Advanced Transition Techniques

Besides the commonly used dissolves and wipes, Premiere Pro offers numerous other transitions ranging from zooms, pushes, and slides to luma fades, spherical blurs, and light leaks.

Planning for your transitions

TIP

Dropping a transition between two random clips helps make them look better; shooting those clips with the intention of using a specific transition makes you look better. Whether it's contrasting angles or extreme closeups, having the content before the edit provides more control, and can make your movie for interesting.

The one-sided transition

Speaking of fade-in and fade-out, those are considered single-sided transitions, as they are applied to the end of a timeline sequence. Many transition are typically double-sided, meaning they are applied to both clips. Besides using them for these opening and closing moments, single-sided transitions come in handy when there are few, if any, clip handles in the clip. (See the section, "Using clip handles," later in the chapter for more info.)

TIP

Here's how you can apply a one-sided transition as a fade-out (or fade-in).

1. **In the Effects panel, double-click the Video Transitions bin to open it.**

2. **Navigate to the Dissolve bin and open it.** You see numerous choices (for a detailed description, see further in the chapter), but Dip to Black works best.

3. **Drag the transition to the end of the clip in the timeline.**

Differentiating transitions in the timeline

REMEMBER

You can recognize transitions in the timeline because a single-sided transition shows a split diagonal with dark and light halves, while a double-sided transition shows a diagonal line with light halves on both sides, as shown Figure 9-12.

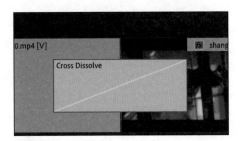

FIGURE 9-12:
A double-sided transition.

Changing and deleting transitions

TIP

Drag the new transition over the current one to replace it. To delete a transition, click on the clip, and hit delete. You can also right-click on the transition and choose Clear from the pop-up menu.

Copying and pasting transitions

Sometimes you will find a transition type and duration that works for you. So, instead of going through the process of dragging and adjusting each time you want to use it, you can just copy and paste it between two clips.

Here's how you do it.

1. Select the transition in the timeline you want to use, and highlight it.

2. Copy the transition by either going to Edit ⇨ Copy or using the keyboard shortcut Cmd+C (MacOS) or Ctrl+C (Windows).

3. Paste the transition on the edit point by either going to Edit ⇨ Paste or using the keyboard shortcut Cmd+V (MacOS) or Ctrl+V (Windows).

Plug in to your transitions

Premiere Pro gives you some great options when it comes to transitions, and that doesn't even include the ones you make yourself (although that's the subject of a more advanced book). When it comes to looking for some other options for the transitions between your scenes, there are numerous plug-in options that can take your movie to the next level. For more information, check out Chapter 19.

Chapter **10**

Finishing Your Edited Video

I f you equate your movie with getting ready for a special occasion, the past chapters were about getting showered and dressed. But you're not quite ready, because you're coiffing your do, putting on accessories, and maybe, adding a little scent. So, here we are in post-production, that process after the movie is put together where you apply the final touches.

Refining the color and tone of the movie, matching the consistency of similar shots, and eradicating any shaky camera shots are still on the agenda. And that doesn't include taking a creative turn. Maybe, you want to be adventurous and bring out your inner Tim Burton and stylize your movie. Whatever you decide, the following techniques, ideas, and suggestions will dress up your movie and "clean it up" nicely.

Exercising Video Correction

While you put your movie together, you will notice it needs some minor corrections, which can be addressed in the post-production process.

Premiere Pro offers some awesome tools for fixing your movie. There's no denying that using the best possible material from the start serves as the best method. But like getting the ocean-front room on your beach vacation or biting into the perfect plum, that's not always possible. So, if the color is less than perfect, some of the footage is a little shaky, or the exposure needs a boost, you will find many solutions in this chapter.

Fixing exposure issues

REMEMBER

In a perfect world, video clips with exposure issues would be fixed at the time the scene was captured by making a simple camera adjustment. But because this is the real world, and real-world problems happen, that's not always possible. Sometimes you may need to quickly shoot the scene without having time to make adjustments to tonality. In other words, is the clip too light or too dark? Other times, the conditions may change. Both can lead to less-than-perfect exposure. The good news is that most exposure discrepancies are easily correctable in Premiere Pro.

Tweaking those tones

REMEMBER

Minor exposure issues, like slight overexposure (shown in Figure 10-1), are easy to correct. Underexposure is even more doable. More serious exposure fluctuations depend on several factors, including how far exposure levels are off, the video codec used for capture, and the light ratio in the scene. At the very least, you can use Premiere Pro to make the footage look better, as shown in Figure 10-2.

FIGURE 10-1:
Overexposed
image.

FIGURE 10-2:
Corrected
image.

Adjusting color

Dealing with imperfections with white balance, matching color in similar scenes, and stylizing hues are all possible with the sophisticated color and tonal correction tools, including the Lumetri Color panel, which is discussed later in the chapter.

Cropping to fill the frame

Color and tone are not the only correctible aspects of your movie; so is what happens in the frame. And sometimes, you have your movie clips laid out, and you will notice the aspect ratio is off.

UNDERSTANDING WHITE BALANCE

This term gets thrown around a lot when it comes to movie editing. It basically refers to the balancing of color in the scene to eliminate unrealistic color casts. The idea being that the white portion of the scene is rendered as a pure white, and not with a tint or color cast. This shift in color occurs when the camera sensor isn't aligned to adjust for the color balance in the scene. Sometimes it's an easy fix; other times it's a matter of compromise because of varying types of light.

TECHNICAL
STUFF

Most video these days is captured at the same ratio of 16:9 regardless of whether a camcorder, DSLR, or smartphone is used. But that doesn't mean that all content for your movie conforms to that ratio. DV content and older material use a 4:3 ratio, with a distinct squarish look. Feature film clips, conversely, can have a 1.85:1 or 2.39:1 ratio, which is considered ultrawide.

This creates one of the following issues.

>> **Pillar boxing:** This is caused by those black borders on either side of the image. This is common when adding a standard-definition clip that has a 4:3 aspect ratio, or when holding your smartphone vertically.

>> **Letterboxing:** Because the frame is much wider than the 16:9 aspect ratio of the HD timeline, displaying this image edge-to-edge will show black on the top and bottom.

What can you do about it?

TIP

Back in days of the squarish 4:3 aspect ratio, when feature films were played, it was necessary to crop the edges of the wide-angle film to the fit the TV format. Old VHS movies used a process called *pan-and-scan* that shifted the frame from edge to edge to include the key parts on the squarer screen. Figure 10-3 offers an example of what it would look like.

FIGURE 10-3:
The red box indicates how much of a wide-aspect-ratio image was included.

These days, the situation is reversed; when you want to include older standard-definition footage, it puts you at a disadvantage. The standard-definition content is already of lesser quality, so expanding it further increases the potential for a degraded image.

As for dealing with the problem (at least in the newsroom) they will put a blurred image on the bottom layer, as seen in Figure 10-4, to leave the aspect ratio intact. Other times, you can fill the frame by scaling the image. A simple way of accomplishing this task is to double-click on the image, the drag the anchors to fil the frame.

FIGURE 10-4: Dealing with pillar boxing by using a background.

Correcting Color and Tone

REMEMBER

The question isn't about whether your clip need tweaking; rather, it's a matter of how much tweaking it needs. Slight color casts are as common as exposure problems. Often, it's a combination of multiple issues, and then there are the extreme ones that resemble the shot being captured through orange juice. These and other tonal issues will plague your movie if they're not corrected. But that's no problem thanks to Premiere Pro's correction tools and various scopes.

Grasping Lumetri Color

Premiere Pro includes numerous adjustment tools, but none quite as powerful as Lumetri Color. Accessed through the Effects panel, the simplest way to use it

is through the Color workspace by going to Windows ⇨ Workspaces ⇨ Color. This loads the Lumetri Color panel on the right side of the workspace. Here you can perform everything from basic corrections to advanced color matching, which can have an amazing impact on your movie.

Understanding the Lumetri Color Landscape

The Lumetri Color panel consists of six sections that cover a lot of ground, from color and tonal adjustments to clip matching and vignetting. You can expand and collapse the panel to access a specific set of tools. The checkmark on the right can disable corrections, allowing you to revert to the state of your video before you added the corrections.

On top of the panel are two boxes: the first one affects the original clip, so no matter where you drag the clip, it brings along the correction that you added. The second one, on the right, affects only changes made to the clip in the timeline. This is important for situations where you want to make changes for a specific use but retain the original clip for another edit.

The following sections allow you to add functionality, but for basic uses, you can skip that one.

TECHNICAL STUFF

The panel also contains the following sections.

>> **Basic Correction:** This set of tools, shown in Figure 10-5, includes White Balance and Tone controls, so you can make basic corrections to color and exposure. For many situations, these controls are enough to improve image quality. You can also change LUT's (see sidebar).

>> **Creative:** These tools allow you to select a particular look for your clip. You can click on the arrow that displays the image, and it displays the appearance that various Looks will create, as shown in Figure 10-6.

>> **Curves:** This tool allows you to adjust color, density, and hue/saturation by dragging the diagonal line as you would in any program that lets you alter color and tone.

>> **Color Wheels and Match:** Shown in Figure 10-7, this section of the panel helps you match the color of clips both manually and automatically, so you can adjust clips to match one to another.

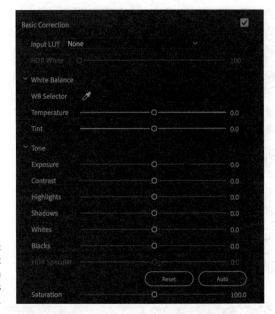

FIGURE 10-5:
Basic
Correction
and all its
functions.

>> **HSL Secondary:** This tool isolates a color or luma key, so you can make a secondary correction. It works on individual hues and won't affect other colors in the scene.

>> **Vignette:** This tool lets you darken the edges of the frame to help draw attention to the clip image.

Adjusting tone

TIP

Seven sliders allow you to control the tone of the image and easily adjust the image density. These images are used interchangeably, and refer the lightness or darkness of the screen image. The Before image, shown in Figure 10-8, needs to be lightened because it was slightly underexposed.

A helpful mnemonic when correcting:

>> Shadows adjust the richness of the image

>> Highlights adjust the energy or sparkle

>> Mid-tones adjust the emotion and time of day

FIGURE 10-6:
The Creative tool showing some of the Looks in pulldown menu.

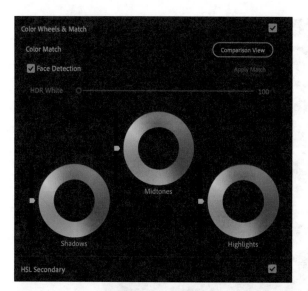

FIGURE 10-7:
Color Wheels &
Match.

FIGURE 10-8:
The image
in this video
was slightly
underexposed.

THANKS A LUT

LUT (short for "look-up table") is a tool that provides filmmakers, editors, and colorists with a particular color grade to use as a template.

The first step is to make an adjustment to the Exposure slider, as shown in Figure 10-9. If the image is a little flat, you can boost the contrast. But sometimes you can use it when you to make the image snappier. On the downside, it loses some highlight and shadow detail. But you can restore both, within reasonable limits, by adjusting the appropriate sliders.

FIGURE 10-9:
After a little tweak to exposure, it looks much better.

Making a quick correction

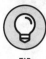

TIP

When working in Lumetri Color, after selecting the scene to correct, the first step is to find something white in the frame. Click on it with the eye-dropper (that icon that looks like a eye-dropper). This corrects the color because it makes what is white appear as white, and the other colors fall in line. But that doesn't always work. When this creates a worse color cast, it's a better idea to try changing the color temperature and tint.

The HSL Color Selector lets you to pick a color and only adjust that color without affecting the others, similar to the Hue/Saturation tool in Photoshop.

For slightly overexposed scenes, use the Curves tool by grabbing the line and pulling up to the left.

Codec limits

TECHNICAL STUFF

While most video images are correctable, at least to some extent, the range of correction will differ depending on the codec used in video capture. On one side of the spectrum are RAW video format codecs, and on the other are video-capture devices like smartphones, which often compress video. When the video endures more compression, movies that are over- and underexposed have less range for correction. Sometimes when you alter the density of the image, you add grain and noise. While Premiere Pro can make moderate adjustments, plugins are available that can reduce ("lower") the noise.

Using color for style

TIP

Have you ever noticed the color palette when watching television or a movie? Some use a slightly warmer and cheerful palette, and others a cooler one. A great example is the Showtime series *Dexter*, which took place in sunny Miami, and used bright, cheerful tones. The reboot of the show takes place in the wintery northeast, using a much cooler palette. While not favoring a dominant color cast, these choices use a cool, warm, or dominant color palette. Hello, Tim Burton. Anyway, the same should be true for your movie. Do you want it to have a cooler look? Warmer? More neutral? These are decisions you need to make before making corrections or color grading your footage. The example in Figure 10-10, captured during an outdoor event, shows concertgoers bathed in red light.

FIGURE 10-10: Concertgoers bathed in red light.

Matching color in the scene

Much like picking a shirt and tie, or finding the love of your life, the color and tonal values in your movie should be a good match. That means slight variations in color balance and tone are often the rule and not the exception, so it must be dealt with accordingly. This means the goal is to make sure clips shot for the same scene look like they were shot at the same time. While you can eyeball the changes and do a decent job, it's better to use the Color Match feature in the Color Wheels and Match section of the Lumetri Color panel. That tool can be your best friend. After using this helpful tool to apply an automatic adjustment for matching the color and tone of clips, so there's consistency from one scene to another. After applying, you can tweak it manually to fine-tune.

Here's what you can do to match color in two separate scenes:

TECHNICAL
STUFF

1. **In the Lumetri Color panel, click on the Color Wheels & Match section to bring up its features**.

2. **Click the Comparison view button.** (You can find a more detailed description of this feature later in the chapter.)

3. **Choose a reference frame.** This is the one for matching, and it's done by placing the playhead over the clip to match to the reference frame.

4. **Enable Face Detection to prioritize skin tones by selecting the checkbox** (that is, if the scene has people). In this mode, faces are automatically found and prioritized for color matching.

5. **Click the Apply Match button.** It takes a few moments to apply the changes.

After the match is applied, you may need to make minor adjustments using the color wheels to tweak the Shadows, Midtones, and Highlights luminance controls before ending up with your final version.

Using Video Scopes

When Edgar Allan Poe wrote, "Believe nothing you hear, and only one half that you see," he wasn't talking about color correction, and yet, oddly enough, the quote can apply to adjusting video by eye. Sure, it has its place, but video scopes can confirm your choices, especially when it comes to analyzing the color and brightness in a clip.

Accessing the scopes

In the Color workspace, you can access the scopes by clicking the Lumetri scopes shortcut above the Source Monitor panel, as shown in Figure 10-11. There are so many choices, but the RGB Parade stands out as a good choice. Over time, you may prefer another choice. This is no problem, because they all provide the information you'll need to make an informed color-grading decision.

TECHNICAL STUFF

Here are some basics:

>> The White Balance Controls, Temperature, and Tint affect the highlights of the image.

>> Dragging the Temperature slider affects the image, and you also see the color channels in the scope change.

>> If you want a warm look, you will notice that the red waveform peaks higher than the others, while a cooler tone sees the blue channel rise. The Tint channel controls the green channel.

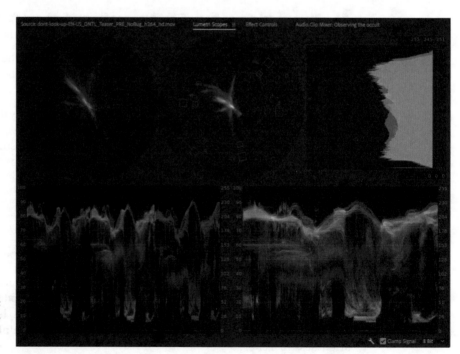

FIGURE 10-11: Lumetri Scopes showing all five choices.

SCOPING OUT THE SCOPES

Populate the panel with different scopes by clicking on the wrench icon at the bottom right of the panel and selecting a scope from the pop-up menu. You can also choose Colorspace, Waveform, and Brightness controls.

Different scopes for different folks

Picking the best video scope is a point of contention with some Premiere Pro editors. Some prefer the Waveform Monitor because it helps you understand grayscale values and how to work with them, while the Vectorscope helps show all we need to know about color.

Premiere Pro has several types of scopes for judging the color and density of your content. And although they resemble psychedelic paintings, each is helpful in its own way.

TECHNICAL
STUFF

Here's a brief description of each scope.

>> **Vectorscope HLS:** This circular graph monitors the hue, saturation, lightness, and signal information of an image. It displays saturation outward from the center and measures hue in a circular pattern.

>> **Vectorscope YUV:** Like the Vectorscope HLS, this scope also uses a circular graph, but this one lets you see if hue and saturation levels are correct.

>> **Histogram:** This helps you accurately evaluate shadows, midtones, and highlights through a grade scale from 0 to 255. Numerical values of the pixel density of each color intensity level are also displayed.

>> **Parade:** This is a popular choice that shows separate waveforms for components of an image. Waveforms are displayed side by side, as shown in Figure 10-12, making it easy to compare the relative levels of color in an image. This helps you detect color casts and shows the effects of adjustments. You can further control this scope by selecting RGB, YUV, RGB-White, and YUV-White (see the following section).

>> **Waveform:** Traditionally used as a piece of hardware back in the day to measure the strength of a signal, the virtual version comes in handy. There are four options to choose from for the Waveform source. RGB provides activity of signal levels in the color channels; Luma allows you to analyze the brightness and contrast; YC Waveform shows the luminance as green, and chrominance in blue; and YC No Chroma Waveform shows only luminance values in the clip.

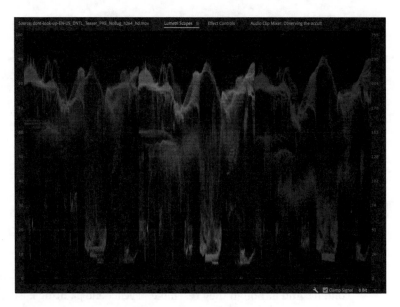

FIGURE 10-12:
Parade scope.

Defining the "scope" of terms

YUV, YC, and RGB are broadcast video terms that have found their way into the nonlinear video space.

**TECHNICAL
STUFF**

Here's a brief description of each term.

» **YUV:** Closer to the way we perceive color, this encoding measurement breaks down to the "Y" referring to the luminosity, or luma, of the scene, which measures intensity of the scene, and is the only part that a black-and-white television could decode in the old days. The "U" and the "V" are part of a calculation that measures color information, with the first referring to blue minus luma (or B–Y), and the other as red minus luma (or R–Y).

» **RGB:** This refers to the RGB color model, which is an additive color model that uses the red, green, and blue colors of light to produce a wide range of colors, depending how they're added together.

» **YC:** This defines the Luminance, which refers to the intensity of the tones, and Chrominance, which refers to the hues of color.

Exploring Some Advanced Techniques

As Emeril Lagasse would say, it's time to "kick it up a notch." Because Premiere Pro has so many features, not all of them can make it into a 400-page book, so let's look at a few key advanced techniques.

Making adjustment layers

REMEMBER

An adjustment layer provides more flexibility over changes that you make to color and tones because it doesn't permanently change the pixels in the clip image. In addition, you can combine effects on a single adjustment layer, as well as add multiple adjustment layers to control more effects, as shown in Figure 10-15. But if you go too far, such as in a color adjustment or effect, no problem! Just delete the layer and voilà — it's like it never happened.

Here's how to use an adjustment layer:

1. **Select the Project panel.** If you don't, the action will be grayed out in the menu.

2. **Go to File ⇨ New ⇨ Adjustment Layer.** After the Video Settings adjustment layer dialog pops up, as shown in Figure 10-13, you can change the settings, if necessary, for the adjustment layer, and then click OK. An adjustment layer appears in the folder.

3. **Drag the adjustment layer to the timeline in a video track above the clips.** Pull it out or push it in to match the areas you want to adjust.

4. **Select the adjustment layer.**

5. **Go the Effects panel and, in the search field, type the effect that you want to apply.**

6. **Double-click the effect to add it.**

7. **Go to the Effect Controls panel to adjust the effect.** You can use the shortcut Shift+5 to bring it up.

8. **Make the adjustment.** When you play the sequence, the underlying tracks are affected by changes to the adjustment layer. You can view the difference by turning off the video track. If you don't like it, you can discard it without any worry of affecting the original.

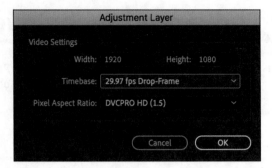

FIGURE 10-13:
Adjustment
Layer dialog.

Making an informed decision

REMEMBER

When it comes to comparing details in similar video clips, or when making tonal changes, our eyes often play tricks on us, making us believe that the color in the scene matches from clip to clip. That often leads to making color and tonal changes that sometimes make the situation worse when matching adjacent frames. Taking the time to fine-tune tonal corrections is best left for post-production. But if you want to clear up some blatant issues, here's what you can do.

Using Comparison view

TIP

Comparing two different frames in the same sequence simultaneously, this relatively new feature comes in handy when color grading, making corrections, and checking effects. This feature offers four different views, which are accessible on the bottom of the Preview Monitor panel. Click on the Comparison view button, which is located on the bottom right and resembles two squares almost overlapping, as shown in Figure 10-14. If you don't see it, go to the "+" button on the bottom right, find it, and drag it into the set of icons on the bottom of the panel. Once this button is activated, you see four buttons next to the timestamp. Here's what they do.

>> **Shot or Frame Composition:** Switches between the reference frame and the current clip to show before-and-after views.

>> **Side by Side:** Shows a before-and-after view of the clips.

>> **Vertical Split:** Creates a left-right, before-after split. In the before-after splits, you can click on the center line to drag it back and forth to see the difference.

>> **Horizontal Split:** Creates an up-and-down split that shows before-and-after views; you can drag the center line back and forth to see the difference.

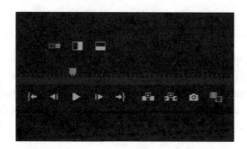

FIGURE 10-14:
Comparison
buttons on the
bottom of the
monitor.

Removing a color cast

TIP

As I've mentioned throughout this book, there's no substitute for taking the time when capturing content to address exposure and color balance issues. Sometimes a strong color cast happens when the white balance wasn't set on the camera when the scene was captured, but you can easily fix it using one of these methods:

>> Make a color correction.

>> Use the Eyedropper tool and set a white point.

>> Make a temperature adjustment, as shown in Figure 10-15.

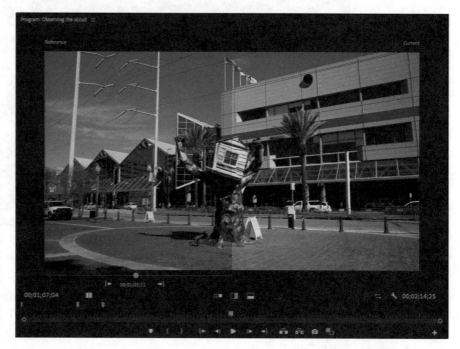

FIGURE 10-15:
When
captured, the
image had a
color cast, but
a quick slide
of the Color
Temperature
in the Basic
Correction
section fixes
the problem,
as shown in
the Vertical
Split view.

Adding punch to the clip

TIP

When your movie plays as a whole, the issues that you thought were acceptable stand out like a zit on prom night. Sometimes a clip needs a little oomph because it's a little flat. Or maybe adding some vibrant color is on the menu. No problem here. Several actions can bring the image to life, as shown in the Comparison view before and after in Figures 10-16 and 10-17.

While working in the Lumetri Color panel, go to Basic Correction and make the following tweaks:

>> Drag the Black slider a few points; 5–10 works nicely.

>> Increase the Whites by 20–40.

>> Add a little to the Highlights if you're not seeing enough detail.

>> Increase the Saturation to your liking.

The clip now looks better, as shown in Figure 10-17.

FIGURE 10-16:
Clip with low contrast and subdued color.

Quickly correct luminance

TECHNICAL STUFF

Before you can correct it, you need to understand the difference between *brightness* and *luminance*. The latter is a quantifiable value that measures the light that reflects or passes through an object; brightness is the unquantifiable perception of it.

FIGURE 10-17:
The clip getting
a little "punch."

A night scene serves as a good example of luminance, especially one rich with shadow areas and some lighter portions. As you change the luminance, details in the scene open up.

The luminance of a scene can be adjusted through the Lumetri Color panel, but an easier and faster solution is possible with the Shadow/Highlight effect.

Just search for *shadow* in the Effects panel, and when it comes up, drag the effect directly onto the clip, or adjustment layer, and you will see a change. You can use the Basic Correction tools in Lumetri Color to tweak the density and color.

Color correction with an Adjustment Layer

The color wheels in the Lumetri color panel can make subtle color corrections to your footage. And when used in combination with an adjustment layer, as previously mentioned, they can make improvements that apply to everything your layer covers. Make sure you are working in the Color workspace.

REMEMBER

Here's how to use this tool:

1. **Create an adjustment layer and place it on the timeline.** You don't have to use an adjustment layer, but it's nice to have the security of not affecting the original pixels in the screen image.

2. **In the Lumetri Color panel** go to **Color Wheels and Match**.

3. **Make color adjustments to Shadows, Midtones, and Highlights by dragging from the center to the desired color shift.**

4. **If the color looks good, but the image still looks flat, you can adjust the tones using the Input Levels slider.** Drag the slider up to increase density in the shadows, midtones, or highlights area. Pulling the slider down will lighten.

» **Working with Blend modes**

» **Using keyframes**

» **Animating effects**

Chapter **11**

Constructing the Video Composite

I f you've ever played a video game like Sim City, you understand that there's a method to building. Your city might expand to incorporate suburbs but, in the city itself, limited space requires you to build upward — adding layers upon layers. In moviemaking, you can add single clips or other assets to create a strong single image for content or correction. In this chapter you will learn about adding such "vertical" growth, what we in the industry call *compositing*.

At this point, if I were a mind reader, the answer would be, "Yes. . .video clips stacked atop one another can only reveal the top one." It turns out that's only partially true, because clip dimensions can change size, showing multiple layers simultaneously. The picture-in-picture is a great example, as it shows a small part of the video in the scene, like an over-the-shoulder commentator shot. Or maybe you will create your own multiple-shot composite, like the opening of the 1970s sitcom *The Brady Bunch*. Perhaps a split screen of two shots is more practical. That's something done in movies, especially when showing a telephone conversation. But it can work for many other situations.

Then comes the technique of blending two clips. Messing with the opacity of the top clip superimposed over another clip can create an effect much like a long dissolve or some other unique effect. Maybe you want to superimpose content from another location behind the subject with a green screen, which can also be a blue

screen. Whatever your idea, the following sections can help build your video up in more ways than one.

Understanding Compositing

Do you remember studying human anatomy in science class and having the books with acetate pages that showed the human body from its full exterior right down to the skeleton? Each transparent page added to the underlying parts of the body as you turned them, like exposed muscle groups, organs, nerves, and other layers. That same concept describes compositing. Here, you're adding elements — some of different sizes, others of varying opacity — that can form a complex single image. A news anchor doing a segment while video from another location plays over their shoulder serves as a familiar example. But that's not all. There are many other situations, ranging from a cool special effect to an insidious element, that help to tell the story visually. So, remember, Titles, green-screen keys and picture-in-picture are all examples of compositing.

Layering clips

In the snack world, there's a certain curved chip that comes in different varieties and is prone to stacking. At least, that's what's suggested in those television advertisements. You can do the same with your movie clips. Instead of dragging a clip next to another one on the timeline, you can place it on the track above the existing clip, as shown in Figure 11-1. That's the basic approach to compositing.

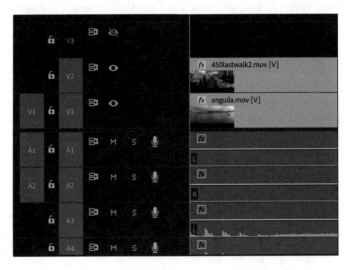

FIGURE 11-1:
Stacked clips in
the timeline.

There are many ways to begin a composite.

>> **Dragging:** Drag clips from the project panel to desired tracks.

>> **Pasting:** After copying an asset from another place, you can paste it. Just make sure the track target is set for the proper track; otherwise, you can overwrite it.

>> **Overlay:** Position the playhead to the desired spot, and in your bin, select the desired clip and drag it to the Program Monitor to Overlay; it will be placed on the next empty track above an occupied track on the timeline.

Adjusting opacity to reveal

Much like cell animation or sheer garments, it's possible to see through layers. In Premiere Pro, this technique is known as *blending*. Unlike clips placed side by side that play out in linear form, the clips are layered atop one another. Under normal circumstances, only the top clip is visible, unless you resize it (more on that later in this chapter) or use a Blend mode that reacts to the color and density of the clips, or change the opacity of the top clip to create a pattern.

Messing with opacity

Stacking clips atop one another and affecting their blend or opacity doesn't necessarily lead to a great image, or even an interesting one, titles, notwithstanding. In fact, it can spawn something that looks like a mistake, or an example of how not to do it. However, there are situations where this technique can work to your advantage and create a compelling image. These are case by case and depend on factors like the main subject placement on each image or its color and density.

It's always a safe bet to use a simple image for texture to produce an interesting effect, like waves, abstract landscapes, or clouds.

Here's how you do it:

1. Drag the base clip into the timeline if it's not there already.

2. Drag the clip you want to blend to the track above the base clip.

3. Click on the track and go to Effect Controls. Navigate to Opacity, as shown in Figure 11-2, and reduce the setting from 100 percent (which shows the entire clip) to 25 percent. This allows the base clip to show, but with texture from the clip above it.

FIGURE 11-2:
The Opacity
slider menu.

Using the Opacity and Blend modes

By using the Opacity and Blend modes, you can easily create a unique effect for your movie that can add cinematically to the scene, you know, make it look more visually interesting. It also acts as great way to texture the text in a title. This requires two clips: the first one, the base clip, shown in Figure 11-3, shows the overall action. It can be the subject of the video or a key location in the scene. The second clip, shown in Figure 11-4, is placed on top. It acts as the blend, and can be more abstract, like clouds, waves, rain, or any other visual that encompasses the entire frame as shown in Figure 11-5.

FIGURE 11-3:
The Base clip.

Striking the right balance between clips

When compositing clips, it's important to make sure they work together.

FIGURE 11-4:
The Blend clip.

FIGURE 11-5:
The two clips
stacked and
showing a
50 percent
opacity.

Here are some aspects to think about.

>> **Is the clip "clean":** If your intention is to create a superimposed effect using a blend layer, make sure that the clip is simply composed and does not contain any other elements.

>> **Correction:** It's possible to make a correction on a clip that has density or contrast issues, by stacking the same clip and applying a blend. You can easily Option-drag the layer atop itself. For example, if you have a lighter image, as shown in Figure 11-6, and you stack it with a copy of itself, the Multiply blend will add density, as shown in Figure 11-7.

>> **Add texture:** Create a textured or dreamlike state simply by dragging a simple pattern atop another clip and applying a blend.

>> **Titles:** Compositing is a way to make simple titles more interesting and top-notch in appearance.

FIGURE 11-6:
Because of the wide light ratio, this scene showing the Brooklyn Bridge has overexposed portions.

FIGURE 11-7:
Using the Multiply blend to make a density correction. Opacity was tweaked to 75 percent, providing a plausible balance.

Let's look at the Blend modes

An entire chapter could be dedicated to Blend modes, and it would not be a skimpy one. But for the sake of space, and the fact that this book takes a general approach to Premiere Pro, I'll give you a brief explanation of the Blend modes.

Blend modes compare the content of two layers and create an effect based on the numerical values of the pixels in the image of each layer. They perform this action by altering the pixel values between those layers to create a specific effect. For example, the Screen Blend mode compares two layers and brightens the images by lightening the darker pixels without affecting the lighter ones. Look at how the various ways the image is affected with each blend as shown in Figure 11-8.

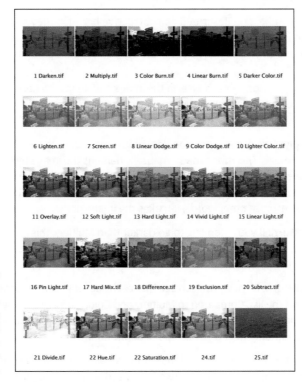

FIGURE 11-8: The Blend modes showing the effect of the two clips from Darken to Luminosity.

Introducing the Blend modes

The Blend modes are divided into six categories — which, by the way, are not named, but merely separated by a line in the menu. Let's take a brief look at how each section treats the blending process.

Group 1: The most basic

The first section of blend groups includes blends that help lead to normal density results. How normal? The first one is actually called "normal."

» **Normal:** The default setting, and one that doesn't affect the layer beneath it — unless you reduce the opacity, in which case it mixes the top layer. The more you reduce the opacity, the more it reveals the layer below.

» **Dissolve:** Turns some of the pixels of the source layer transparent to reveal the lower layer. Most of the time, this mode requires an opacity adjustment.

Group 2: The subtractive

This group can best be described as subtractive because they provide options that darken and increase the density of the resulting image. These all manipulate the shadow values in two images with Multiply as the most popular option.

» **Darken:** Compares each pixel in the image and keeps the darker one of the two layers. It replaces pixels lighter than the blend color, while pixels darker than the blend color stay the same.

» **Multiply:** One of the more popular choices for adding some density to a lighter image. This mode mathematically darkens the image by comparing the two layers and using an equation that takes grayscale values from the selected layer and multiplies them by the lower layer before dividing by 255 for the result; in other words, it makes the image darker.

» **Color Burn:** If you're looking to go darker than Multiply, this mode will do it for you, by also increasing the contrast and color saturation but cutting down highlights.

» **Linear Burn:** By now, you can see that each subset gets more intense as you go down the list. Compared to Multiply and Color Burn, this mode creates a darker image by decreasing brightness and increasing contrast of the darker colors, without affecting overall color saturation.

» **Darker Color:** Similar to yet different from Darken. This mode doesn't blend pixels; rather, it compares the two layers and keeps — you guessed it — the darker one.

Group 3: Increasing density

While the previous group involved increasing density and playing with contrast, this next set takes the opposite approach by brightening the resulting layer. This group manipulates the highlight values in an image. The most popular is Screen.

Many choices in this subset also change colors by mixing, much like the way you can affect color change by mixing projected light.

>> **Lighten:** Examines the base and blend layer and retains the lighter version. If the pixels are the same, they remain untouched.

>> **Screen:** More than anything, this popular choice conjures the idea of projecting multiple images on top of one another and essentially lightening the darker values without affecting the lighter ones. This comes in handy when you have a darker exposure. If you duplicate the layer, it can lighten the overall image without losing detail.

>> **Color Dodge:** Another choice that works well with correction. This layer blend lightens the source color and decreases contrast.

>> **Linear Dodge (Add):** If you were to combine the effects of the Screen and Color Dodge modes with a lighter and lower-contrast tone, this would be the result.

>> **Lighter Color:** Similar to its sister Blend mode Lighten, Lighter Color chooses the lighter pixel for the source and underlying color value, but does not apply the blend to individual color channels.

Group 4: Making a difference

Next comes the Difference category. These Blend modes work by affecting the color of the blend by exploiting the differences between source color values and the underlying color. These modes influence contrast by either lightening or darkening the resulting colors, depending on the mode. This group manipulates mid–tone values in the two images. The most popular option is Overlay, followed by Soft Light.

>> **Overlay:** Another one of the cool kids, this Blend mode combines the Multiply and Screen modes and can add a little "pow" to the image. This is how dark areas become darker and light areas become lighter.

>> **Soft Light:** Colors less than 50 percent gray will render lighter, while those greater than 50 percent gray will get darker. This mode works great when blending textures.

>> **Hard Light:** Similar to Soft Light, except that it multiplies pixels on the darker side to 50 percent gray, and screens the lighter ones, leading to an intense effect that almost always needs an opacity adjustment to appear realistic.

>> **Vivid Light:** Another potent blend that needs some dilution thanks to its high contrast from darkening colors greater than 50 percent gray.

>> **Linear Light:** Sharing similarities with Vivid Light, this Blend mode adjusts brightness instead of contrast. It works great for making colors pop, but the result is still potent and will need an opacity adjustment.

>> **Pin Light:** Another Blend mode that has limited uses. It behaves like both the Lighten and Darken Blend modes, except that it chooses the top or the bottom pixel based on brightness, blending pixels darker than 50 percent gray in either layer, or leaving the lighter tones alone.

>> **Hard Mix:** Perhaps the most unique Blend mode of all. Unlike the other choices, it turns every color into one of eight basic colors — red, green, blue, cyan, magenta, yellow, black, and white — leading to an illustrative, almost animated appearance. But where it truly shines (almost a pun intended) is when it comes to livening up flat video clips that have low contrast and subdued colors. By layering the video on and applying the Hard Mix Blend mode, you can create a cool effect, as shown in Figure 11-9.

FIGURE 11-9: This once-bland image pops by doubling the layer and adding the Hard Mix blend.

Group 5: The HSL category

This group of blend modes can lead to some groovy and surreal results:

>> **Difference:** As the name implies, this one subtracts the pixels of the base and blend layers to create increased brightness. When subtracting pixels in each layer with the same value, the result is black. This comes in handy when creating a psychedelic effect, or when seeing the difference between similar scenes, and is most effective with shooting from a tripod.

>> **Exclusion:** Similar to Difference, but with a little less intensity. And while Difference shows, well differences in black, this one is all about gray.

>> **Subtract:** By its very name, this one is about subtracting values between two layers, and ultimately making the image darker. The order of the layers matters, so changing the order of the layers will provide different results. It does not affect black areas, and will turn white areas darker.

>> **Divide:** Another mathematical term, this one is the opposite of subtract. This one comes in handy for correcting scenes that contain a lot of white, and works best when blended with a solid layer off-white that you want to affect the overall color.

The last category deals with the hue, saturation, color, and luminosity of your video clip.

>> **Hue:** Affects the image by retaining the hue of the top layer with the luminosity and saturation of the underlying color.

>> **Saturation:** Affects the image by retaining the saturation of the top layer with the luminosity and hue of the underlying color.

>> **Color:** Great for adding color to a grayscale image and tinting color images. It works by retaining the hue and saturation of the color of the top layer and the luminosity of the underlying color.

>> **Luminosity:** Similar to the Color blend, this mode does the opposite by retaining the luminosity of the source color. However, sometimes the image mostly disappears.

BREAKDOWN OF BLEND MODE COMPONENTS

Let's break down the lingo.

Source color refers to the color from the layer where the Blend mode is applied.

Underlying color applies to the track layer below the source layer in the timeline.

Result color refers to the outcome of the blend applied to the composite. The effect of each blend can also be impacted by altering their opacity.

Applying a Blend mode to an adjustment layer

You can make a Blend mode correction by applying an adjustment layer. More radical in Premiere Pro than Photoshop, you know, because it's a moving image, and can apply a Blend mode or opacity adjustment to a range of clips. Just change the Blend mode under Opacity in the Effect Controls tab of the adjustment layer. This technique is equivalent to duplicating a clip in a video track over an existing clip, and then changing its Blend mode.

You can add an effect to an adjustment layer, like a tint or color correction effect, and then resize it. This technique allows you to highlight an area of the screen.

Transform effect and adjustment layers

You can add a transform effect to an adjustment layer, like Scale or Rotate, and then animate it over a span of clips (or still images). This technique allows you to achieve motion effects formerly done by nesting clips. When you play back the sequence, the clip now has a transform effect that animates over the span of two or more clips.

Merging clips in a nest

This is the practice of taking separate clips and transforming them into a single clip. If that sounds organized, you're on the right track. But that's not the point. (Well, it's kind of the point.) There's another reason, and that's when you want to create a sequence and apply an effect to it. For example, you may want a portion of your sequence to be in black and white, so an efficient way to do that is to grab all the clips and *nest* them, a technique of making many into one.

Here's how to nest clips:

1. Select the clips you want to merge.

2. Right-click on the selected clips, and when the menu pops up, choose Nest.

3. In the dialog that appears, type a name for the nest, and click OK, as shown in Figure 11-10.

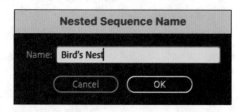

FIGURE 11-10:
Naming a nested clip.

Working with the nested clip

Nesting multiple clips creates a single clip that you can more easily move around the timeline. But it's not like any single clip, because you also have access to each component. Think of it in the way you place clips in a bin or other container, except here, instead of residing in your project folder, it's on the timeline. But let's say you have three clips in this nest, and one of them requires a color tweak; you can easily fix it.

Here's how:

1. Double-click on the nested clip.

2. When it opens on the timeline, you see the individual clips. Make the change you want to the individual clip.

3. Right-click on the clip and select Nest; it goes back to being a single nested clip.

Understanding alpha channels

An alpha channel is an extra channel placed on the image that acts as a map of transparency by allowing you to edit certain elements without affecting the rest of the image. It does this by creating transparent areas based on color that make compositing and green-screen editing more efficient. To understand this better, let's examine color video clips, which contain three channels of color information: red, green, and blue (RGB). Adding an alpha channel requires a fourth channel that contains transparency information, which allows you to make certain colors disappear, so you can see the background in a green-screen composite, as shown in Figure 11-11.

FIGURE 11-11: Image with a green screen background, indicating the surrounding area to remove.

Here's how you make an alpha channel.

1. Grab a clip, and knock out the green by going to Keying ⇨ Ultra Key.

2. Use the Eyedropper tool, shown in Figure 11-12, to select the green; it turns black.

3. Go to File ⇨ Export. In the panel, change the format to QuickTime. You can leave the preset at Custom.

4. Head down to the Audio and Video checkboxes. If the alpha channel is for graphics or effects only, you can deselect Audio, but make sure Video is selected.

5. Scroll down to the Video tab. Change the Video Codec to Animation for 8-bit or ProRes 4444. Both support an alpha channel, so be sure to check either option as you scroll down further.

6. Choose Maximum Depth, and below it, make sure the 8-bpc+alpha radio checkbox is selected.

7. Export it. After exporting the alpha channel video using the Export command, import it back into your project folder and drag it onto your timeline to check it out. When you import it into the timeline, you see the transparency in white, shown in Figure 11-13.

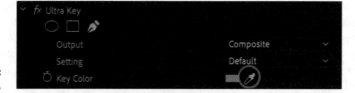

FIGURE 11-12:
Eye dropper.

FIGURE 11-13:
Alpha channel
of the image.

Creating an image mask

A little more sophisticated than creating an alpha channel, creating a mask in Premiere Pro lets you apply effects to specific parts of your video. Masking lets you select areas of the clip that you want to blur, block, or make a correction to. For example, you can use it to mask someone's face or a product name. You can use various tools, like the Ellipse or Rectangle tool, to make a selection, or you can draw a defined area with the Pen tool.

Here's how to do it:

1. Select the clip in the timeline that you want to mask.

2. Go to the Effects panel and choose an effect to apply to the clip; for example, you might try Stylize ⇨ Posterize.

3. Drag the effect to the clip to apply it.

4. Go to Effect Controls and navigate to reveal the controls for Posterize.

5. Determine which tool you want to use from the Ellipse, Rectangle, and Pen.

6. Using the Ellipse tool, adjust the oval on the image in the Program Monitor by using the anchors. You see the shape, and the effect is constrained within the masked area.

Working with Keyframes

Much like markers denote areas of the clip or timeline that are important for one reason or another, keyframes perform a similar action. The difference is that instead of merely pointing out important areas, they can perform actions. Think of the keyframe as an individual instruction that, when combined with others, leads to the effect.

How keyframes work

Keyframes represent points in time that you set for a particular change to occur, so animating a video clip or photograph lets you change its position and size over an allotted period of time. The keyframe marks the point in time where you begin your movement of the frame.

When you add a keyframe, it marks the point in time where you want an action to take place, for example, when changing the size of the image over time. Just add a keyframe where the action begins, then drag the playhead to where the action should end, make changes to the clip, and add another keyframe.

If you want to take the action further, you can add another keyframe to begin panning the image. The more keyframes you add, the more changes you can make to the clip. One more thing: the further the keyframes are spaced apart, the longer it takes for the effect to unfold.

Here's how add a keyframe:

1. **Position the playhead in the timeline at the spot where you want the action to begin.**

2. **Go to the Effect Controls panel and navigate to the effect that you want to add a keyframe.** Use the Toggle Animation button to initiate keyframing; it's the one that looks like a stopwatch. When you click it, you activate the Add Keyframes control. As you add keyframes, you see them populate the right side of the control, and they look like diamonds. Figure 11-14 shows the layout.

3. **Click the keyframe each time you want it to add, click it again on a keyframe to disable.**

FIGURE 11-14: Effect Controls with (circled from left to right) the Toggle Animation button, the Add Keyframes button, and a keyframe.

Keyframing in action

While you can use keyframes for most changes and variations to your clip, the following example keeps it simple by creating movements across a still image.

Making a still image move (aka the Ken Burns effect)

After finding a suitable image, drag it to the timeline. Because the objective is to move around the image, you need to increase its size in the frame. Before you apply any keyframes, think about what you want to do with the image.

The example used here was captured as a panoramic view. Because its aspect ratio is much wider than the screen size, it is ideal for creating a sweeping pan across the entire image.

Here's how to create this effect:

1. Drag the image onto the timeline.

2. Select that image in the timeline.

3. Double-click the image in the Program Monitor, as shown in Figure 11-15. Pull the anchors down so it fills the frame. Then drag the image to the left, showing the edge of its right side, as shown in Figure 11-16. You can also use the Scale tool, described in Chapter 12.

4. Select the clip in the timeline. Go to Effect Controls and navigate to Motion. Move the playhead in the Effect Controls area to the location you want the effect to begin. That playhead mimicks the one on the timeline. It's a good idea to begin a few frames in.

5. Click on the Position Toggle Animation button in the Motion controls, it looks like a stopwatch. Move the playhead in the Effect Controls area to the end of the image, or where you want the effect to end.

6. Double-click the image in the Program Monitor, and move the image to the far right in the frame, or as mentioned, where you want it to end.

7. Go to the beginning of the clip on the timeline and hit Play to see if the simple pan meets your approval.

FIGURE 11-15:
Panoramic
image.

FIGURE 11-16:
Image dragged
to the edge.

Taking keyframing a step further

That was a simple, yet effective, method for panning an image. But you can add more actions if you like. For example, if you want to zoom in on the center of the frame, here's how you can add that action.

1. Because it's a photo image, you can drag or push the edges to change the running time. In this example, you might pull it to extend another five seconds.

2. Drag the playhead a little bit down the frame — say, 2 seconds — and change the scale to make the image larger. This creates a keyframe.

3. You can make as many keyframes as you want, and with other actions. Basically, anywhere you see that stopwatch icon allows you to make a keyframe action.

SELECT ZOOM LEVEL MAKES LIFE EASIER

Due to the size of the image, it's hard to see the portions outside the aspect ratio. To get a better view when position your clip, change the Select Zoom Level pulldown, located on the bottom left of the Program Monitor panel from Fit to 25%. You can change it back for playback.

Compositing with Special Effects

As a movie-watching culture, we've become so spoiled by special effects that there's hardly anything special about seeing them on the big screen anymore. But that may have a different impact on the audience watching your movie. Instead of watching special effects in the movies, you'll be making them.

Keen on green screen

Sandra Bullock floating around in space and Leonardo DiCaprio cruising to the city in a 1929 Duesenberg are not what they seem. Instead, the environmental shooting for *Gravity* and *The Great Gatsby* were done on a soundstage, with the actors filmed against a green screen and those surrounding elements superimposed thanks to chroma key technology. This process combines two separate video sources into one. It often places the subject in the middle of action. Once a feature limited to high-end production houses, producing a chroma key segment is not only affordable, but also slightly simplified.

Blue too for chroma

When it comes to chroma-keying effects, you'll often hear the term *green screen* bandied about, but the truth is that a blue one works, too. Other colors can also work, though that's not advisable. The main difference between green and blue depends on what colors you're looking to key. On a practical level, green works best because the nearly phosphorescent elements shown in Figure 11-17 rarely make it into one's wardrobe. That makes "clashing" less likely than if you go with blue. Historically, green worked better for film, while blue worked better for video, based on the way each media recorded light. Digital video capture changed the game, so color is determined by costume, not technology.

Shooting your very own chroma key

When you experiment with chroma key, expect it to be just that, an experiment. Even experienced users will find that it requires some tweaking to get it right. The following steps should set you on the right path to green-screen heaven. (Okay, blue too.)

FIGURE 11-17:
Subject
captured in
front of a
green screen.

>> **Plan your shot:** Figure out what the subject is doing and how they interact with the background, as shown in Figure 11-18. At this point, you should also have your background movie or image. If not, get to shooting, because you can't compose and light the scene without knowing both sides of the equation.

>> **Choose the background:** Set up the background screen. You can purchase an inexpensive one, or improvise. It can be paper, canvas, or even a bright-green blanket. The important thing is that you evenly illuminate it with flat lighting for the background as-is, as opposed to attempting to creatively illuminate it with a graduated falloff. Notice the even illumination in Figure 11-19.

>> **Lighting the subject:** Make sure the lighting is consistent with the scene.

>> **Position the camera:** Make sure the camera angle of the subject matches the background scene. For example, if the chroma background shows the angle of view looking downhill on a snowy mountaintop, be sure the subject is at a complementary camera angle.

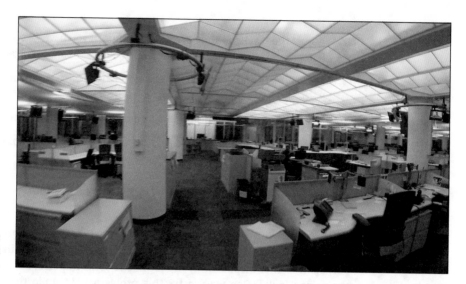

FIGURE 11-18:
An evenly lit
background.

FIGURE 11-19:
The subject
keyed
against the
background.

Putting your green-screen composite together

Here's an example of using a bright-green screen and its effectiveness. After selecting the green-screen image and background you want to key out, you're ready to make magic.

1. **Drag the clip for the background onto the V1 video track on the timeline.**

2. **Drag the green-screen image onto the track above it.**

3. **Adjust the tracks so they are equal in time.** If you have 15 seconds of background, then make sure you have an equal amount of subject.

4. **Go to Effects and navigate to Keying.** Open the bin and go down to the Ultra Key icon. Drag it onto the green-screen clip.

5. **Go to the Effect Controls and find your way down to the Ultra Key.**

6. **Select the Eyedropper tool and click on the green in the clip. The entire color disappears, revealing the background.**

Fine-tuning your key

Sometimes, lighting the green background doesn't evenly expose it edge to edge. At other times, the green reflects off the subject. So, while the image looks keyed out, upon further inspection, you may notice some imperfections, detracting from the "clean look." One way to fix this problem is to undo the key and reselect another area. But more often, it's simply about making adjustments.

There are several ways to address this issue in no specific order.

>> **Adjust the alpha channel:** Go to Output and select Alpha Channel from the pull-down menu to create a mask.

>> **Click on the down arrow of Matte Generation.**

>> **Adjust the transparency:** The subject should be solid white.

>> **Shadows and Highlights** are another choice, but more than likely you will not have to adjust them.

>> **Adjust Tolerance:** This fine-tunes the edges to help the subject stand out more naturally.

>> **Tweak the Pedestal:** This helps with making adjustments to fine details like hair or grass by filtering out noise from the alpha channel. This can improve the key, especially with low light footage.

Layering video

Now that I've established that you can assemble your video edit by placing video clips side by side, or layered atop one another, let's combine those effects. The best example that you've seen repeatedly is a news segment where the reporter

is seen on the video, but then the video changes to another sequence and the reporter is still talking. This is done by overlaying the "talking head video" with the specific content being talked about.

This could be for a few seconds, or for most of the segment. Here's how you do it:

1. **Drag the on-camera segment on the timeline.** Make sure it has enough space for an over-the-shoulder clip, as shown in Figure 11-20.

2. **Determine which parts you want to overlay.** If you want to lead into the second video with dialogue, use markers to show the areas you want to cover.

3. **Drag the video clip you want to use as the overlay**, as shown in Figure 11-21. You can either drag it to the track above or set the playhead on the timeline and drag clip to Program Monitor onto Overlay. You can also click Overlay in the Source Monitor. Not sure see Chapter x

4. **Make sure that the audio tracks beneath the dialogue are targeted**; otherwise, you run the risk of overwriting it.

5. **Select the video track and go to Scale to size it**. Or you can just double-click in the Program Monitor and drag the anchors to size and move the clip, as shown in Figure 11-22.

FIGURE 11-20: Main subject.

FIGURE 11-21:
Over-the-
shoulder
video added,
but it needs
adjustment.

FIGURE 11-22:
Video adjusted
for the scene.

Making clips side-by-side

This classic technique has been used for years, often to show people on the telephone for some reason, but it can also be used to show other situations. For this example, I used 50 percent of each image.

Let's start off simple with two clips. After you find the clips you want to use, you're ready to begin.

1. **Drag the clips into the timeline, and place one above the other, as shown in Figure 11-23.**

2. **Go to the Effects, navigate to Transform ⇨ Crop, and drag the icon to both clips.**

3. **Select the top clip.**

4. **Go to Effect Controls and navigate to Crop.** Adjust the Right and Left. It's a good idea to justify the side where you want the hard edge. As you move the slider, you see a percentage. Once you have the desired edge, say, on the left, go to the Right control and type the difference into the other side so they add up to 50 percent, as shown in Figure 11-24.

As you can see, the half frame occupies an area somewhere in the middle, as shown in Figure 11-25.

5. **Go to Position and drag clip to edge.**

6. **Select the bottom layer clip and reposition it.** Adjust the crop values.

7. **Match it up** by slightly moving the clip as shown in Figure 11-26.

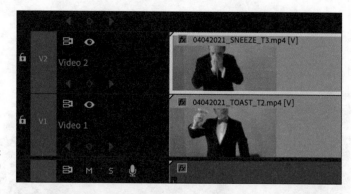

FIGURE 11-23:
Clips stacked in the timeline.

FIGURE 11-24:
Crop settings in Effect Controls add up to 50 percent.

FIGURE 11-25:
Frame sized,
but not moved
into place.

FIGURE 11-26:
Final version.

Chapter **12**

Choosing Cool Effects for Your Movie

You've assembled a rough layout of your movie on the timeline. Now it's time to make things interesting by adding the titular effects. Some of them will wow your audience, some will wow you.

There is another kind of effect nobody notices, and it's a good thing. This is because not all video looks perfect, and sometimes the help it needs goes beyond a color correction. So rather than creating a noticeable effect, some correction tools do the opposite — they prevent your audience from experiencing distracting or unappealing elements.

Understanding Effects

Many effects discussed in this chapter reside deep in the bins of the Video Effects folder. Many of these effects are dragged onto the clip and tweaked through Effect Controls. They are all very different, so let's take a look at some of the most prominent ones.

THE EFFECT CONTROLS PANEL

If this were a romantic comedy, the Effects panel would tell the Effect Controls panel, "You complete me." These two panels, first described in Chapter 1, go together like your flat screen and a remote control. They're separate, but you need them to change the channel, or fine-tune a Premiere Pro effect. Here's a refresher on how they work together. When you apply an effect from the Effects panel, like Lighting Effects or a Gaussian Blur, the Effects Control panel populates with the specific actions for that effect.

Enhancing the look of your video

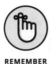

REMEMBER

Nested in the bins of the Video Effects folder are numerous effects that can improve, enhance, or correct your video. And like many of these deeper features, it's hard not to write entire books on what features are at your disposal and what you can do with them.

While those literary projects simmer on the back burner, let's look at a handful of features that can improve your movie.

Improving the scene with Lighting Effects

The key to great video depends on many factors, with effective illumination at the top of the list. That makes the Lighting Effects control one of your best friends. Sometimes you don't have the resources required for a specific lighting technique. Other times you need to enhance the scene or focus on something specific through lighting.

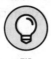

TIP

Lighting Effects is a unique set of features that lets you add some effects in post-production. It acts like a virtual light kit, allowing you to add up to five different lights, much like you would in the physical world. (Though in this case, I'll stick to a single light.) It can solve many problems, and when used sparingly, it can up your visual game.

Here's how you can use Lighting Effects:

1. Open the Video Effects bin and navigate to Adjust. Open the Adjust bin using the down arrow, as shown in Figure 12-1.

2. Navigate to the Lighting Effects icon and drag it onto the chosen clip.

FIGURE 12-1:
Lighting Effects nested in the Adjust bin.

3. Go to Effect Controls and navigate down to Lighting Effects.

4. In the Light Type section, choose the type that offers the spread you would like to use. The default setting is None, but you can also use Directional, Omni, and Spotlight (as shown in Figure 12-2) when the menu is opened. For this example, choose Spotlight.

5. The next choice, Light Color, lets you add a color tint if you want. But let's leave that for now.

FIGURE 12-2:
Pull-down menu showing lighting types.

Controlling Lighting Effects

TECHNICAL STUFF

In the Effect Controls panel, you have access to the Lighting Effects feature, which includes several light sources and a variety of controls. One of the most useful is the little box at the top, circled in Figure 12-3, which allows you to position and center the light, as shown in Figure 12-4. Depending on the light type you've selected, you can tweak the lighting using the following controls:

FIGURE 12-3:
By clicking the circled box, you can center the light by dragging and adjust its scope.

FIGURE 12-4:
Showing the effect in Spotlight mode.

- » **Major Radius:** Adjusts the scope of the light source.

- » **Minor Radius:** Controls the light spread.

- » **Angle:** Adjusts the angle of the light.

- » **Focus:** Controls the focus point of the light.

- » **Intensity:** Adjusts the amount of light. Set it around 10 as a baseline, then adjust Ambient Intensity to create the contrast you need.

- » **Ambience Intensity:** Allows you to alter the intensity outside of the effect. Setting it between 0 and 25 works as a baseline.

Breaking down light types

While the previous example showed the basics, moving forward, let's examine how each lighting type affects the image, and how you can tweak them in post-production almost as if you brought a set of lights to the location. Here's a little about what they do.

TECHNICAL STUFF

- » **None:** This shows the image without any Lighting Effect, as shown in Figure 12-5.

- » **Directional:** This is the most basic choice among the trio. It allows you to control a wide swath of light, as shown in Figure 12-6. This effect is more about tweaking the existing light sources by increasing their intensity or making slight color adjustments to the illumination.

FIGURE 12-5:
Image without any effect.

>> **Spotlight:** If you wanted a spotlight during the shoot, but didn't have one, or you think the scene should have this effect after seeing it during the edit, then this setting can work for you. You can alter the effect by dragging the anchors. The result is shown in Figure 12-7.

>> **Omni:** This effect behaves similarly to the spotlight, but with broader coverage. Omni offers a circular light shape, as shown in Figure 12-8. It has some of the same adjustment tools as the Spotlight effect.

FIGURE 12-6:
Directional lighting effect.

FIGURE 12-7:
Spotlight lighting effect.

FLIPPING THE SWITCH

You can turn effects on and off in Effect Controls by clicking on the *fx* icon in the section where you made the change.

FIGURE 12-8:
Omni lighting
effect.

Scaling video

TIP

Change the space in which the video fills the frame by using the Scale tool. You can make it bigger or smaller to fit your needs. The clip, as shown in Figure 12-9, should be a little tighter. You can fix it by scaling it up, as shown in Figure 12-10. Just remember, the more you scale up, the softer the screen image becomes. But a little boost should be fine for most uses — in other words, it's probably not a good idea if you are doing a feature.

Here's how:

1. Select the clip in the timeline.

2. Go to Effect Controls and navigate to the Motion menu.

3. When you see the Scale control, click the down arrow to display the control, as shown in Figure 12-11.

4. Drag it to the right to increase the size, or to the left to decrease it.

5. If you want to correct the aspect ratio, deselect the Uniform Scale checkbox below; you can then fix a 4:3 clip that is stretched out, or a 16:9 clip that appears squished.

FIGURE 12-9:
Original image.

FIGURE 12-10:
Scaled version.

RESIZING IN THE PROGRAM MONITOR

You can also adjust the scale by double-clicking an image in the Program Monitor and pulling the anchors. Resizing conforms to the aspect ratio, unless you deselect the Uniform Scale checkbox in the Motion menu.

FIGURE 12-11:
Using the Scale control.

Cropping video

TIP

If you're looking for more control with sizing, or changing the format, the Crop tool can work for you. It lets you change the size and aspect ratio of a video clip, and comes in handy when you want to remove a section of the frame or if you're looking to display multiple clips on the same screen, like in split-screen or multiple screens. With a myriad of uses, you can make compelling composites with this tool.

Here's how:

1. In the Video Effects folder, go to Transform ⇨ Crop.

2. Drag the Crop icon onto the clip you want to change.

3. In the Effect Controls panel, navigate down to Crop. Some choices appear for the side of the video clip you want to crop, as shown in Figure 12-12.

4. Click the down arrow on each option, beginning with Left, and drag the slider to adjust each side of the image until you get the result you want.

FIGURE 12-12:
Crop tool.

Making Corrections

Many effects in Premiere Pro do more than make your video look cool; they also help it to look better. Sometimes there's a fine line between the cosmetic and correction. The following techniques can either improve the look of your movie or help effectively make your point.

Dealing with shaky footage

Unless you had your camera out during an earthquake or on the front car of a rollercoaster, there's no excuse for shaky footage. It's too late for the "I told you so" response about keeping your camera steady and not making the shot look like you were standing in a rowboat. True, you could have used some form of stabilization, like a gimbal to counteract movement, a tripod to keep the camera steady, or using other forms of stabilization (or maybe ordering a smaller-sized latte). It's too late now, though; you're stuck with some shaky footage, and you need to edit it. No problem. You can rest easy because there are some tools to make it right. Enter your new best friend, the Warp Stabilization tool. Remember, a video with smooth shots will work in your favor.

Understanding Warp Stabilization

TIP

Your shaky footage can become. . .less shaky at the least, and steady at best. This sophisticated function can save the day by eliminating camera motion, jitter, and overall unwanted motion.

Here's how to use it:

1. Go the Effects panel and navigate to Video Effects, open the folder, and scroll down to Distort.

2. Double-click Distort and choose Warp Stabilizer. You can also just search for Warp Stabilizer, but now you know where it resides.

3. Select the shaky clip or clips and drag the Warp Stabilizer icon onto them.

4. Go to the Effects panel, and scroll to Warp Stabilizer. You see the feature is already analyzing the scene in the Program Monitor, as shown in Figure 12-13.

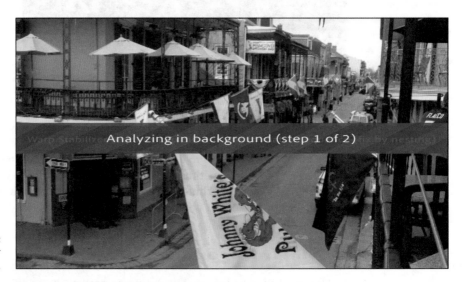

Analyzing in background (step 1 of 2)

FIGURE 12-13:
Warp Stabilizer in action.

Warp Stabilization settings

REMEMBER

The default setting can improve an unsteady shot, but does that mean it's the best setting? Well, it's not the best choice for every situation. If history has taught us anything, it's true that the average setting will lead to average results. That's because one size does not always fit all. But more precise settings can expand the scope of correction, leading to a more refined and — more importantly — more natural-looking image.

Here are some tips.

>> **Only change what you have to:** Depending on factors like the length of the clip, its size, and the speed of your computer, stabilizing your clips can take an extended period. It's certainly worth the wait when it comes to stabilizing a shaky scene. But not every clip needs stabilization from start to finish, and applying it will just cause you to wait longer. Instead, segment the shaky portion, and apply the effect to it.

>> **Make a settings choice:** In the Result section of the controls, there are two choices: Smooth Motion and No Motion. The former is a default setting and is ideal for smoothing over hand-held footage. The latter makes the content smoother, as if it were shot on a tripod.

WARNING

>> **Look at this key setting:** Here's a situation where the default setting doesn't offer the best look. Setting the Smoothness option at 50 percent (as shown in Figure 12-14) can lead to a wonky look for your footage because it's too extreme. A setting of 20 to 25 percent is more than adequate for creating smooth movement without it appearing over-corrected.

>> **Save your changes:** When you find a setting combination that works for you, you can save it as a preset. Just right-click on the Stabilization heading to bring up the pop-up menu. Choose preset and name it. Now whenever you need it, you can just select and apply it.

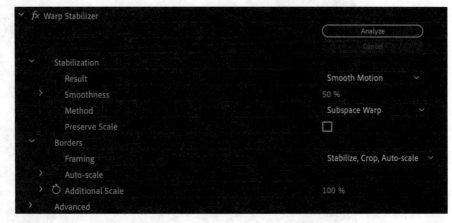

FIGURE 12-14:
Warp Stabilizer settings.

Blurring video

TIP

Depending on your needs, you can blur a clip for effect by using the Blur and Sharpen tool. That begs the question: If the goal for footage is crisp and sharp, why do you need to blur it? Good question. And there are quite a few reasons. There are times when it makes a good effect. For example, the perspective of someone who broke their eyeglasses, or a dreamlike situation. But often it's to affect the layer for a composite. Another technique involves blurring the image and placing another partial clip over it. This is sometimes done on television news when they show old footage with a different aspect ratio, vertical smartphone video, or a still image.

Using Blur under a still image

TIP

To make a vertical still image look interesting on a wide screen despite the empty space it shows on the sides, this technique lets you fill the screen while showing a full version of the vertical image, as shown in Figure 12-15.

CINÉMA VÉRITÉ

Cinéma vérité refers to a documentary style of filmmaking that uses an immersive approach that finds the story while shooting it, as opposed to it being planned or scripted. Evident in many of the shots is the motion from handholding the camera, yet it seems intentional, thus making the viewer feel like they're present in the middle of the action. Sloppy camera movement does the opposite and can make the viewer queasy.

FIGURE 12-15: Now the entire frame is filled without having to change the orientation of the vertical image.

Here's how you do it:

1. Find a video that has some motion, and drag it onto the timeline.
2. Open the Video Effects bin and navigate to Blur and Sharpness. Double-click to open or use the down arrow to see options.
3. Scroll down and select Gaussian Blur.
4. Drag the icon onto the clip.
5. In the Effect Controls panel, navigate to the Gaussian Blur section.
6. Click on the arrow to open Blurriness, and drag the slider to the right until you see the desired level of blur. Try to make the subject indistinguishable.
7. Once satisfied, drag the vertical video or still frame to the layer above it.
8. Drag its edges to increase it to the desired length.
9. Play it back.

Making video sharper

TIP

Making the video sharper seems more helpful, as opposed to going the other way. Sometimes you're just going to have video footage that leans to the "soft side," which is a nice way to say the focus is slightly off. Not blurry, but still not sharp enough. Sharpening video does not actually put soft video in focus. All it does is enhance edge detail, which gives the illusion of sharpness. Other situations may have you opt for the effect of increased sharpness. Whatever the reason, fixing sharpness in Premiere Pro is simple.

Here's how you can do it:

1. Open the Video Effects bin and navigate to Blur and Sharpness. Open or use the down arrow.

2. Scroll down and select Unsharp Mask.

3. Drag the icon onto the chosen clip.

4. In the Effect Controls panel, navigate to the Unsharp Mask section.

5. Click on the arrow to open Amount, and drag the slider to the right until you see the desired level of blur. You can also adjust Radius and Threshold.

Creating a mosaic

TIP

More a coverup than an effect, the mosaic remains a popular choice when it comes to hiding someone's identity or some salacious part of them. It behaves like a blur, but uses the color palette of the scene, so it seems natural. Mosaic is a device for covering up something in the scene — like someone's identity, or a product name you don't want to share — especially when controlled with a mask and keyframes to follow the action. That allows the effect to stay in place as the subject moves through the frame. Of course, you can also use it as a transition.

One great use for this feature is to block sensitive information or nudity. Let's examine how to use the Mosaic effect as a mask to cover someone's face.

1. In the Video Effects folder, go to Stylize ⟡ Mosaic.

2. Drag the Mosaic icon on the clip you want to change.

3. In the Effect Controls Panel, navigate down to Mosaic. You will see something to control the size of the horizontal and vertical blocks that make it up.

4. Choose the Mask tool and confine the mosaic within it, as shown in Figure 12-16, by pushing and dragging the points.

5. For moving subjects, add keyframes (discussed in Chapter 11).

COVERING UP PRODUCT NAMES

Sometimes brand names are included as an insidious form of advertising called *product placement*. Many productions earn revenue form this practice, so unless free advertising is your thing, it's best to limit what products you prominently show. It's not always possible, or practical to do this, so use your discretion.

FIGURE 12-16:
The Mosaic effect used to hide the subject's face.

Removing effects

REMEMBER

Sometimes you may apply numerous changes and effects to a particular clip, only to feel a bit of buyer's remorse. Premiere Pro makes it easy to revert to the original version, or perhaps just shave off a few unwanted changes.

Here's how you can fix it:

1. Right-click on the clip.

2. At the top of the menu, choose Remove Attributes. When the window pops up, you can deselect the attributes you no longer want, as shown in Figure 12-17.

3. Click OK.

Adding a timecode

The timecode is primarily used as a tool for editors to reference key parts of an edit for effects, changes, or to share instructions with other team members. These numbers, usually on the bottom of the frame, count either frames or SMPTE (Society of Motion Picture and Television Engineers) timecode, as shown in Figure 12-18.

Here's how to add a timecode:

1. In Effects, go to Video ➪ Timecode.

2. Drag the icon onto the clip.

3. Make adjustments, if necessary, to how you want to present the format, which can show frames, SMPTE, or measurement in feet, as in film footage.

4. Determine the Timecode Source: Clip, which shows information about the clip; or Media, which shows the entire sequence.

5. Choose the Time Display, which refers to the frame rate at which the video was captured.

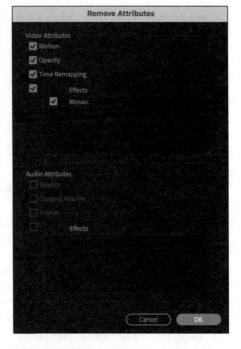

FIGURE 12-17:
Remove Attributes dialog.

FIGURE 12-18:
Timecode in video.

Playing with Your Clips

REMEMBER

Sometimes creativity comes from playing with functions and features that you had no intention of using. Call it practice or therapeutic or maybe some version of personal research and development, but it can make you more comfortable with Premiere Pro. Maybe it can even relieve stress, even if it doesn't lead to any tangible use. But then one day it does, and you now have a cool feature that helps you to tell your story visually.

Flipping video

TIP

You may wonder what reason anyone would have for turning their movie upside down. Then a lightbulb goes off over your head, and you realize that the opposite orientation can have its place. Maybe it's the perspective of a subject being held upside down. That certainly could warrant it. Another scenario would be when you accidentally change a setting, and the video records upside down. Maybe you were upside down when you were shooting. Or maybe you want to fix a scene shot in a mirror. Whatever happens doesn't matter if the camera was not right-side up, as shown in Figure 12-19. All that matters is that these situations are easily adjusted with a few simple actions in Premiere Pro.

FIGURE 12-19:
Upside-down video: Intentional or accidental?

Here's how to change the orientation:

1. Go to Effects, and navigate to Transform ⇨ Flip.

2. Click on the Vertical Flip.

3. Drag it onto the desired clip.

Changing speeds

TIP

Altering the speed of your clips provides another way to make things interesting, whether it's slowing down the universe with a slow-motion effect, speeding things up with fast motion, or emulating the chaos of time-lapse. Premiere Pro makes it easy to accomplish these changes to the space-time continuum in post-production with relative ease.

Slowing down the action

Whether slowing down the action to examine details missed at normal speed or just trying to create a cool effect, there are times when using slow motion can help get your point across. Just right-click on the desired clip, and choose Speed/Duration from the pop-up menu. Change to 50 percent to halve the speed, or whatever works for you. The lower you go, the slower it gets. A good measure is picking a percentage that divides equally into 200 for the smoothest playback.

Speeding up the action

TIP

Speeding things up is just as simple. This technique uses the same approach. Just right-click on the clip, choose Speed/Duration, and change the speed to 200 percent to double it. Go even higher to make things move even faster.

REMEMBER THE FOUR-POINT EDIT

As mentioned in Chapter 8, you can also change clip speed by using the four-point edit technique by fitting a clip into a timeline gap that stretches or contracts the time remapping.

Time lapsing your video

TIP

This technique speeds up your video, but instead of just making normal video faster, it covers a much wider swath of time, creating an effect that resembles still frames that capture action every 30 seconds (this could be shorter or much longer) played at a regular video rate, resulting in a chaotic sequence. It's like fast motion on steroids with a large latté and an energy drink on the side.

1. Go to Effects and navigate to Time.

2. Click the down arrow and select Posterize Time.

3. Drag it onto the clip.

4. In Effect Controls, go to Posterize Time.

5. Change the frame rate. If the original footage was shot at 29.97 frames per second, by selecting 1, you're speeding it up 30 times, as shown in Figure 12-20.

FIGURE 12-20:
Posterize Time
settings.

Trying Turbulent Displace

If, for some reason, it's a trippy kind of effect you're looking for to depict an idea, then this could be the filter for you. Turbulent Displace creates liquid-like distortions that move with the actions, making your video both trippy and drippy, as shown in Figure 12-21.

Here's how to use it:

1. Go to Effects and navigate to Distort.

2. Click the down arrow to access the Turbulent Displace icon.

3. Drag it onto the clip.

4. In Effect Controls, go to Turbulent Displace.

5. Displacement defaults to Turbulent, but you can choose other effects, including Bulge, Twist, and Cross Displacement.

6. While the default settings work for many situations, you can try the following for a zanier look.

- Amount: 100

- Size: 100

- Complexity: 2.0

- Evolution: 8.0

FIGURE 12-21:
Turbulent
Displace using
the Turbulent
effect.

Chapter **13**

Working with Audio

This just in from the Department of the Obvious: It's no secret that without sound, video has little impact. Let's take that a step further. The better your movie sounds, the better it looks. Need more confirmation on that one? Have you ever watched *Die Hard* during the holidays, especially with a great sound system? Or any other action movie, concert film, or musical, for that matter? Then you know it's a multisensory experience.

That's no accident; getting it that way was quite intentional. Sound editing is as important as putting the video together. So where do you start? It begins with recording pristine sound in the first place, and then massaging it in post-production. When done effectively, great audio makes the entire project feel like an experience. Maybe it's because the eyes get happier when the ears are content. Maybe it's because sound and action go together like yin and yang. Whatever the reason, Premiere Pro provides ample tools to record, edit, and enhance the audio portion of your movie.

Understanding Your Audio Needs

Good audio helps convey the content of your movie More appropriately, it's grasping its content within your movie. The term *cinematic* doesn't just conjure up strong silent visuals. Yeah, they get all the attention. And why not? The word

cinema translates to the art or technique of making motion pictures. But as it turns out, for the experience to work, at least since 1929, the audience needs to hear what's happening to inform what they're seeing. Sound recording and editing becomes a huge part of the process. How big? Most movie and television productions capture sound separately, and not just capture, but also enhance it in post-production. You could even use some royalty-free music, or perhaps create your own with an audio program like GarageBand. Then there's the score, where a composer writes a piece of music that fits the project. A good score does more than add some serious swagger to your movie; it becomes a part of its DNA.

Sound matters

REMEMBER

When you think of the best movies, it's not just that they have good sound, it's that they have great sound. Isn't this the reason why you bought that sound bar or splurged on that Dolby 6.1 sound system in the first place? It's hard to deny that the experience of watching the aforementioned *Die Hard* or the visually and musically stunning *Sweeney Todd* improves when listening on a great audio system. A mere few notes can easily identify the movie. *Star Wars*, *The Pink Panther*, and *Raiders of the Lost Ark* are among the most well-known scores.

While the score is important, it's not the only measure of good sound. The other important aspect, though insidious, has arguably more impact, and that's the stuff that you don't always take into consideration. This is the audio — whether the levels are off, the sound is distorted, or there are annoying background noises. If they're not fixed, those problems are far more noticeable than a hummable soundtrack.

Defining great sound

Even when you take the necessary steps to capture great audio, you still have a long way to go when it comes to post-production, and the responsibility carries over as you put it all together in Premiere Pro.

This can be somewhat subjective because there are so many levels of great audio. For example, an audiophile's definition may allude to aspects that the average person cares little about, while many people believe an MP3 sounds good. Let's push that aside and talk about all the aspects that would make great audio.

Consider the following.

>> **Watch those levels:** When editing in Premiere Pro, keep an eye on the audio meters. They will let you know when your sound is where it should be, or where it should not be. It's good practice that speaking levels reside in the –12 decibel range, as shown in Figure 13-1. Any higher, and the sound will clip, in another words, be distorted beyond repair; any lower, and it will not be dynamic enough.

>> **Adjust ambient sound:** Audio levels for ambient and background naturally produce a lower sound, at least most of the time. So, raising ambient sound to the same level as dialogue, or not bringing it down when it's captured too high, creates an unnatural soundscape. Instead, ambient sound should not exceed –18 decibels.

REMEMBER

>> **Make sure levels play nice with each other:** Dialogue, performance, and ambient sound all have their range, but when they are positioned next to each other, they should sound natural. In other words, audio levels should match each other. There's nothing worse than one voice being too low or too loud when compared to another. As Yoda would say, "Adjust, you must."

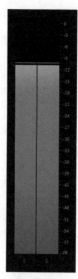

FIGURE 13-1: Dialogue levels hovering around –12 decibels.

Adjusting audio levels

It's rare for audio levels, as recorded, not to require some tweaking. Premiere Pro provides numerous methods to take care of this issue.

Here are some of the ways you can change audio levels.

TIP

>> **Move to the rubber band in the audio track:** It's the line halfway down the audio track, as shown in Figure 13-2. This is the easiest adjustment to make, and it's great for a quick fix. Making precise adjustments from track to track is not always easy and can be cumbersome.

FIGURE 13-2:
Rubber band in the audio track.

>> **Audio Mixer:** Resembling a virtual version of the studio mixing board, the Audio Mixer provides a great deal of control over the overall sound of the project. See Chapter 3 for more details.

>> **Clip Mixer:** This provides control over the clip, as if you were using the rubber band feature, though much more accurately.

>> **Pen tool:** Back to working with the audio track in the timeline, this Toolbox tool, circled in Figure 13-3, lets you make keyframes in the audio track and shapes the sound as you raise or lower them.

Mixing audio

The key to making your video sound just right lies in the audio mix. This involves adjusting the volume levels to maintain proper sound and making sure the other audio channels proportionately match it.

FIGURE 13-3:
Pen tool in the Toolbox.

Get those levels right

First things first. Let's start with getting the sound within range. Make sure the audio meters are prominently displayed. That's how you'll know if levels are too high or low.

If that's the case, here's what you can do.

TIP

>> **Fix it on the timeline:** Mouse over the line, also known as the rubber band, and pull it down to lower the volume, or bring it up to increase it.

>> **Use the Audio Mixer:** Go to the Audio Mixer, and adjust levels based on the entire track.

>> **Adjust individual clips:** The Clip Mixer lets you fix specific tracks. Find out more about it in Chapter 3.

Consider the following when adjusting volume levels.

WARNING

» **Keep audio levels from peaking:** When levels are too high, clipping can occur. That's a tap-like distortion. Make sure levels are within range on every track to avoid this problem.

» **Use Gain:** Right-click on the clip and select Audio Gain, as shown in Figure 13-4. Change the numerical value. Remember, a level of 0.0 decibels is the original volume. Changing the level to a negative number reduces the volume, and changing the level to a positive number increases it.

Audio Gain
○ Set Gain to: 0 dB **OK**
● Adjust Gain by: 0 dB Cancel
○ Normalize Max Peak to: 0 dB
○ Normalize All Peaks to: 0 dB
Peak Amplitude: -4.9 dB

FIGURE 13-4:
Audio Gain dialog.

» **Make keyframes:** Sometimes the volume level differs on the same clip, with one part too loud, and the other too low. After setting keyframes, you can raise and lower the volume level by dragging them.

Simplifying varying audio levels

Some clips have a weird balance that is both too low and too loud. And while there are so many techniques to name, here's a simple way to fix it.

Here's how you can fix varying audio levels

1. In the Effects Panel, go to Audio Effects, and navigate to Hard Limiter. You can just type it in the search field, as seen in Figure 13-5.

2. Go to Effect Controls and navigate to the Hard Limiter section shown in Figure 13-6. Click on the Edit button. The Clip FX Editor will pop up.

3. In the Maximum Amplitude slider, change the -0.1 db level to -12. As shown in Figure 13-7.

4. This will balance the levels in the clip. You can copy and paste attributes to other clips by right clicking on desired clips in the timeline, and going to Paste Attributes, and make sure the Hard Limiter box is checked.

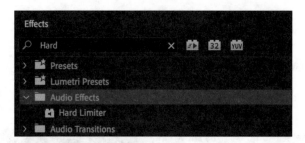

FIGURE 13-5:
Search for the
Hard Limiter in
Effects.

FIGURE 13-6:
Click the Edit
button in Effect
Controls.

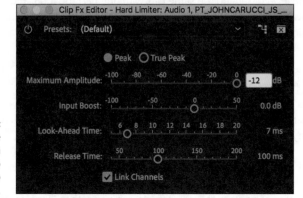

FIGURE 13-7:
Adjusting the
Maximum
Amplitude to
-12 dB in Clip
FX Editor.

Beginning with Recording the Audio

Regardless of the tools available in Premiere Pro for fixing audio-related issues, there's no substitute for honoring the symbiotic relationship between audio and video recording. It all begins with capturing audio on the scene using best practices. Even under the best of circumstances, your edit will require some audio work. Think of it as someone who takes good care of their teeth. They still need to go to the dentist, but the visits will go more smoothly than for those who ignore their oral care.

Considerations for capturing audio

REMEMBER

While it's unavoidable when shooting your video, recording sound on location can give you nightmares. I'm not saying it's rough, but if you had to pick a movie title that describes capturing sound on location, *The Good, the Bad, and the Ugly* makes for a fitting one. At the granular level, great audio capture begins with being cognizant of ambient noise on the scene. But even the most careful preparation can lead to problematic issues like unwanted background noise.

Dilemmas aside, location shooting does add to the movie's realism. It's certainly more interesting than shooting in a studio or on a soundstage. On the downside, you'll have to contend with a host of problems, including competing sounds. But you can't pick and choose the ones you want; some natural sounds work well with the movie, like passing traffic, while other situations require sophisticated measures to remove, like blaring horns, loud voices, or the whirr of an emergency vehicle. This can make you want to pull your hair out (disregard if said hair is no longer present, and sorry for bringing it up). It's best to try to work around these problematic sounds by continuing to shoot around them.

While the pros deal with the same issues, they take some extra steps to control sound. For one, they capture audio separately. You can, too — see Chapter 2 for more info. They also re-record in post-production for optimal audio, otherwise known as Automated Dialogue Replacement, or ADR (see Chapters 2 and 6 for more info). Thankfully, many of these problems are easily fixed with standard audio tools found in Premiere Pro, especially the ones found in Essential Sound. But for now, let's look at the audio tracks, and what adjustments we can make.

Be aware of sound on the scene

REMEMBER

The symbiotic relationship between audio and video quality remains nothing more than a concept unless you take the proper steps, and in this case, it involves audio capture. Sometimes it's as simple as being aware of ambient noise on the scene and shooting around it. Other times you may consider using a specific microphone technique. For example, some situations require a directional microphone, while others benefit from a shotgun microphone (also known as the interference-type line microphone). Sometimes plugging a cable between the camera and a soundboard at an event can best reproduce the most clarity. Whatever the technique, perfect sound recording puts the cherry on the cake — or whatever your dessert of choice.

Here are some aspects to consider:

Consider the following when you're adjusting volume levels.

TIP

>> **Keep audio levels from peaking:** When levels are too high, clipping can occur. That's a tap-like distortion you cannot correct. Make sure levels are within range on every track to avoid this problem.

>> **Trust your ears:** Aside from holding sunglasses on your head, they're great for picking up sounds, lots of different ones! Take a second and listen before hitting Record. It will pay off.

>> **Don't try to capture dialogue from a distance:** Unless the subject is close to the camera, you're going to pick up every sound between the camera and the subject. Sound quality will still be usable, but doubtfully optimal. Instead, use a shotgun microphone or a wireless model closer to the subject.

>> **Get close to the subject:** There's no way to overstate this advice because the closer the subject is to the microphone, the more clearly their voice will record, and the voice recording will rise above competing environmental noises.

WARNING

>> **Be cautious in noisy locations:** Regardless of how good the setting is, the microphone picks up everything. That means a little of the stuff you want, along with a lot of what you don't need. Airports, train stations, and high-traffic environments, as shown in Figure 13-8, are a few examples that look great in films but are nightmarish to capture.

FIGURE 13-8:
Shooting on a
busy street.

>> **Use a shotgun microphone:** This works best for ambient sound, making it ideal for picking up natural sound in the scene. Some examples are automotive traffic, the whoosh a babbling brook, and the rhythmic tones of an assembly line. These microphones also work well with talking heads, but only when close enough to the camera — say, four to seven feet.

>> **Make sure levels are not too high:** There's no sense in capturing audio if it's going to clip, meaning that levels are so high that everything becomes irreversibly distorted.

Working with Audio in Your Movie

Maybe you drink orange juice, and hopefully you brush your teeth. But it's doubtful you would do one after the other, and if you did, you would not find the combination appealing. The same can apply to video clips.

REMEMBER

Individual clips may sound good, but when they are played together, you may find they don't go together as well as you thought. Maybe the levels don't match, there are extraneous noises that don't flatter the edit, or the sound isn't clean because the camera microphone picked up natural sound on channel 2. This can create a distraction. Thankfully, these issues and more are easily correctible in Premiere Pro.

Linking and unlinking tracks

When you bring video into your timeline, it usually consists of two tracks that move together as a unit. Sometimes, the stereo will reside on one track, other times with older formats may only include a monaural single track, while others will include two channels of stereo audio on a single track of stereo. (More on that in the next section.)

REMEMBER

Anyway, your video and audio tracks are connected and synchronized, and that's a good thing. Otherwise, if you're not careful, your video will look like a badly dubbed movie. In other words, the video will not match the audio. But sometimes, you may want to intentionally separate the video from the audio.

After double-clicking the clip, select an In and Out point in the Source Monitor. At this point, you can drag the complete clip onto the timeline (video and audio) or just one of them.

To drag only video, click on the Drag Video Only button, the first one circled in Figure 13-9. To drag only audio, click on the Drag Audio Only button, the second one circled in the figure.

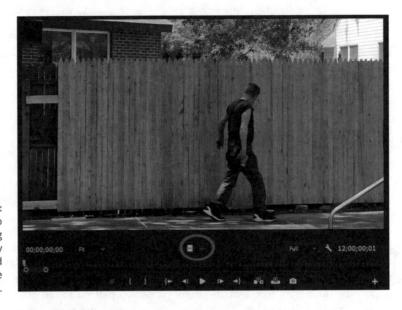

FIGURE 13-9:
The Drag Video
Only and Drag
Audio Only
buttons circled
in the Source
Monitor.

Unlinking a track

TIP

If you already have the full track in the timeline and want to unlink the video and audio tracks, it's pretty simple.

Here's how:

1. Select the clip on the timeline to unlink.

2. Go to Clip ⇨ Unlink, or right-click on the clip, and choose Unlink from the pop-up menu.

 The video and audio tracks are now separate and can be moved independently.

Re-linking clips

Unlinked clips can be linked again. Just remember to select them as a group first.

TIP

Here's how:

1. Make sure the clip elements on the timeline are selected.

2. Go to Clip ➪ Link, or right-click on the clip, and choose Link from the pop-up menu.

 The video and audio tracks are now together and can be moved as a single entity.

Working with separate tracks

TIP

Stereo tracks may contain two separate channels, but some reside on a single track when you drag them into Premiere Pro, as shown in Figure 13-10. In most cases it's not a problem, but there are situations where you may want to change the levels in one channel without affecting the others — for example, if you're using the camera microphone to pick up natural sound and a directional microphone for an interview. Because you may want to reduce the audio level of one of the tracks, likely the camera microphone, you need to create separate tracks.

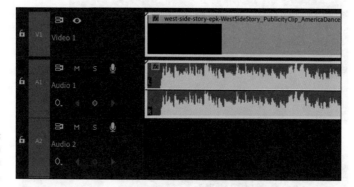

FIGURE 13-10: Clip with stereo on a single track.

You can't fix this problem in the timeline. So, if you dragged the audio in, it's time to get rid of it, and start over.

Here's how you can create two editable tracks:

1. In the project bin, right-click on the clip. In the pop-up menu, go to Audio Channels.

2. In the Modify Clip dialog, go to Clip Channel format and change it to Mono.

3. Change the number of Audio Clips to 2.

4. In the Media Source Channel, shown in Figure 13-11, make sure that you select the other channel in the second track.

5. Click OK. You now see two audio channels, as shown in Figure 13-12. Now you can adjust each channel separately.

FIGURE 13-11:
The Modify
Clip dialog.

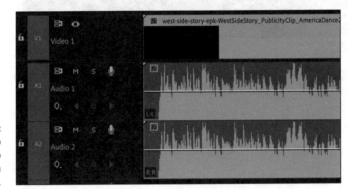

FIGURE 13-12:
The clip
showing audio
channels on
separate tracks.

Navigating the Essential Sound Panel

REMEMBER

Up until now, making minor audio adjustments through the mixers or by changing track levels on the timeline has served your needs in a limited way. But using the Essential Sound panel (shown in Figure 13-13) puts you in a new bracket. If this panel were a hat store, you would walk out with a bunch of them, including one prominently displaying "Audio Engineer." It warrants the title because it reimagines the complexity of mixing various types of audio into an intuitive set of game-changing tools, comparable to the invention of autofocus for cameras or number-crunching with your favorite spreadsheet.

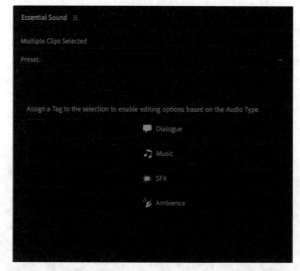

FIGURE 13-13:
Essential
Sound panel.

This tool can accurately balance various audio types throughout your entire movie, including dialogue, natural sound, music, and other elements, using a few keystrokes or actions. You can find this unique feature by going to Window ⇨ Workspace ⇨ Audio.

Using the Essential Sound panel

REMEMBER

Residing on the right side of the workspace, this all-in-one panel provides a central location for your audio needs, including a broad collection of mixing techniques and repair options, making it useful for audio-mixing tasks. It's divided into four basic groups, so you can classify your audio clips using these preset options: Dialogue, Music, SFX, and Ambience. When you assign a set of selected clips, you can carry out adjustments associated with each group, such as unifying the different recordings to common levels, reducing background noise, and adding compression or equalization (EQ). But that doesn't mean you're limited

to using only these controls. Think of the Essential Sound panel as the place for mixing you clips, then use the Audio Track Mixer to fine-tune.

After making primary edits, you can apply finishing touches using traditional methods. For example, if your clip contains dialogue, you can use the options under the Dialogue tab in the Essential Sound panel to repair the sound by reducing noise, rumble, hum, and "ess" sounds, as well as making a variety of other adjustments.

Working with audio tracks in the Essential Sound panel

TIP

When you add tracks to the timeline, depending on the type of track, it will have its own color label generated by Premiere Pro. For example, camera tracks are blue, video tracks are green, still photos are pink, and so on, as shown in Figure 13-14. You can change the colors by going to Premiere Pro ⇨ Preferences ⇨ Labels. In this panel, you can assign these tracks so that you make corrections to each type of audio track.

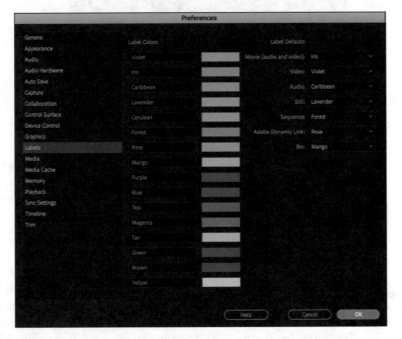

FIGURE 13-14:
Audio tracks differentiated by color.

Organization is key

REMEMBER

Because your audio components will have different purposes, it's a good idea to classify your audio clips for each type, as previously mentioned. After assigning an audio type, the Essential Sound panel presents you with several parameter groups to perform common tasks, such as reducing background noise, and adding compression and EQ. Here are the tags you can use to organize your audio clips.

>> **Dialogue:** The speaking parts from your talking heads.

>> **Music:** The soundtrack and/or music pieces that you include.

>> **SFX:** Whatever audio enhancements you add to the edit.

>> **Ambience:** The cutaways, setups, and other sound elements in the scene.

Assigning audio track roles

REMEMBER

After you lay out your movie on the timeline — and that encompasses everything, including sound effects and music — the tools in the Essential Sound panel can quickly balance different types of audio. First, you must define each type of sound you're using in the movie. Select the clips and click on the appropriate button. Now when you apply an action, it will apply to all of the selected tracks.

Delving into the Dialogue presets

REMEMBER

Dialogue presets allow you carry out common tasks on a group of clips, and chances are that you will end up using these presets the most. And why not — people speaking in a scene, being interviewed, or narrating the action can make up a big chunk of your movie.

RESETTING THE AUDIO TOOLS

After you select the checkbox for the group you're working on, the tools populate the panel. If you want to go to a different panel, go to the upper-right corner and click the Clear Audio Type button.

Let's explore what the actions under this tab can do. After clicking on a set of clips that you want to enhance, click on the Dialogue checkbox in the Essential Sound panel. The panel populates with controls and sub-menus related to this option, as shown in Figure 13-15.

Here's what they do.

>> **Preset:** This section lets you apply presets that either ensure consistency or create the illusion of sound coming from a specific situation or source, as shown in Figure 13-16.

>> **Loudness:** Clicking on this button shows the Auto-Match control. This feature automatically adjusts the levels of each clip so that they all sound the same.

>> **Repair:** Click on this button, and you have an array of tools that let you make basic corrections to noise, esses, EQ, and other factors that can influence the sound of your movie.

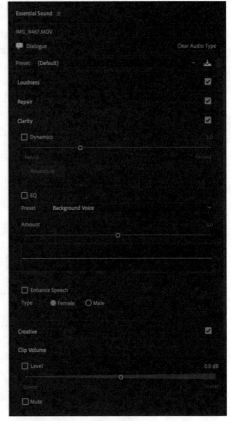

FIGURE 13-15:
The Dialogue options.

>> **Clarity:** With a wide range of factors that can influence audio, these controls help balance the fluctuations in the frequency and volume of the human voice, along with other issues that determine the clarity of the track.

>> **Creative:** This feature lets you set a reverb effect using a variety of preset options that can provide your movie with a sense of presence.

>> **Clip Volume:** These settings allow you to mute the track or adjust levels via the slider.

CLARITY CONTROLS

Here's what the Clarity controls allow you to adjust.

- **Dynamics:** Expands or compresses the dynamic range from natural to focused.

- **EQ:** Reduces or boosts different frequencies in your recording through various presets, including background, outside, on the telephone, and so on.

- **Enhance Speech:** Allows you to adjust human voices by changing frequencies.

- **Creative:** Provides presets for the environment where the dialogue takes place, such as in a church, outside, in a small room, and so on.

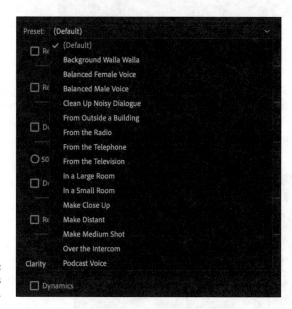

FIGURE 13-16: Preset options for dialogue.

Looking into the Music option

TIP

Similar to the Dialogue option, the Music option offers similar control when it comes to balancing the loudness of a track. But it has another unique function: *ducking*, as in ducking the audio. Some terms are misleading, and this one certainly qualifies, as it can be misconstrued as trying to avoid or dodge (duck) audio. But that's not what it means. Instead, this function allows you to alter the levels of the music track when other tracks are playing. So, when you have the clips laid out on the timeline, and then click Generate Keyframes, as shown in Figure 13-17, this feature automatically creates keyframes that decrease the music levels so that

the foreground sounds like dialogue are prominent, because you want the music levels to go down when people are speaking.

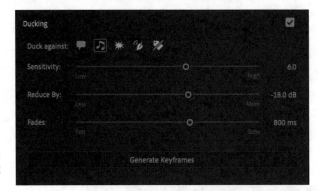

FIGURE 13-17:
Auto-ducking feature.

Effecting the SFX track

TIP

If Premiere Pro lets you create artificial sound effects for your audio, SFX helps you create illusions such as the music originating from a particular position in the stereo field, or an ambience of a room or field with appropriate reflections and reverberation as shown in Figure 13-18.

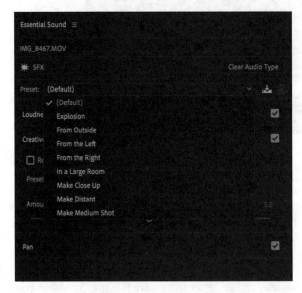

FIGURE 13-18:
SFX presets.

To add SFX to your audio:

1. Add the effects clip to the timeline.

2. Select the clip and click on SFX in the Essential Sound panel.

3. Adjust the Reverb effect by choosing the Reverb checkbox under Creative.

4. Select a Reverb preset that works for you.

Adjusting Ambience

TIP

As its name implies, this set of tools helps to deal with natural sound and the background noises of a scene. This function lets you exaggerate, de-emphasize, or fabricate the echo and reverberation of various spaces, as shown in the pull-down menu in Figure 13-19, and the Creative menu choices in Figure 13-20.

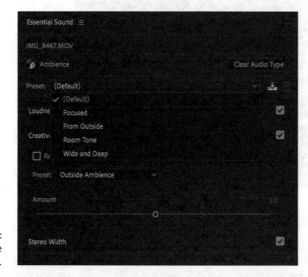

FIGURE 13-19: Ambience presets.

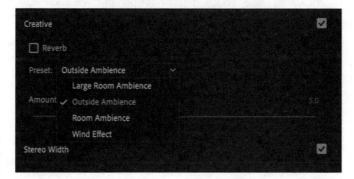

FIGURE 13-20: Creative menu choices.

Making voices sound better

TIP

Making sure the dialogue audio is just right is a necessary part of the editing process. Unfortunately, sometimes audio capture is inconsistent with each clip. Sometimes the audio levels of people speaking range in volume, but more often there are issues with noises and hisses. Under the Repair tab, shown in Figure 13-21 (it's located in the Dialogue option on the Essential Sound panel), are a variety of tools to correct audio issues.

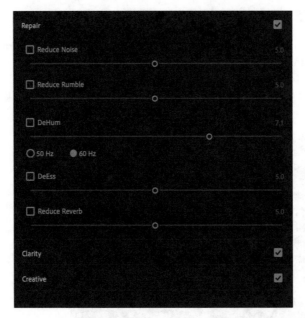

FIGURE 13-21:
Repair tab.

Here are what the Repair controls do.

>> **Reduce Noise:** Reduces the level of unwanted noise in the background, such as clicks, studio floor sounds, and microphone background noise. The proper amount of noise reduction depends upon the type of background noise and the acceptable loss in quality for the remaining signal.

>> **Reduce Rumble:** Reduces the rumble noise, which is a very low-frequency noise that ranges below the 80-hertz range — for example, noise produced by a turntable motor or an action camera.

TECHNICAL
STUFF

» **DeHum:** Reduces or eliminates hum — noise that consists of a single frequency, in the 50-hertz range (common in Europe, Asia, and Africa) or 60-hertz range (common in North and South America). For example, electrical interference due to power cables laid too close to the audio cables can cause such noise. You can select the hum level depending on the clip.

» **DeEss:** Reduces harsh, high-frequency ess-like sounds, including sibilance in vocal recordings that cause s-sounds created by breathing or air movement between the microphone and the singer's mouth.

» **Reduce Reverb:** Reduces or removes the reverb from audio recordings. This option allows you to use original recordings from various sources and make them sound like they're coming from the same environment.

Chapter **14**

Dazzling with Titles and Graphics

I n the early, silent days of cinema, title cards were essential for communicating the onscreen action. Even when sound arrived and the movies began to talk, words still filled the screen with information, like credits, graphics, lower thirds (the title in the bottom of the frame that names the person speaking), and, of course, more titles. So, when it comes to making your movie, adding words can enhance the storytelling aspect by informing the audience about everything, from setting up the scene, to providing cues throughout the entire movie, and of course, the opening and closing credits.

Premiere Pro offers fantastic graphic capability when it comes to creating titles and motion graphics that spice up your edit. Not convinced? Try watching a movie without any titles. You may inevitably draw the conclusion that there's some unfinished business going on. Conversely, when you think about how movies and television shows use text, it's hard to imagine not waiting for a movie title or the ending credits to pop up.

New segments and documentaries are another place where onscreen titles are essential. How else would you be able to identify the talking heads without the obligatory lower third (see the section, "Adding static titles," later in this chapter)? Then there are the locations and timeframes of the scene. So, when you think about it, it's hard to imagine an edit being complete without these valuable assets.

Understanding Titles and Motion Graphics

REMEMBER

Though title cards, or any other words onscreen for that matter, are no longer the only way of communicating with the audience, they can still pack a punch with your movie. Premiere Pro changed the game with the addition of advanced graphics that you can drag and drop on the timeline, and they look like you made them in After Effects. Now, they've taken it a step further with the Essential Graphics panel. Here, you'll find a wide range of graphics and the tools to help you position words onscreen, add motion, and customize your message en route to a more dynamic presentation for your audience.

Using the Text Tool

The newest version on Premiere Pro makes adding text even easier. The new Type tool lets you type directly in the Program Monitor to add a text clip. Just select it in the toolbar and click on the monitor and begin typing. You can then use the Selection tool to move text around. After that you can use the tools in the Essential Graphics panel to format the text.

Navigating the Essential Graphics panel

Like many other specialties in Premiere Pro, loading a dedicated workspace makes the process more efficient. So, when you're ready to add a movie title, identify a subject with a lower third, or make a cool opening sequence, you need to choose the appropriate workspace; you do that by going to Window ⇨ Workspace ⇨ Captions and Graphics. All the tools needed for putting words on the screen in any way you see fit are found in this section, on the right side of the workspace in the Essential Graphics panel.

This panel lives up to its name when it comes to working with graphics and titles, and it also includes your preloaded templates, graphics, and Adobe Library. The Graphics workspace and Essential Graphics panel provide a powerful workflow that allows you to fulfill your needs for titles and graphics.

Browsing the templates

REMEMBER

Atop the Essential Graphics panel, you find two sections, Browse and Edit. You can find the graphic you want by browsing titles loaded into the program and you can download others. After selecting a title and dragging it onto the timeline, it's time to fill it out. Them. The next tab, Edit, lets you input data that will populate your title or graphic, and then align, transform, or add keyframes.

You can easily search, browse, and grab motion graphics directly from the Essential Graphics panel. This relatively new feature provides the kind of graphics once found only in After Effects; with relatively simple operation, you can customize a graphic to add immediate zing to your movie. The panel allows you to see all the motion graphics stored locally on your computer, on Adobe Creative Cloud, and available from Adobe Stock. As the name implies, *motion graphics* are graphics that show motion, which can be pretty cool. Think of it as a title that's animated.

Using Text to Speech

Sometimes speaking words doesn't do much. I think of the episode of *The Office* when a financially strapped Michael Scott screams out, "I declare bankruptcy," as if uttering the words would make that happen. Sadly, it did not. But that's not the case with Premiere Pro, where your movie's spoken words turn into text with the new Speech to Text feature that automatically converts the dialogue of your video into editable text for transcription and captions.

Here's what this feature can do for you.

>> **Transcribes your video:** After laying your video out on the timeline, you can select a portion, or the entire edit and, with a few clicks, quickly create a transcription.

>> **Create closed-caption:** After applying transcription, your video can match the pace of the dialogue, much like turning on Close-Captioning on your flatscreen television.

>> **Handles multiple languages:** This feature currently works in 13 languages, including Spanish, Italian, Hindi, and Mandarin, as well as both American and UK English.

>> **Stylize captions:** After creating the transcription, you can make style and creative choices to fine-tune your words. Try that in real life.

STAYING UP TO DATE

Since this is a new feature, if want to take advantage of the game-changing set of tools, you'll need to run the latest version of Premiere Pro, which requires a quick trip to the Adobe Creative Cloud for a download.

Creating a transcript

One of the most tedious tasks of putting together a news segment, interview, your social posts, or any package that requires a transcript in the actual transcribing. Premiere Pro now simplifies that process with its Speech to Text feature. You can activate it through the updated Captions and Graphics Workspace, so make sure you select it.

Here's how you can use it.

1. Go to Windows ⇨ Text and the Text Panel will populate. Click Transcript on the left side of the panel, as seen in Figure 14-1.

2. Select your video in timeline, or the portion you want transcribed, if you marked In and Out points.

3. When the Create Transcript dialog pops up, shown in Figure 14-2. It shows information such as file name and duration, as well as let you can make choices, including if you want to transcribe a mix of the audio or a specific track. This is also where you choose capturing between In and Out points, selecting a language, or separating when different voices are speaking.

FIGURE 14-1: The Click Transcript button in the Text panel.

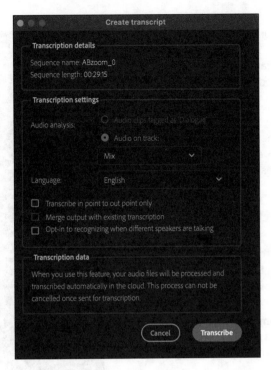

FIGURE 14-2:
Create
Transcript
dialog.

4. Once satisfied with your selection, click OK, and the process will begin.

5. Once complete, your transcript will populate the panel. You can three-dot button on the far right of the panel, as seen in Figure 14-3, and choose to check spelling or Export as a text file.

Creating Captions

After creating the transcript, you can create captions for your video, much like Closed Captioning on television. The process is simple. After you created your transcription, click on the Caption link on the left side of the panel.

Here's how:

1. Click the Create Captions button and Create Captions dialog pops up.

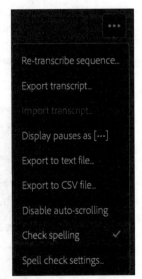

FIGURE 14-3:
Options for your transcript.

2. Choose your options, shown in Figure 14-4. See sidebar for what they do regarding the way captions are arranged on the Timeline.

3. Click OK. After the captions process, you will see them added to the Captions Track on the Timeline, as seen in yellow in Figure 14-5, and aligned with the dialog in the video, as seen in Figure 14-6.

Understanding Create Captions Controls

Before setting the controls for captions, here's the lowdown of what each one affects.

>> **Create from sequence transcript:** Clicking this radio button lets you create captions using the transcript you just made.

>> **Create blank track:** Another radio check box, this one lets you create a space to manually add captions or import an existing .srt file.

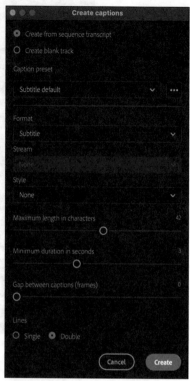

FIGURE 14-4: Caption options.

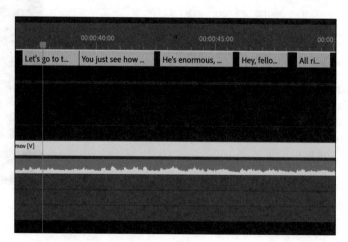

FIGURE 14-5: Captions track in yellow.

FIGURE 14-6:
Captions
on video.

Let's go to the other side of this.

>> **Caption preset:** The pull-down menu offers various choices, but the Subtitle Default option works for most situations.

>> **Format:** Pull-down of caption format choices, most of the time Subtitle is the right one.

>> **Stream:** Lets you adjust to caption for streaming formats.

>> **Style:** After using this feature, you may save some style choice, here's where you can access them.

The next three sliders let you adjust the length, duration, and gap between captions. The last choice lets you select single or double spacing.

Editing text

Speech-to-text transcription functions are almost as reliable as our ability to speak clearly. And even then, uniquely pronounced or spelled words can also create some typo or inaccurate phrasing. No problem, you can easily fix your transcription. These problems are easily fixed by double-clicking on the text box in the transcription to edit.

You can take it further by opening up Essential Graphics, and having complete control over tracking, fonts, size, and shadow.

Editing Graphics

After finding the graphic you want to use, drag it into the Timeline and place it at the desired spot. Double-click it, and fill in the fields. It's that simple.

Searching for a graphic is easy

TIP

Type a name in the search bar to find a specific graphic or title. You can select either the My Templates button on the top of the panel for access to those loaded in Premiere, or Adobe Stock, where you can find free or other graphics for a small fee in the Creative Cloud. The Local Templates Folder and Libraries checkboxes also help with your search. One shows the templates loaded into Premiere, while the other provides access to specific libraries.

You can check out the effect by scrubbing over the graphic choice, as shown in Figure 14-7, to see if it does what you want. If it takes you a while to find the right one, you can click on the star to mark it as a favorite; then, you can search your favorites later to select the one you want. When you decide on an effect, drag it to the timeline.

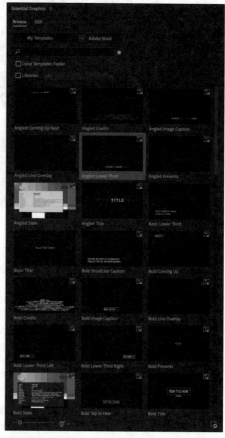

FIGURE 14-7:
Template choices in the Essential Graphics panel.

The Browse section

REMEMBER

Browse local templates, or search for others in Adobe Stock. Some are free, while others require a fee. These professionally designed templates are easily dragged to the timeline where you can add your own flair. If you're looking for something more, try the Adobe Stock marketplace, where you can find titles, motion graphics, and photos.

The Edit section

After you drag the graphic template to the timeline, you're ready to add text. Click the graphic in your timeline; for some choices, this section provides a place to fill out the necessary fields with text, properties, and alignment controls, as shown in Figure 14-8. This makes it easier than typing directly into the graphic, which is populated with your input, as shown in Figure 14-9.

Here's what the Edit section helps you accomplish:

>> Align and transform layers

>> Change appearance properties

>> Edit text properties

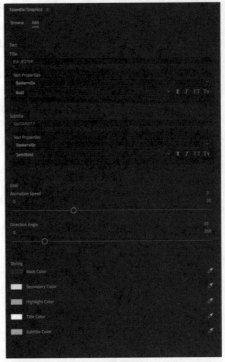

FIGURE 14-8:
Filling out a form for a graphic.

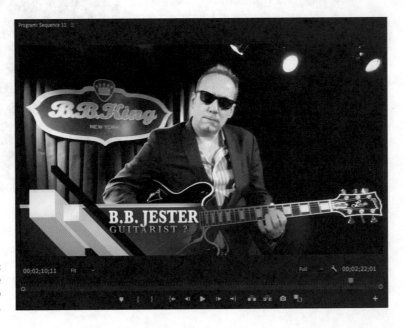

FIGURE 14-9:
Seeing the resulting info in the graphic.

Putting words on the screen

It's hard to talk about this topic without mentioning the opening crawl that begins with "A long time ago in a galaxy far, far away. . ." As the franchise continued with its final trio of films, it was still used onscreen to assist with storytelling. There's even a plug-in (see Chapter 19) called Star Titler that lets you make your own text crawl. I'm not sure if that works in many situations, but maybe you'll encounter that perfect opportunity. Words on the screen help convey everything from the title of the movie, to the people who worked on it, to some key pieces of storytelling.

Breaking down text adjustments

TIP

Merely adding text doesn't mean much — that is, until you can tweak it to match your needs. Figure 14-10 shows text edit tools.

After you create your text, here's a brief description of the tools you can use to change it.

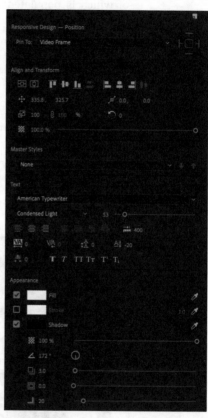

FIGURE 14-10:
Editing tools for text.

>> **Align and Transform:** Includes a set of features that control the alignment and scale of your text.

>> **Text properties:** Provides all the basic controls for your text, including font type, style, size, and tracking.

>> **Appearance:** Four color-selection tools that let you determine fill, stroke, background, and shadow.

Replacing fonts

Not completely satisfied with your font choice or size? No problem. Premiere Pro lets you replace or update them in a single action. For example, if you have a graphic with multiple layers of text and you decide that the MS Gothic font lacks the pizzazz of Century Gothic bold, you

can use the Replace Fonts in Projects command, shown in Figure 14-11, to change the font of all the layers simultaneously.

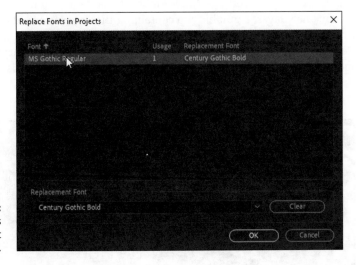

FIGURE 14-11:
Replace Fonts
in Project
command.

TIP

Here's how you do it:

1. Go to Graphics ⇨ Replace Fonts in Project. The Replace Fonts in Projects dialog opens. Here, you see a list of fonts used in the project.

2. Select the font you want to change by highlighting it.

3. On the bottom of the panel, use the Replacement Font pull-down menu to find the font you want to use.

4. Click OK.

EXPORTING TITLES

One flaw with Premiere Pro is its inability to save titles. That can be annoying, especially when you have an often-used title that you would like to apply in different projects. While you can't save the title, you can export it by selecting the title, and going to File ⇨ Export ⇨ Title. Name the title (which seems redundant), point it to a location, and hit Save. Afterward, you can import it into a project like any other asset.

Create graphics

Graphic choices in Premiere Pro offer multiple text, shape, and clip layers. You can combine multiple layers as a single graphic track item in your sequence. When you create a new layer, a graphic clip containing that layer is added to your timeline. Any graphics you create in Premiere Pro can be exported as a Motion Graphics Template folder, Local Drive, Creative Cloud Libraries for sharing or reuse. As mentioned, some graphics require input via the Edit tab, but most are editable on the image, as shown in Figure 14-12.

FIGURE 14-12: Editing directly on the clip.

Adjusting graphics

Whether it's a static title or one that moves, graphics must occupy the layer above the video track. Like any other clip, you can move it on the timeline precisely where you need it, add transitions, and in most cases, alter the duration by click-dragging the edges.

Making a text layer

REMEMBER

You can easily add text to your movie using several methods in Premiere Pro — the simplest being with the Text tool, which is accessible from the T icon on the Toolbox. Select the Text tool, click someplace on the clip, and start typing. You can make size, font, and style adjustments after you finish. It's also accessible through a menu command by going to Graphic ➪ New Layer ➪ Text Commands, selecting the Type tool, and clicking on the spot where you want to add text. Then there's the Essential Graphics panel, which provides an assortment of features.

Here's how to make a text layer.

1. Go to align and transform to change position, opacity, and other settings.

2. In the timeline, move the title to the exact spot where you want it.

3. If you want the title to fade in and out, right-click on the end of the clip and, when the menu pops up, choose Default Transition.

Creating titles

While the titles you choose to add to your movie can help tell the story, how you present them is also important.

TIP

Whether creating title sequences, lower thirds, or a motion graphic, here are a couple of tips for choosing the right types of fonts for your video projects.

>> **Keep it simple:** Try not to use flashy fonts or too many effects. That can detract from the movie and also gets outdated quickly.

>> **Be brief:** You don't want to give the audience too much to read, so make sure you're succinct. Closing credits need not apply. Opening ones, too.

Adding static titles

Not all titles need to move or do anything. For that matter, some onscreen graphic elements make their point with a few words. For example, if you're using someone else's footage, you could use a static courtesy in the upper-right corner. Or perhaps you want to add a locator to let your audience know where the scene is taking place, as shown in Figure 14-13. Those are a few situations that work well with static titles.

REMEMBER

While there are many reasons to add some text graphics to your movie, here are some of the basic ones.

>> **Title:** Pretty self-explanatory. This lets the viewer know the name of the movie, show, or episode.

>> **Locator:** Lets the viewer know where the scene is taking place. This type of graphic often takes the form of a lower third.

>> **Courtesy:** When you get permission, and that's the operative word, to use someone else's material, it's obligatory to provide a courtesy denoting the studio, creator, or distributor. It's usually placed in the upper-right side of the screen.

- >> **Lower third:** Identifies the person speaking on camera, and their title. This is used mostly in documentaries and news segments. It's customary to run this graphic for 5 to 10 seconds. After identifying the subject, it usually doesn't repeat, especially in a news segment. In a documentary, it's prudent to show it every now and then so the audience's memory is refreshed.

- >> **Date:** This can literally be the actual day or year of the scene being shown. Or it can say something more generic, like FILE or ARCHIVE.

- >> **Chapter or title card:** This one has a wider range of uses, including separate scenes, time, place, or any other differentiating factor. Quentin Tarantino often uses title cards in his movies, for example, the description of every assassin in "Kill Bill: Vol. 1."

- >> **Opening credits:** The credits that inform the viewer of the name of the movie and the people who worked on it, beginning with the production company and film title and ending with the cast and directors.

- >> **Closing credits:** Provides the reverse of the opening, though with more details about the cast, crew, locations, music, and other stuff.

FIGURE 14-13:
Locator
graphic.

Title Safe and Action Safe

Ever wonder what rectangular boxes near the edge of a video frame mean? They show the area that the movie will safely display, and where it may not. More relevant, it harks back to the tube-TV days when the rounded corners and various overscans (making the picture slightly larger) made it important to define a

place with the important stuff could be seen. Nowadays, they're still useful. Staying within title-safe area will assure that your image, and in this case, text and graphics, isn't cut off when viewing on a smart phone.

Making a graphic title

Making a graphic title for chapters and sections is easy. In the Graphics workspace, find your way to the Titles folder and double-click to open it.

1. **Drag the Film Presents Graphics template onto a video track in the timeline.**

2. **Adjust the duration to match your needs,** and add a transition to soften its emergence.

3. **Copy the motion graphics throughout your project.** You can simply Option-drag in MacOS (Alt-drag in Windows) to copy the effect to other parts of the edit.

Smartening up your movie

REMEMBER

While you rarely think about titles — and maybe even stop the movie, or leave the theater, as the credits roll — it's hard to imagine any movie or television show that doesn't contain any words onscreen. Even social media clips often use text, so clearly, it's essential. We've firmly established that movies and TV shows have credits because they are necessary, even if the audience doesn't appreciate them.

Crediting your movie

REMEMBER

Cast, crew, locations, and courtesies can make your movie resemble a big-budget Hollywood feature. And while bigger movies roll credits that can equal the length of a short film, with sometimes two, three, or more full songs playing in the background, yours will probably take up a fraction of the time. Still, there are some standards you should follow for structure. While there are no real rules for setting up your titles, there are certainly some traditional ways of doing it.

Here's what they do.

Here are some tips for organization:

>> **Triple-check spelling:** Be sure to spell names correctly; otherwise, you'll hurt some egos and it'll take hours to fix.

>> **Confirm title information:** It can be embarrassing and amateurish when you get names and titles wrong, so take the time to get them right.

Here are some examples of credits.

>> **Title:** The name of the movie or TV show, as shown in Figure 14-14.

>> **Opening credits:** The listing of the cast at the beginning of a television show or movie.

>> **End credits:** The listing of the cast, crew, and others at the end of a television show or movie.

>> **Identification titles:** Used for documentaries and news segments to identify the person speaking on camera with a lower third under them.

FIGURE 14-14:
Laying out a
movie title.

Arranging your opening movie credits

The structure of opening credits follows a basic form that usually begins with a studio or production company name. That's followed by the name of the film, its stars and producers, and finally, the director. That's pretty basic, but the rest of the credits depend on the size of the project and the obligations to the cast and crew as to what else you include. More than entertainment, the purpose of film credits is to acknowledge the contributors, cast, and crew. But that doesn't mean there's anything wrong with a little flair. Font choices and how they appear onscreen are up to you.

TECHNICAL
STUFF

The most common movie opening credits are structured in a particular way. Let's take a look at the order:

>> Production company

>> A film by. . .

>> Title of film

>> Main actors

>> Supporting actors

>> Music composer

>> Costume designer

>> Associate producers

>> Editors

>> Production designer

>> Director of cinematography

>> Executive producer

>> Producer

>> Screenwriters

>> Director

Closing credits

The closing credits are not just about signaling you to leave the theater or change the television channel. They also do more than to stand in opposition to the opening. In the closing credits, you can list everyone who worked on the project. That's why they can go on for so long. Chances are you don't have a couple of hundred people who worked on your film, so your end credits should be fairly basic.

Another thing: sometimes they show some surprising information, like a clue to an upcoming sequel, or some additional scenes that the editor or director cut from the original film. Depending on the length of your film, that's an option, but that's not the point here.

WARNING

Here is a potential example of a scaled-down list of closing credits. If you're curious about what's missing, try watching the end credits of any blockbuster.

The most common movie closing credits are structured in a particular way. Let's take a look at the order:

>> Production company

>> Director

>> Writers

>> Producer

>> Executive producer

>> Cast roles

>> Director of photography

>> Production designer

>> Editor

>> Associate producers

>> Costume designer

>> Music composer

>> Casting director

Adding credits to your movie

REMEMBER

While you can choose templates for your movie credits in Premiere Pro, they are single-page credits. If you're looking for credits that roll, they're available to purchase through Adobe Stock, or as a plug-in.

In your templates folder, there are several choices, including the Film Credits option. Just drag it onto the timeline, and you can edit it directly, as shown in Figure 14-15.

Making your own rolling credits

The previous options used the static choice included in the templates folder, purchased content from Adobe Stock, or added a plug-in that specializes in creating a rolling title.

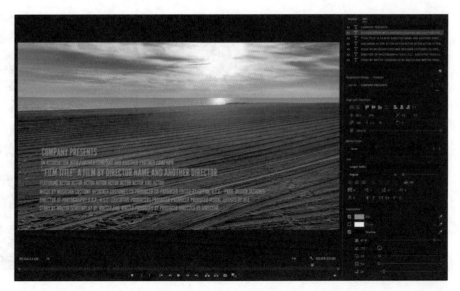

FIGURE 14-15: Adding content to the Film Credits graphic.

TIP

But as Yoda tells the ghost of Obi Wan in *The Empire Strikes Back*, "there is another." And it's not Leia this time. Nope, it's creating your own rolling credits from scratch while working in the Essential Graphics space. While this approach involves the most work, at least you will be able to decide what you want to include.

Here's how:

1. Click on the Edit tab and select New Layer by clicking the icon circled in Figure 14-16.

2. Select Text in the pull-down menu. You see a field emerge in the Program Monitor, highlighting the area on the screen graphic by double-clicking. It turns red.

3. Type directly into the field. You can use the order described earlier, or some version of it. Your entire set of credits needs to be typed into this field, so use the Enter key to create a space and/or new line for each one, as shown in Figure 14-17.

4. After typing in the first line, go to the text section on the panel and click on the Center Align Text icon, as shown in Figure 14-18. This ensures that your credits are justified down the middle within the field.

FIGURE 14-16: New Layer icon circled under the Edit tab.

FIGURE 14-17:
Editing text
directly in the
field on
the clip.

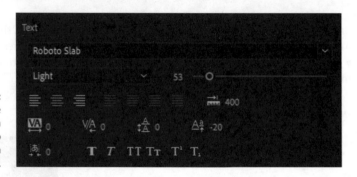

FIGURE 14-18:
Clicking the
Center Align
Text button to
center text in
the field.

5. In the Align and Transform section, click the Center on Screen button. This assures that the credits are centered on the screen, as shown in Figure 14-19.

6. Add the remaining credits. Specify the font, sizes, and styles you want for each line.

7. Once you've added all the text, click out of the field. Go to the Responsive Design — Time section of the panel and click the roll box. After you select the checkbox, it populates with edit timing cues, as shown in Figure 14-20.

8. Make adjustments to the duration, and try it out using the scroll bar on the right, as shown in Figure 14-21.

FIGURE 14-19:
Centering the credits onscreen using the controls in the Align and Transform section.

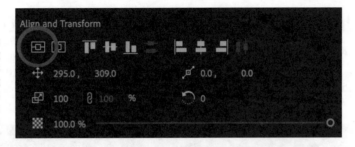

FIGURE 14-20:
Responsive Design — Time section on the Essential Sound panel with the Roll checkbox selected.

FIGURE 14-21:
Making adjustments with the scroll bar to view the finalized version.

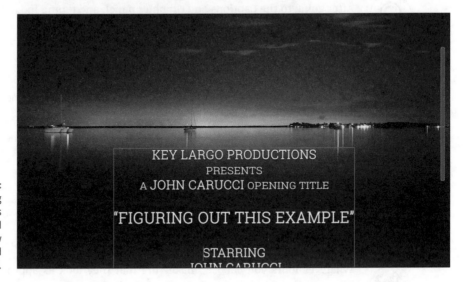

Identifying a subject with a lower third

If you're working on a documentary or doing a news segment, you will want to use a lower third to identify the person speaking, as shown in Figure 14-22. Premiere Pro offers several choices, and you can find others in Adobe Stock.

FIGURE 14-22:
Subject identified with a lower third.

TIP

After going to the Captions and Graphics panel, and typing in Lower Third, here's how to edit:

1. After selecting the lower third that works for your movie, drag it to the timeline, and position it. Now, you're ready to add content.

2. With the title selected, go to the Essential Graphics panel, and choose Edit.

3. On the image, you see two fields that represent the person's name and title. Type in the information. For style reasons, use All Caps. If it's a motion graphic lower third, see the example earlier in the chapter.

4. Make adjustments, if necessary, to the text, color, and style. When you're done, click out of the field.

Tweaking fonts

REMEMBER

Whatever fonts you choose, make sure that they look as appealing as possible. That sounds logical, but each font and particular character associated with it has inherent features that can affect the look of the text. That means the relationship between individual characters sometimes needs adjustment.

Here are some font adjustments you can make.

>> **Leading:** This is the amount of vertical space in between lines. Depending on the size of the font, there should be adequate distance between lines of text.

>> **Kerning:** This is the space between individual characters. Some character and case types.

>> **Tracking:** Similar to kerning, tracking involves the spacing throughout the entire word.

Making a (simple) motion title

Sometimes, the only thing better than a great title is a great title that moves. Premiere Pro offers a few options to bring your movie titles to life with drag-and-drop simplicity. These ready-to-use motion titles are fully customizable with animated graphics, stylized text, and background styles.

TIP

In the Essential Graphics panel, you can choose the graphic you want. Each template may include text and graphic components and a background component, which can all be customized to your liking. More choices are available in Adobe Stock, but for now, let's transform a sports quote motion graphic, shown in Figure 14-23, into a comment on using motion graphics in Premiere Pro, replete with a color scheme that matches the book cover.

FIGURE 14-23:
Generic sports quote motion graphic.

Let's get started:

1. Drag the aforementioned motion graphic into the timeline. Click on it.

2. Under the Edit tab, shown in Figure 14-24, it's time to get to work. In the Title field, change the default text to **Premiere Pro Tip Du Jour**. Caps are important, so make sure the Force Uppercase checkbox is selected. Next, change the subtitle to **Using Motion Graphics**, as shown in Figure 14-25.

3. Change the background color of the graphic. What's black, white, and gold all over? Not this graphic. Instead, let's change it to match the color of this *Premiere Pro CC For Dummies* book, which uses purple, yellow, white, and black. With the book cover imported into Premiere Pro, use the eyedropper to change the main color to purple.

4. Adjust the orientation of the motion part of the graphic, or hide it altogether by clicking on the appropriate checkboxes. Choose Flip to make things more interesting, as shown in Figure 14-26.

5. Make adjustments to the header; you can change the color, font, and alignment.

6. Add the quote by either typing, or copy and pasting. Start the process by using the Type tool and clicking on the area. Once you do this, it creates a new layer, and the panel populates with a new set of controls, as shown in Figure 14-27.

7. Make a statement with your font, both literally and figuratively, as you pick a whimsical font and style. In this case, the Baskerville font works best. After playing with the size and alignment, and adding a purple shadow, the final version appears in Figure 14-28.

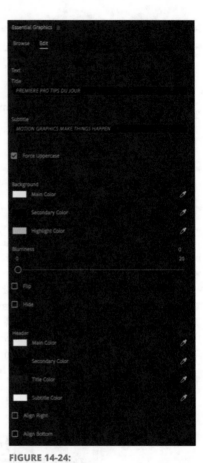

FIGURE 14-24:
Controls for the graphic under the Edit tab.

FIGURE 14-25:
Changes shown on the motion graphic.

FIGURE 14-26:
Flipped version with a changed main color.

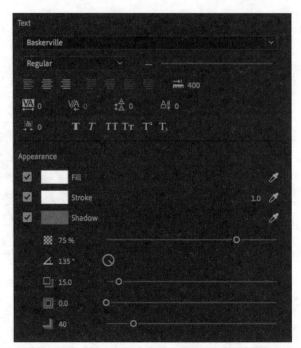

FIGURE 14-27:
Text controls.

FIGURE 14-28:
Final version
with text.

4

Finishing Off Your Project

IN THIS PART . . .

Finalize your video production.

Choose the right export format for your video.

Post video content to social media.

Other ways to share your video production.

Chapter **15**

Finalizing Your Project

Almost there. . .but not quite.

Even when you think the movie is done, guess what? It's probably not. Yeah, the movie looks great when you're playing it through Premiere Pro, but you need to cut the cord and let it stand on its own as a self-playing movie. But before taking that important step, some quality control is required on your part. Here's a situation where less is not more.

You've already worn a few imaginary hats while making your movie, so let's add one more. Maybe it's blue or green or purple — it doesn't matter, it's ceremonial. All that matters is that you're the quality control monitor of your movie. Paying attention to imperfections now can save you a lot of work later. One or two blemishes may not be a big deal, but when grouped together, a bunch of tiny imperfections begin to cast a bigger shadow over your work, and not the good kind. So, for this section, let's re-examine the relationship between the video, audio, and effects of your movie to make the necessary tweaks before showing it for real.

Being Your Own QC Monitor

As the quality control monitor, you need to be your movie's harshest critic. Don't be concerned about the size of the audience; it doesn't make a difference. Whether you're showing the movie to a few friends in your living room or uploading it to Vimeo for a bigger audience, you should make sure the movie looks and sounds just right. If this were a musical, you would eliminate the negative and accentuate the positive. So, look at every imperfection and fix it before you bestow the job of critic to your audience and start to receive the harsh comments that will surely follow.

Watching and studying

TIP

Quality control requires looking closely to find noticeable flaws, so there's no substitute for taking time to watch it over and over. The constant perusal brings blatant imperfections to your attention, then smaller ones, and even smaller ones than that. Along the way, you're making tweaks that eventually lead to a movie that makes you proud.

Assuring clip continuity

Some imperfections can arise from the relationship between adjacent clips, especially if they don't go well together. Sometimes it's obvious, other times not so much. Putting your movie together requires assembling various clips, but that doesn't mean they work as whole. Many factors affect the outcome; here are some of them.

WARNING

>> **Clips that don't go together:** If you have a medium shot of theater and then the next shot is a medium shot of the same location from another angle, as shown in Figure 15-1, it can be visually awkward, especially if the angle is similar. The shots may work individually, but together they can detract from the visual storytelling.

>> **Messing with the time-space continuum:** Movies are shot out of order for good reason, yet there's no excuse for not taking continuity into consideration when editing. For example, the subject may hold a half-full glass of water in one scene, but in the next scene, that glass may be full. Movies with a budget have someone who takes care of this problem, called a script supervisor. But for you, chances are, that's the name of the other hat you'll be wearing.

- **Failed creative choices:** Sometimes an ineffective transition can break a movie's flow. Transitions are one of those elements that are hard to judge, so keeping them at a minimum can't hurt. What does that mean? Well, for one, too many wipes can be jarring. But then again, George Lucas often used them in *Star Wars* with great results.

- **Matching:** For scenes shot in the same location, make sure the color and tone match. If not, now is the time to tweak those settings so the colors are the same.

- **Proper order:** Not saying that standard, wide, medium, close-up is always the order, but having shots that go well together is important. So, if you notice that it looks awkward while watching, fix it.

- **Zooms:** Unless you have some creative reason, putting zooms side by side will make your movie look awkward.

FIGURE 15-1:
These two images would not go together.

Matching audio levels

REMEMBER

When it comes to the relationship between adjacent clips, making sure the sound levels match is another important factor. Disparity between audio levels can detract from your movie, and there's nothing worse than having your audience raise and lower volume throughout the movie because some parts are too loud, and others too low. As described in Chapter 13, many techniques exist for making sure audio levels are optimized for your movie.

Checking graphics and titles

WARNING

Have you ever watched the evening news and spotted a misspelled word or maybe saw the wrong player identified on that cable sports network? Or someone writing a book identified with a typo, as shown in Figure 15-2? How does that make you feel? Probably okay. Still, it's not something you want to happen to you. While watching your movie, make sure names are spelled correctly and the subject is correctly identified. Otherwise, why bother?

A.I McGUY
EXPET ROBOT BARBER

FIGURE 15-2: Seems like the letters are transposed on this one, unless this cyborg is an ex-pet and not an expert.

Previewing the Timeline

Watching video obviously helps ensure that your movie looks great, but so does looking at the timeline. So many factors in the timeline can affect playback, and they may be visually noticeable so you can fix them.

Casting a critical eye

While misdirection justifies success for a magician, it's not effective when checking your movie for mistakes. There's nothing magical about a flash frame interrupting the flow of your movie, even if a rabbit's in the scene. Watch the content and double-check with a visual inspection of the timeline. Maybe there's a tiny gap between clips that you didn't notice. Sometimes, there's a typo in the filename that goes unchecked. Then there are those pesky extra frames on a clip end. What about the track controls? Sometimes they're turned off, as shown in Figure 15-3.

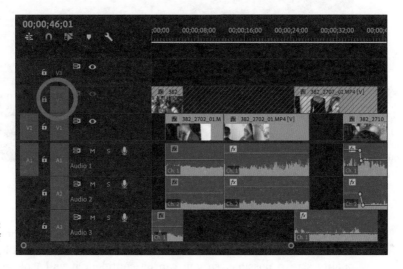

FIGURE 15-3:
Turned off
video track.

TIP

It's a good idea to check all of your movie, much like that last scan of your hotel room before checking out. Make sure that all the audio and video channels are enabled. Maybe you hid an audio channel while working on a sequence and forget to turn it back on, or there's an extra piece of video well after the video's intended end in the timeline.

Having gap insurance

REMEMBER

Depending on video duration, it's possible to miss some minor aberration like a black frame, jump cut, or something else that doesn't belong. Then there's the space between clips that manifests as a black frame during playback, as shown in Figure 15-4. Nobody wants those showing up during a screening, so you need to scour the timeline. One great technique is to expand the track by using the (+) key.

Then, you can move from cut to cut by using the down arrow to stop at every cut. If you visually notice a gap, or it takes two keystrokes to move past it, then you can investigate and fix the problem.

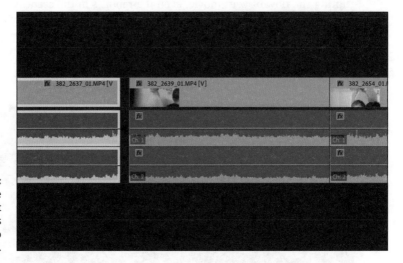

FIGURE 15-4:
If the timeline wasn't expanded, this gap could go unnoticed.

Watching on an external monitor

Better than the concept of trickle-down economics comes the more effective trickle-down viewing. That's watching your movie on the biggest, highest-quality screen possible, so you can be confident it will look great on smaller screens, too. It's important to observe quality on a high-end, calibrated screen to assure optimum quality. Whether it's noticing tonal variations or some minor aberration in a clip, this technique comes in handy, especially when you consider that audiences will watch your movie on a variety of interfaces, ranging from an iPhone or iPad to a computer screen or larger 4K television.

Viewing the meters

They look cool, bounce to the music, and have pretty colors with numbers next to them. But those colors and numbers mean something. When levels rise, they hit the yellow area. And that's a great place to be. It means you have a reasonable level for the loudest sounds. But when levels are too high, they hit the red. And that's not good.

TECHNICAL STUFF

Normal audio levels generally range between −6 and −12 decibels, as shown in Figure 15-5. But that doesn't mean that all levels are right smack at −12. If that were the case, then a scream and a whisper would make the sounds level. That makes for an incredibly loud whisper or a low scream. Impressive? Yes. Realistic? No. That's why you need to monitor audio levels so the audience can clearly hear them with the appropriate amount of range, but no clipping. That's a fancy word for distortion, and the kind that you cannot fix. Slightly high levels, that don't clip, or those a little on the low side, you can easily adjust in post-production within range, but it's also important to notice how it sounds to your ears.

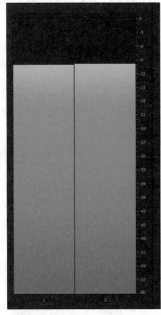

FIGURE 15-5:
Audio levels.

Listening on speakers

Watching your movie on a high-quality screen has its rewards, and the same applies when listening on the best possible sound system. Headphones are acceptable, but when it comes to checking the quality of your movie, nothing compares to listening through a good pair of speakers, especially when evaluating sound quality and audio levels. The end user will experience the audio portion using everything from earbuds to a high-end 5.1 stereo system, so monitoring in the best possible way ensures that everyone has the best experience.

Being a good listener

REMEMBER

The operative word here is "listen," because sometimes we become complicit by monitoring audio levels by focusing on the audio meter. Audiences don't really care if the levels match; they only care that the movie sounds good. So, put on the audience member hat and give your movie a good listen on a decent pair of speakers.

Hearing with your eyes closed

Few things, outside of the obligatory covering your eyes for a surprise, are worthy of keeping your lids down. Listening to the differences in audio with your movie by focusing on sound with your eyes wide shut makes the list. Here, you can notice any difference in levels, without being distracted by the video. Those minor tweaks can make all the difference.

Fine-Tuning Video for Export

Here a tweak, there a tweak, everywhere a tweak-tweak. Maybe that's what Old McDonald would beatbox if the farm took on Premiere Pro editing jobs. Cadence of the catchy nursery rhyme aside, those little changes that you make over time have a cumulative effect that leads to a stronger edit. And it all starts with watching and listening.

Pre-export process

Unlike those ridiculous airport announcements for pre-boarding, this one can make sense as sort of an unofficial checklist for getting your video ready for export. Approaching this process as a checklist helps to ensure that each aspect of your movie passes muster — especially when you consider there's a lot going on behind the scenes. While you're editing the actual file, you're not importing the media itself, so you can't "damage it." But before the software can do its thing, you must do yours.

REMEMBER

Let's look at the nuts and bolts of the editing process to help you understand how some of the actions that run in the background can affect your exported movie.

» Make sure video doesn't have visible issues. This includes gaps, unwanted clips, or an adjacent track erasing another one.

» Audio levels should be properly balanced throughout the edit. Even if you checked it earlier, it doesn't hurt to check it again.

» Watching and listening for clipping. If you hear distortion or see the meters turn red, adjust accordingly.

» Double-checking the sequence settings. Nothing is worse than editing HD content and finding out it was exported in standard definition.

» No gaps or extra frames between clips. Hopefully you have checked for this, but there's no harm in checking again.

Being efficient

The export process takes time. How long? Well, that depends on how much you've done. The longer the video duration and various effects, the more processing is required and the longer it takes to export. It's all part of doing business, but when

you're exporting the same file several times for review purposes, and you have no plans to change certain sections, then you can skip the re-encoding and rendering process to save time with those preview files. Premiere Pro can render clips rich with effects as a stored preview file, so the process is quicker.

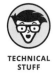

TECHNICAL STUFF

Here's how to export a movie with portions already encoded:

1. Set In and Out points for the section.

2. Go to Sequence ⇨ Render In to Out, as shown in Figure 15-6. Premiere Pro then saves that portion and will not have to render during output. Think of it as a "pay now, save later" kind of deal.

3. When you re-export, make sure to select the Use Previews checkbox on the lower-right side of the Export panel.

Bumping up the preview quality

FIGURE 15-6:
Choose Render In to Out in the pull-down menu.

Just because Premiere Pro uses a lower-quality codec for the quick render mode doesn't mean you need to start over when you're ready for your final export. Au contraire!

THERE'S A CAVEAT

Premiere Pro uses a low-quality codec when dealing with preview files, making it a great option for quickly exporting the same file numerous times for review purposes. Unfortunately, the preview section that you save for a faster export will have substantially lower quality. So, when it comes time for the final version, you need to make an adjustment to the codec. To reiterate, that's the process that compresses your video so it can be stored at a smaller file size. (See Chapter 10 for more information about codecs.)

TECHNICAL STUFF

When you're ready to export, go to Sequence ⇨ Sequence Settings. In the dialog that appears, go to the Video Previews section, and in the Preview File Format drop-down menu, change the *I-Frame Only MPEG* setting to *QuickTime*. Then, in the Codec drop-down menu, choose a more substantial codec, as shown in Figure 15-7. If you don't have one in mind, it's always safe to pick *Apple ProRes 422*. Of course, this takes up more space, but the quality is worth it.

FIGURE 15-7:
Choosing a codec.

Avoiding crashes

WARNING

Another example from the Department of the Obvious states that you should avoid computer crashes. Who knew dodging freezes and crashes was an essential part of the editing process? Everything goes smooth for most of your project, and then you make a complex edits, and boom, it shuts down. Being ready for this situation makes good sense, especially when you invest hours, or weeks, or longer to create your video. Unfortunately, these unplanned disasters happen when you least expect them. There you are, moving through your edit, when suddenly, something goes wrong, and some — or most — of your hard work is vaporized like it was on the business end of Captain Kirk's phaser.

Here are some effective solutions for limiting the potential for Premiere Pro to crash on your project.

Is there enough disk space?

REMEMBER

Make sure you have enough disk space on the drive. Videos files take up an exorbitant amount of space, so make sure you have enough room before exporting. It's a great idea to give your computer a spring cleaning, even in October, before working on a major project.

Clearing media cache

TIP

The big data behind your movie takes place behind the scenes in the form of cache files. Premiere Pro keeps track of all your clips and effects when editing your movie in the cache folder. But as the folder fills, simple actions can feel like you're in a line at the Department of Motor Vehicles on a Friday afternoon. But worse than that, at some point, all that data can crash Premiere Pro in mid-export, so let's look at some pre-emptive solutions to prevent that from happening.

1. Go to Adobe Premiere Pro menu ⇨ Preferences on a Mac, or Edit ⇨ Preferences on Windows, and navigate to the Media Cache section, as shown in Figure 15-8.

2. Select the Delete option (next to Remove Media Cache Files).

3. Click OK.

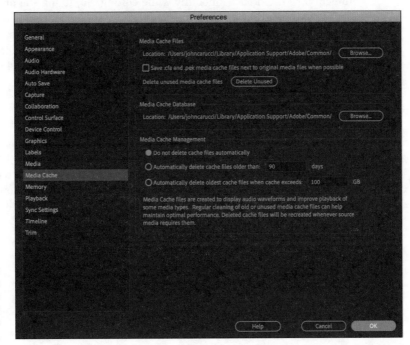

FIGURE 15-8:
The Media Cache section of the Preferences dialog.

CACHE VALUE

Although this term sounds monetary, it's actually about the value. *Cache* is temporary storage that your computer uses to make certain actions more quickly accessible than your computer drive. But cache files grow as duration increases and you add elements like effects and corrections. And the more that the cache folder expands, the slower your computer can potentially run. That's why purging the cache is important by using the previously mentioned instructions.

Checking the timeline closely

Occasionally, a bad frame or effect may cause Premiere Pro to hiccup, which is code for something not-so-good — you know, like crashing, locking up, or generating the spinning beachball.

WARNING

Sometimes, you can easily identify the problem; other times, it's more insidious. If you notice that your export percent fails at the same point, there's a chance the problem exists at that point of the export. For example, it could be a render issue. The red line above your clips in the timeline means the section is unrendered. *Rendering* is an operation where the program creates temporary video files to help play them back smoothly while editing. So, fixing the problem can be as simple as rendering an area in red by going to Sequence ⇨ Selection (or going to Sequence ⇨ Effects In to Out if the problem looks like it was coming from an effect). Other times, it's an image or special text characters that Premiere Pro doesn't like for some reason. Remove the questionable effect and re-export to see if that clears up the problem. You can always add it back later.

Dividing the export

TIP

Sometimes a big edit can crash your system. While there could be many reasons for the complication, one possible solution to remedy the problem involves breaking the edit into several sections, depending on the actual duration. Later, you can combine the parts to restore the movie to its full length.

TIP

CANCELLING SOFTWARE HOGS

Video files include a great deal of data and can be affected by other software applications that are sharing the spotlight. Quitting those applications when exporting your video can optimize speed and reduce crashing or the slow crawl to the finish line. It's also a good idea to disable any plug-ins; they have been known to cause random crashes. Of course, you would not want to disable any plugins you're currently using.

Relinking media

WARNING

Chances are, your Premiere Pro project consists of content spread across different places on your drive and maybe even on an external SSD. With that kind of digital sprawl, the potential for clips going offline increases significantly. With the missing footage comes the dreaded red frame, as shown in Figure 15-9.

Several things can cause this to happen, including a change in asset location, renaming a file, a disconnected drive, or some other glitch. Whatever the reason, Premiere Pro unsuccessfully tries to find it, and you get a red card. Soccer (or football) references aside, the media needs relinking for Premiere Pro to play it back.

Sometimes, the fix is as simple as quitting Premiere Pro, making sure all the drives are connected, and restarting. The program finds the assets from the connected media and repopulates the timeline or Project panel. But if you moved assets or changed a filename, then that requires a little more work.

If that's not the issue, there are several ways you can fix the problem.

TECHNICAL
STUFF

1. **Right-click on one of the red tracks in the timeline — yep, they're red there, too — and when the menu comes up, click Link Media.** You can also right-click on the red item in the Project panel or go to File ⇨ Link Media.

2. **In the Link Media dialog, shown in Figure 15-10, click Locate and navigate to find the asset or file.** You can also let Premiere Pro do the work by clicking Locate on the bottom of the panel. Be warned that the search can take a while, and only if the media is still connected.

3. **When you find the file, click on it, and hit OK.** It's back, and the image replaces the frame.

FIGURE 15-9:
The dreaded red frame of a missing link.

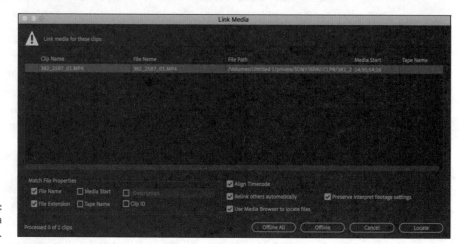

FIGURE 15-10:
The Link Media dialog.

Grabbing freeze frames

Freeze frames are still images made from your video. Also known as a "frame grab" or an "exported still frame," a freeze frame comes in handy for a variety of reasons, including the following:

- To take a still image from the video.

- To use in your movie as a still image. It's the only way for selecting a frame to show it for a few seconds.

- To emphasize a point. Something that makes the viewer stop and think. Once again, the "Modern Family" opening comes to mind.

- To promote your movie. Make still frames of vital scenes as part of a press kit.

- To use for a movie poster. While many posters are made from photographs, sometimes the best image comes from your video. Obviously this is problematic for a full-size poster, due to low resolution. But it works fine for an online poster.

- To create a thumbnail for online viewing.

Here's how to make a freeze frame

We've discussed the "why" when it comes to freeze frames, now it's time to look at the how to do it.

TECHNICAL STUFF

1. **Select a point of the clip in the timeline, and scrub through it to find the desired frame**. Once you find it, place the playhead over it; you see it in the Program Monitor.

2. **Click the Export Frame icon on either the Source Monitor or the Program Monitor.** This icon looks like a small camera, as shown in Figure 15-11. When you click it, the Export Frame dialog appears, as shown in Figure 15-12.

3. **If you want, you can change the name and select a format**.

4. **Designate where to save the frame.** Click the Browse button to navigate to the desired folder. You can also import the frame into the project by selecting the Import into project checkbox.

5. **Click OK.**

FIGURE 15-11:
The Export Frame icon resembles a small camera.

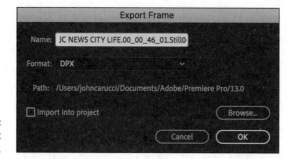

FIGURE 15-12:
The Export
Frame dialog.

Exporting a JPEG sequence

Not all movies contain video; some are a sequence of still images that play together like an animation. When it comes to photos, though, it's usually a time-lapse movie with each frame as a separate still-image file that, when played together, simulates motion. Exporting as a sequence is useful for the following purposes:

>> Using a clip in an animation movie

>> Making a time-lapse movie

>> Exporting for use in a 3D application

TECHNICAL STUFF

Here's how to export a sequence:

1. **Scrub through the video on the timeline to find the desired section.**

2. **Set the In and Out points.**

3. **Open up the Export panel by going to File ⇨ Export ⇨ Media.**

4. **Select JPEG from the Format menu.** The Preset menu should read JPEG Sequence. You can also select TIFF, but be aware that while the quality can be better, the size is substantial.

5. **Create a filename.** Click on the link, name the sequence, and navigate to the desired folder.

6. **Change the Source Range to Sequence In/Out.** You can find it below the monitor at the bottom center. Most of the time, it defaults to this setting, as shown in Figure 15-13.

7. **Click Export.**

FIGURE 15-13:
The bottom
of the Export
panel.

Chapter **16**

Kicking Out Your Movie

You've assembled the clips, color-corrected them, tweaked the audio, and — if you're adventurous — there's also some music, sound effects, and titles on your timeline. The movie looks great. Unfortunately, the timeline is the only place you can play it, which can be problematic, especially if you want to show it to anyone not residing near your laptop while it's running Premiere Pro.

The lesson here is to cut the proverbial cord and make your masterpiece a self-playing movie. First, you need to figure out the right size and format. But that's where things get complicated. Picking a size and format that works for your needs can feel overwhelming. So, consider what your needs are for the movie, and read on to find the answer that works for you.

Exporting Your Movie

In the spirit of just about everything else in Premiere Pro, there's no single solution when it comes to exporting your production. Numerous choices for export are available, and at your fingertips. Whether you're hoping to post a

video to your YouTube channel or show it on a big screen at a wedding, the journey to exporting video out of the timeline begins by going to File ⇨ Export ⇨ Media, as shown in Figure 16-1, which brings up the Export dialog.

Let's run through the process and then examine the options. Here's how to export your movie.

1. **Go to File ⇨ Export ⇨ Media** (or use the shortcut Cmd+M in MacOS or Ctrl+M in Windows).

2. **Choose your format.** QuickTime and H.264 are the most popular choices.

3. **Pick your preset.** This is specific to the format and depends on your needs. (See the section, "Choosing a format," if you're not sure.)

FIGURE 16-1:
Accessing the Export panel though the Main menu.

4. **Change the output name (if necessary)** by clicking on the link and changing the filename when the dialog pops up.

5. **Be sure that the audio and video checkboxes are selected,** or your file will be missing these components when the export is complete. Premiere Pro allows you to export audio and video separately, so be sure the boxes are checked. This comes in handy when all you need is video for an art installation, or audio, as part of a soundtrack.

6. **Click Export.**

The export time can take several minutes or longer, depending on a variety of factors, including the level of compression, frame size, frame rate, sequence duration, and computer processing power.

Familiarizing yourself with the Export panel

Before exporting the video from your timeline, it's time to make decisions about the kind of self-playing movie you want to create. After bringing up the Export panel, as shown in Figure 16-2, you see a healthy number of choices through pull-down menus, radio buttons, links, and tabs. Let's take a look at what each one does.

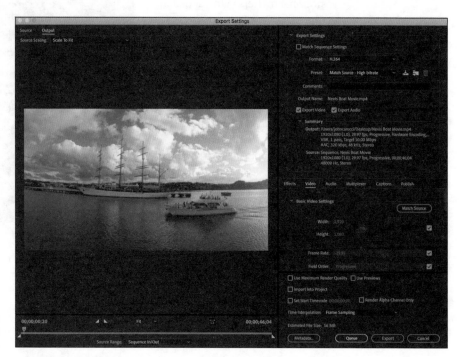

FIGURE 16-2:
A view of the
Export panel.

Choosing a format

Beginning at the top-right side of the export dialog, the first pull-down menu allows you to select the file format for your movie. As shown in Figure 16-3, this menu offers a robust selection of file types for both video and audio files. These include H.264, QuickTime, and WAV files, among others. And be sure to check the Match Sequence Settings.

Not sure what format you want? Here's the lowdown on some of the most common formats and why you should or should not use it.

>> **QuickTime:** More than a format, it's an entire framework, but that's not what matters in this situation. The QuickTime file format will give you an uncompressed file that's perfect for archiving and high-level showing but not so much for online use or sharing.

>> **H264:** A compressed format that holds its own, quality-wise, and is excellent for sharing finished videos and uploading to social media.

>> **WAV:** Essentially an audio file of your movie. Why would you need it? Lots of reasons, including clarification of a comment, creating an audio podcast, or uploading to a transcription site.

FIGURE 16-3:
The many choices found in the Format pull-down menu.

Introducing the presets

Depending on the format you choose, this next pull-down menu provides preset choices specific to the chosen format. For example, the H.264 presets will include variations in compression, file size, resolution, and even options for uploading to YouTube or Vimeo. After selecting H.264 in the Format menu, Figure 16-4 shows the various options that coincide with that choice.

Understand the top video file extensions

When using the H.264 preset to export, the video will have an .mp4 extension at the end of the filename. This compressed format prides itself on being the most common digital video format and can play on almost any device. MP4 works in a variety of situations, including when you upload videos to YouTube, Facebook, Twitter, and Instagram.

The popular extension MOV (with the file extension, .mov) for exported QuickTime movies ranges from lossless, uncompressed quality to a variety of compression settings. ProRes 422 works for most projects. The QuickTime format was developed by Apple for its QuickTime Player, although these files work well for various uses, including TV viewing.

Popular file formats

New to the movie file formats, or just need a refresher? The most popular choices for video are the H.264 and QuickTime formats. Supported by many devices and platforms, the compressed H.264 strikes the right balance between file size and image quality. This format is necessary when your intention is to upload a movie to the Internet or send it using a file transfer app for play. Editing is another story, and that requires an uncompressed format. QuickTime is a great option, especially if you plan to make other sizes and formats later with a video conversion program.

Here are some other popular file formats.

FIGURE 16-4:
There are so many preset choices for H.264, that you need to scroll to see all of them.

>> **WMV:** The Windows Media Viewer is to Windows what QuickTime is to Macintosh. Microsoft developed it for their Windows Media Player. The WMV file works well with YouTube, but other uses require a WMV player.

>> **AVI:** The Audio Video Interleave file format works with most web browsers on Windows, MacOS, and Linux machines. Another file format developed by Microsoft, AVI offers high quality and the large file size that comes with it. The AVI format is supported by YouTube and works well for TV viewing.

>> **MXF:** The Material Exchange Format is a robust, stable file container that supports numerous codecs and is ideal for video and audio. Based on SMPTE (Society of Motion Picture and Television Engineers) standards, the MXF video file format supports full timecode and metadata, allowing you to use those assets in many high-end situations, including TV broadcasting. Premiere Pro uses the MXF OP1a version of the format.

Some other formats include the following.

>> **AVCHD:** The Advanced Video Coding High-Definition file format, specific to high-definition video, was created for HD camcorders. The format retains high quality in a reasonable file size without losing any definition.

>> **MKV:** Developed in Russia, the Matroska Multimedia Container format is free and open source and supports almost every codec, but it has limitations because it's not supported by many programs besides open-source media players like VLC or Miro.

>> **MPEG-2:** 2002 called and they want to burn a DVD. If so, this preset works for you.

Checking the Summary

With information being our most vital resource, it's comforting to see the Output and Source data on the file you're about to export. A quick perusal of the Summary section, shown in Figure 16-5, will confirm that the output information matches your needs.

FIGURE 16-5:
Output and Source information in the Summary section of the Export panel.

> Summary
> Output: /Users/johncarucci/Desktop/Nevis Boat Movie.mp4
> 1920x1080 (1.0), 29.97 fps, Progressive, Hardware Encoding,...
> VBR, 1 pass, Target 10.00 Mbps
> AAC, 320 kbps, 48 kHz, Stereo
> Source: Sequence, Nevis Boat Movie
> 1920x1080 (1.0), 29.97 fps, Progressive, 00;00;46;04
> 48000 Hz, Stereo

The lower section of the Export panel

With a group of six tabs, as shown in Figure 16-6, the Export panel is the place for you to make advanced adjustments to your video before exporting. Effects, Video, Audio, Multiplexer, Captions, and Publish can all be tweaked, but are already adjusted based on the preset.

Bitrate Setting

There are three choices here: CBR, VBR 2-pass, and VBR 1-pass. CBR creates the largest file size and should only be used for situations that demand the highest quality, like a movie. VBR 1-Pass is the smallest. For most uses, VBR 2-Pass

works as a useful option. The sliders below adjust Target Bitrate and Maximin Bitrate. Measured in megabits per second, an HD (1920 x 1080 pixel) H.264 video should be compressed between 3 Mb/s and 5 Mb/s when played on your system. When uploading to social media, 10-15 Mb/s can work, because all social media platforms automatically recompress your media. When working with 4K, or UHD, 15-20 Mb/s works for storage on your own system. You can go 35-40 Mb/s for uploading to social media.

FIGURE 16-6:
Advanced
adjustment
tabs.

Checking the right boxes

There are a lot of radio boxes spread out over the Export panel. Let's examine them from top to bottom, and select the ones you need.

>> **Match Sequence Settings:** Does exactly what it says — matches the settings for that sequence.

>> **Use Maximum Render Quality:** Great for action sequences. Selecting this checkbox before exporting improves the quality of the motion in a clip. However, the rendering takes longer to export, increases the file size, and is processor-intensive.

>> **Use Previews:** An export setting based on using the preview files that Premiere Pro uses for playback, which are not the highest quality. It renders more quickly, but with less quality. This is a good setting to use for a low-quality export for review.

>> **Import into Project:** Selecting this checkbox adds a version of your file in the Project panel. This comes in handy when you plan on using the export as part of a bigger edit.

- **Set Start Timecode:** Another reference function, selecting this checkbox adds a timecode to your export, so it's possible to have an exact time where changes need to be made.

- **Use Proxies:** Check this option if you want to export a smaller version of your file, which is useful for sending review files to friends or clients.

- **Render Alpha Channel Only:** Selecting this checkbox lets you export an alpha channel.

- **Render at Maximum Depth:** Renders your video content in 32-bit color. Although few formats support this option, the video can still benefit as this function produces improved quality for effects and compositing when scaled to the format's actual bit depth.

Knowing the difference between file containers and codecs

An emoji and an emoticon are basically the same, but they're also different. While an emoji is a definable graphic like a smiley face or one with a winking eye, an emoticon is a typed character that gets the same point across. Type a colon+hyphen+closing bracket to make a smiley face in a text message, and your smartphone immediately turns this emoticon into an emoji. Insert :-) (smiley face) here.

That same relationship exists with codecs and file containers. Think of the codec as the software that compresses your video file, while the container is the package the final project uses for playback. Think of a container as a file cabinet that holds a variety of objects, only instead of documents, receipts, and indulgent magazines, these media containers contain video, audio, timecode, and metadata. In the file format world, the MP4 you see at the end of your movie file is the container, while the H.264 you chose from your pull-down menu is the codec. Some examples of file containers include MOV, JPG, and MP3, while MPEG-4, H264, and DivX are codecs.

WHAT'S A CODEC?

For starters, it's a portmanteau of coder/decoder. Technically speaking, the codec is a mini program that processes a video file — which can be very large — and encodes its data and compresses it for storing and sharing. The most common example is JPG, which makes your image files a fraction of their original size when stored. Others include MP3, H.264, DIV-X.

Setting output names for delivery

As mentioned earlier, clicking the Output Name link below the Preset menu on the Export panel brings up the dialog for changing the filename, as shown in Figure 16-7, where you can navigate to the desired folder or drive. If you haven't already done so when creating or editing the sequence, it's a good idea to use a naming convention for your files that will help you organize and differentiate them.

FIGURE 16-7:
Inputting the proper name in the dialog.

Here are a couple of suggestions.

>> **Naming convention:** A popular method uses an eight-digit date code that is either succeeded or preceded by the filename. Here's an example: 20211225_ San Diego Scene.

>> **Differentiate through case:** Use an uppercase naming style when exporting a master file. A clip package, cuts for other edits, and various edits should use lowercase.

Choosing the Right File Format for Your Needs

Before exporting your edited video, ask yourself, "How will the video be used and delivered?" Uploading an uncompressed QuickTime video to YouTube can work, but it takes longer to send, and the application needs to compress it. Compressing and uploading smaller files makes more sense because they are faster to upload and process. Besides, you wouldn't want to send a high-resolution video of Junior playing drums to Grandma over email. Even if it did eventually download, it would not be prudent. Just the same, if your segment were to play for an audience on a large screen, you wouldn't want to send a small file or an overly compressed one.

Exporting uncompressed video as a master file

Preserving the integrity of video and audio quality, the high-quality export retains the most data, making it suitable for high-quality applications. It also comes in handy when producing a master file.

Here are some export tips for this format.

>> After bringing up the Export panel and choosing an uncompressed format like QuickTime, you're on your way. But you're not there yet, because you still need to select a suitable codec. If you click on the Preset pull-down menu, you see a couple of dozen choices. Not sure which one to pick? One of the most versatile selections for high-quality uncompressed video is Apple ProRes 422 HQ. While this codec retains a great deal of information, you can expect a massive file size. (But that's the point, isn't it?)

>> If you go to the bottom of the panel and click on the Video tab, you will see the same choices, with the chosen preset listed there. You can make some tweaks under this tab, but unless you have something specific to adjust, you can leave it.

Pre-export checklist

Some things in life require multiple attempts to get right. You know, stuff like precise parallel parking or tying a Windsor knot. Exporting your video — well, that should not be one of them.

Depending on the size of your movie and the file format, the process can take anywhere from a minute to an hour, or more. While it's prudent to redo an export because of a silly mistake, it's better to make sure you check your video before hitting the Export button.

Here's a checklist to make sure:

>> **Watch the movie.** Using a similar logic to "measure twice, cut once," it's worth taking the time to view your movie in its entirety with a critical eye to make sure there aren't any issues with audio or video. Expand the Program Monitor panel to get the full-screen experience, as shown in Figure 16-8.

>> **Make sure all tracks are turned on.** Sometimes with more complex edits, there's a chance you're hiding a video track or muting audio to focus on a specific task. A quick scan of the timeline could save you minutes or even hours.

>> **Check audio.** Make sure there's continuity with the levels of each clip. Also check that audio levels are not clipping (in the red); otherwise, the sound on your movie will have distortion.

>> **Set In and Out points.** Sometimes there may be a short clip or even a couple of errant frames after your edit somewhere on the timeline. Premiere Pro has no idea that those few undetectable frames after minutes of black were unintentional. That makes the video longer, which in turn increases the file size and takes longer to export. Controlling the beginning and end ensures that all that you export is part of the movie.

>> **Eradicate flash frames.** Sometimes, there's an extra frame, commonly known as a flash frame, that you don't notice until it's too late, which can distract from the hard work you put into your movie. That's just another reason for watching your movie with an eagle eye before committing to export.

FIGURE 16-8:
Watch the
movie in full
screen.

Exporting a portion of the movie

Sometimes you don't need to export the entire movie — or maybe, not right away. Maybe, it's a long-form piece, and you need to show a clip for some reason or you want to export it in several parts. There are a couple of ways to accomplish a partial export. One way is to set In and Out points on the timeline and export. That works well. But you could also set In and Out points in the Export panel. Just drag the sliders beneath the image, as shown in Figure 16-9, and proceed as normal.

Pointing the file to a folder

The Output Name link on the Export panel is not just for changing the filename; it can also be used to save your movie in another location, either in a specific folder on your drive or on a separate one altogether. Just navigate in the dialog to the desired drive and export. Keep in mind that you need to point to that place each time you export.

Saving settings for future exports

Whether your project has a specific use, or you're just fond of your custom export settings, you can save them as a preset with your name on it. It's as simple as clicking the Save Preset button (located next to the Preset drop-down menu in the Export panel) and naming it when the dialog pops up, as shown in Figure 16-10. Name it after yourself, your dog, or whatever you like, so the next time you want to use it, you can just select it from the Preset menu.

FIGURE 16-9:
The In and Out
sliders in the
Export panel.

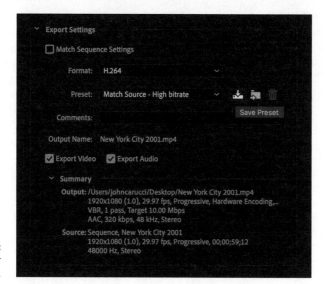

FIGURE 16-10:
Saving your
preset.

Converting outside Premiere Pro

While Premiere Pro lets you export numerous file formats and variations, it's not practical (for several reasons) to open an active timeline every time you want to export a specific format and resolution. On top of this, there's a chance you may inadvertently make unwanted changes on the timeline.

Once you're happy with your movie, it's best to make a high-quality master file and use it for exporting specific file types and sizes with a video conversion program, which lets you create whatever format your heart desires.

Here are several software options.

- » **Prism Video Converter:** Reasonably priced, this stable and comprehensive multi-format video converter can convert or compress video files within minutes into most popular formats. It even allows you to create files directly from DVD. Only for Macintosh. For more info, go to `https://www.nchsoftware.com/prism/index.html`.

- » **Adobe Media Encoder:** Installed as a sister program to Premiere Pro, every time you export a file, it's this program that encodes your video with the parameters set in the Export Panel. But it does more than that. Media Encoder can be used to compress and convert many file types.

- » **Movavi Video Converter:** Supports a wide range of media formats (nearly 200) and mobile devices, high-quality file encoding, and high-speed processing. Available for both Mac and PC. For more info, go to `https://www.movavi.com/videoconvertermac/`.

- » **Online Video Converter:** This free online media conversion application lets you convert any video link or file to a specific format without the need to install software on your computer. Fully compatible with most browsers, this helpful utility offers high-quality, quick conversions to dozens of formats. It's also supported by a wide range of online video portals, including YouTube and Vimeo. For immediate access, go to `https://OnlineVideoConverter.com`.

Chapter **17**

Spanning the Globe with Your Movie

After buckling down and working your fingers to the bone as you go that extra mile, along with any other idioms you choose to throw into the mix when it comes to describing the efforts you put into your masterpiece, the time has come to show it to an audience.

But this isn't 1984, so your options don't entail tacking a white bedsheet to the wall or stacking books under your projector for alignment. Nor is it 2004, when capturing tape playback from a DV camcorder required fingers crossed that the system didn't crash.

Today's choices offer more variety than the menu in your favorite coffee house chain. Showing your 4K movie on a large-screen LED television, uploading to a video site like Vimeo, or shipping it off for consideration to a film festival are a few potential options. Maybe you're not conventional in your pursuit of an audience, and it's the kind of piece that's got TikTok written all over it. Or maybe Tweeting is your thing. The possibilities are endless. And not even digital projection or playing a DVD are off the table. Because there are so many ways to get your movie out there and more places to send it, you'll surely need to figure that out now, rather than later.

Showing Your Movie

The idea of sharing movies has changed since the early days when aspiring filmmakers broke out a clunky projector for an intimate audience that included family, friends, and maybe their Film Studies professor. Some aspiring filmmakers made copies of their 8-millimeter movie reels to send to film competitions, prospective employers, and others with the hopes of getting noticed. That spirit remains alive today, but instead of a physical movie, you're sending a virtual one. And often, you're not sending it to a specific individual, but many — maybe even millions.

Here are some of the places you can show your movie to a wide audience:

>> Share on social media

>> Upload to video-sharing sites

>> Send as a file transfer

>> Burn to DVD (if you want to go retro)

On your computer

If this were the 1950s, and someone said movies would be constructed on a computer screen, it might have seemed an implausible premise. Or they would say that you were — I'll use a period-based insult — "off your rocker." Meaning something on the order of "being of unsound mind," especially with such a far-fetched idea.

REMEMBER

Movies are made with computers, and here, Premiere Pro serves as your main editing tool. It's a far cry from a generation ago when your desktop computer was a low-quality alternative with its small screen, low-resolution, and slow processing. So much has changed since the days of early MPEG videos. Computers are now much faster, the technology is far superior, and the monitors offer more detail than some people would ever want to see. Add an awesome sound system, and any location can turn into a screening room.

Watching on a smartphone

Think about the evolution of the smartphone. Not that long ago, the idea of watching a movie on your device was limited to short, low-resolution clips with buffering issues and some lag. Those days are long gone with the advent of 4G and now 5G, high resolution, better services, and so many other factors that make

watching movies on your phone, not just an option, but a viable alternative when you're away from home. As shown in Figure 17-1, a smartphone is a great place to watch a movie, even when you're on the move.

FIGURE 17-1:
Movie clip
shown on an
iPhone.

Tablet viewing

Somewhere between a computer and a smartphone lies the tablet. It's a high-quality tool that is accessible from wherever you happen to be sitting. In addition, they offer full access to advanced peripherals like a keyboard and sophisticated sound system. The size of the device makes it perfect for travelling, and the quality is 4K or better. Tablets like the Apple iPad (shown in Figure 17-2) or Microsoft Surface Pro provide a great way to watch movies. Not to mention its larger portable screen enhances the viewing experience.

Projecting on a screen

REMEMBER

The modern version of the cumbersome, whirring, dusty film projector makes for a great choice when showing your movie — the only noise that your audience will hear is superior audio. Assembling a group in your living room, basement, or backyard provides the look and feel of a movie theater. No surprise there, as digital projection lies at the foundation of how we currently watch movies in the theater. Connecting your computer or laptop to a video projector is a great alternative and can help you turn your own space into a perfect viewing environment. While it may not be as grand as a drive-in movie theater, tacking a sheet onto an outside wall of your house and projecting your movie on it can provide a similar experience, as shown in Figure 17-3.

3:14 PM Wed Feb 9

FIGURE 17-2:
Movie
played on an
Apple iPad.

FIGURE 17-3:
Image
projected onto
a bed sheet
screen.

Playing on a home theater

That brings us to big-screen television. With diameters bigger than an NBA star's wingspan, and affordable sound systems that will have your audience feel every crack and howl in your makeshift screening room, these TVs will give your local

multiplex a run for their money. Playing the movie directly through Premiere Pro, accessing it on a video-sharing site, or playing it from a portable drive can let you show a film with great impact.

Cast a movie on your iPhone or iPad

If your movie ends up on your iPhone or iPad, you can screencast to your flatscreen with relative ease.

Here's how:

1. Make sure your iPhone is connected the same Wi-Fi network as Apple TV. If you set them up together, chances are it's ready to go.

2. Locate the movie on your device and get it ready to play.

3. Click the Share button (the one that looks like a box with an arrow sticking up) and navigate down to Airplay.

4. Choose the television name and hit play.

A warning about intellectual property

WARNING

Because you can easily share your movie over the Internet, it also means that someone can use it without your permission. There's not much difference between your possessions being physically stolen and your content being virtually stolen when it's online. Both are violations and threaten what you've worked hard to accomplish. Remember, you are the creator of your work, and when someone uses it without permission, it's not only frustrating, but it's also stealing. While the public domain presents some challenges, there are some steps you can take to both lessen the chances of this happening, and also go after the people who perpetrated the crime.

Here are a few ways to protect your video.

>> **Monitor where you send it:** Don't just upload your video at will to every place that tickles your fancy. Instead, study each site and find out how your rights are protected. Also, limit where you send the video and keep a log of the time and site you've uploaded your files.

>> **Use a watermark:** Sometimes it's distracting, but it may deter content thieves from using it in the first place and also lets you confirm that it's your content. Let serious parties — like those acquiring movies or administering competitions — request a "clean" version from you.

>> **Periodically scour the web:** You'd be surprised how many users purloin content and retain your original filename. Regardless of it being dumb, brazen, or ignorant, when you find they've done it, you must let them know. Measures range from a cease-and-desist letter to taking legal action.

Using the World's Largest Screening Room

The idea of sharing movies has changed since the early days when would-be moviemakers made copies of their 8-millimeter reels to send out. Then came the VHS tape, which was a significant improvement in quality, including sound, not to mention that it would play in the ubiquitous video cassette recorder. The DVD took that premise to new heights by allowing creators to use nonlinear editing software like Adobe Premiere Pro. But all of those formats, as shown in Figure 17-4, were soon eclipsed by the digital movie file, which you can easily edit in Premiere Pro and export in 4K for maximum quality, so it can be viewed on someone else's computer not long after being uploaded.

FIGURE 17-4: The old formats included 8-millimeter film, VHS tapes, and DVDs.

Uploading your movie

Movie files are substantial in size, especially when you consider HD and 4K versions. Each online, social media, and delivery site has its own criteria when it comes to file size. Even when compressed, some of the longer movies generate

file sizes that entire computer systems couldn't deal with a generation ago. While handling big files has become the norm, it's important to strike the proper balance between file size, quality settings, and compression level before uploading to the Internet to play on numerous social media and video sites.

Sharing videos on YouTube

When it comes to sharing user-generated video content, this online sharing site is the de facto standard. YouTube, as shown in Figure 17-5, lets you upload short films, instructional videos, movie trailers, video art, music performances, and everything else in between.

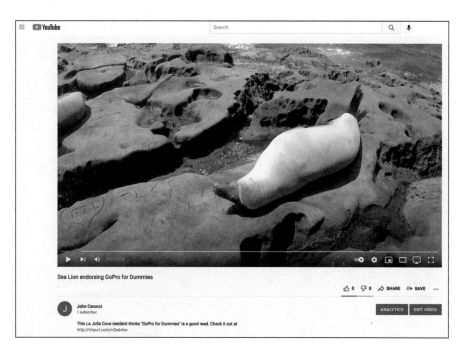

FIGURE 17-5: The familiar YouTube interface.

Five billion video views per day means that your content has the potential to have a lot of eyes on it. Of course, that's only if they know it's out there. If you're not ready for such an audience, you can make your movies private, sending would-be viewers an invitation to see them.

TECHNICAL STUFF

Here are some things you should know about YouTube:

>> It supports a variety of file formats, and allows for some to upload in full HD and even UHD (4K).

» Video length cannot exceed 15 minutes, unless you verify your account.

» It requires that the video was made by you, or that you are permitted to share it.

» The site provides basic analytics.

Uploading a video to YouTube is relatively easy. Follow these steps.

1. After logging in, go to the top of the page and click the Create icon — it's the camera with a plus sign (+) on it. When you click it, you see two choices: Upload Videos and Go Live. Select Upload Videos, as shown in Figure 17-6.

2. The Upload Videos screen appears. You can drag files onto the screen to upload them or click on Select Files.

3. After navigating to the desired file, select it, and click the Choose button in the bottom-right corner, as shown in Figure 17-7.

FIGURE 17-6:
The Upload Videos button.

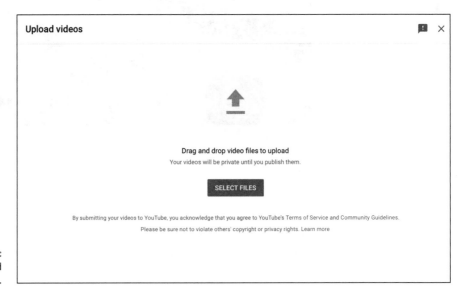

FIGURE 17-7:
The Upload Videos screen.

4. The next screen, shown in Figure 17-8, allows you to add details to your upload, including title, description, and thumbnail. You can also pick a playlist, and set audience restrictions, tags, category, and a host of other information. Hit Next.

5. The Video Elements screen lets you add subtitles, end screen, and cards.

6. The last screen provides the option for making the video public or private. Once you're satisfied, you can click Publish.

7. You can add metadata while uploading. Depending on the file size and length, uploading can take an hour or more. Use this time to properly name the movie and provide the appropriate information.

8. Watch your movie. Also keep an eye on the page views to see if you have a viral favorite on your hands.

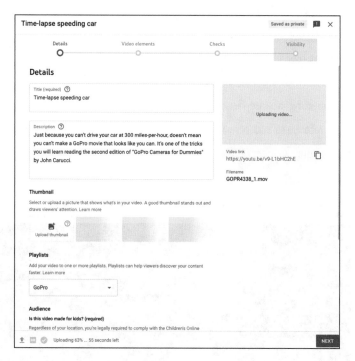

FIGURE 17-8:
The Video
Details screen.

Sharing video on Vimeo

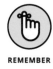

REMEMBER

This popular video-hosting site, as shown in Figure 17-9, acts as an alternative to sharing movies on YouTube. With a name cleverly derived as an anagram of *movie*, Vimeo acts as a more serious place for independent filmmakers to upload, share, and view movie content. Another notable difference is that this site demands that all uploaded content must be original, and they have strict requirements for commercial content.

SOME YOUTUBE DETAILS

While each site has specific requirements, YouTube lets you upload 4K and HD movies, providing the file is properly encoded.

Recommendations include the following.

- Container: MP4
- Audio codec: Stereo or Stereo 5.1
- Sample rate: 96 KHz or 48 KHz
- Video codec: H.264
- Frame rate: use as recorded
- Covers: 24, 25, 30, 48, 50, 60ß
- Interlacing: de-interlaced before uploading
- Bit rate: 50 to 800
- Resolution/aspect ratio: 16:9

FIGURE 17-9:
The Vimeo interface.

TECHNICAL
STUFF

Here are some things you should know about Vimeo.

>> **The origin of Vimeo:** It preceded YouTube.

>> **Much smaller community than YouTube:** Still, the site has approximately 175 million registered users and connects to more than 60 million video creators in more than 150 countries.

>> **Vimeo provides several levels of access:** While it is free to upload video, users are limited to 500MB per week of upload space, and 500GB total storage. An inexpensive Vimeo Plus account allows users a greater weekly upload amount, as well as the ability to limit advertisements before videos, unlimited HD videos, and unlimited creation of channels, groups, and albums. Vimeo PRO provides the highest level of service and offers large storage, third-party video player support, and advanced analytics.

Uploading a video to Vimeo is simple. Follow these steps.

1. **Log in to Vimeo.** You can use either your Vimeo account or your Facebook login.

2. **Click the Upload button.** The splash screen provides the option to drag files onto it, as shown in Figure 17-10, or to choose a file on your drive.

3. **Navigate to the video file on your computer and select it.**

4. **Upload the video file.** Click on the Upload Selected Videos button, as shown in Figure 17-11. Depending on the file size and length, uploading can take an hour or more. Use this time to name the movie and provide the necessary information.

5. **Admire your work.** You'll notice the sleeker presentation.

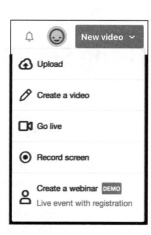

FIGURE 17-10:
The Vimeo splash screen.

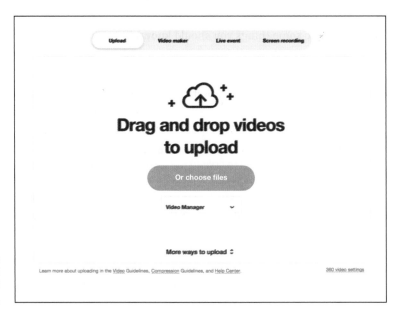

FIGURE 17-11:
The Upload
Selected
Videos button.

Using Social Media

When it comes to using social media for sharing your movie, purloining a bit of the Gandhi quote, "Remember the past, plan for the future, but live for today. . ." comes in handy.

Looking back on the methods that aspiring filmmakers used in the '70s and '80s, they seem as antiquated and irrelevant as Fred Flintstone playing a record on a player with a live bird using its beak for a needle. While that concept was clearly improbable, the notion of showcasing your movie as a silent 8-millimeter projection seems almost as far-fetched.

Here we are 50 years later, creating high-definition stereo movies that can make someone halfway around the world laugh or cry or smile or. . .write a nasty comment. Nobody has ever said that posting content on social media sites like Facebook, Twitter, Instagram, and TikTok is perfect.

Social media has become an important tool for easily sharing your movie with a global audience. It's become something that people depend on, like ordering take-out from a phone app or driving on a toll road without ever seeing a toll booth. Sometimes the biggest issue users have with social media is figuring out which app makes the most sense.

Let's take a brief look at their role as a vital place where your movies are shared, as well as some basic methods for uploading your movies.

Showing your movie on Facebook

TIP

Nearly three billion monthly active users participate on this social media site, with an estimated 500 million viewers per day. Yikes. It certainly provides a forum for your video. Of course, how many people see it depends in part on your friends list, and how effective you are at getting others to check out your movie. Facebook allows you to directly upload a video from your computer to the site, or you can add a link to YouTube, if your video is posted there.

TECHNICAL STUFF

Current Facebook restrictions are as follows:

>> The video should be less than 10GB in size.

>> Video length cannot exceed 240 minutes.

>> The video was made by you, or you are permitted to share it.

Uploading a video to Facebook is relatively easy. Follow these steps.

1. **Make sure the video is properly formatted (see the previous list).** Just because you can upload a short, uncompressed QuickTime file, doesn't mean that it's a good idea. Instead, make an MP4 movie file and use the H.264 video codec and main-profile AAC for audio. Make sure your video doesn't exceed the size or time limits you see on the upload page.

2. **Click Add Photo/Video at the top of your home page, as shown in Figure 17-12.** Click Post and grab a cup of coffee. While you wait, you can add some information, like a description of the movie.

3. **Share the movie.** Determine who gets to see it and tag. This is self-explanatory because you already know Facebook; otherwise, why would you post a video there?

Instagram

While Instagram is used primarily to capture video through the app, it's also possible to add a video edited in Premiere Pro. This used to be more difficult, but the process has become easier.

TECHNICAL STUFF

Here's how to upload a video to Instagram:

1. **Click on the Plus Box button at the top of the page.** In the list of choices that appears, click Post. You can drag videos directly into the space or click the Select from Computer link and navigate to the desired file, as shown in Figure 17-13.

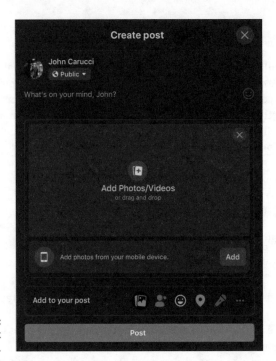

FIGURE 17-12:
The Facebook
Upload button.

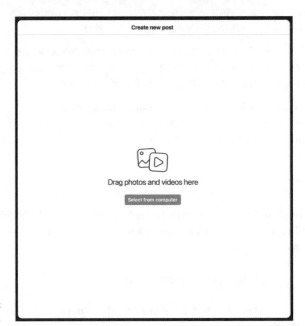

FIGURE 17-13:
Select interface.

2. **Once you locate the file, highlight it and click Choose.** That brings up the Crop screen.

3. **To crop the image, click the circle with arrows on the bottom right; to pick an aspect ratio, click the circle on the bottom left,** as shown in Figure 17-14.

4. **Once you are satisfied, click Next.**

5. **Pick a cover image** by scrubbing the video to find the desired frame.

6. **Trim the length.** This screen lets you add a caption, location, and comments on the image. You can also tag people.

7. **When you're satisfied, click Share.**

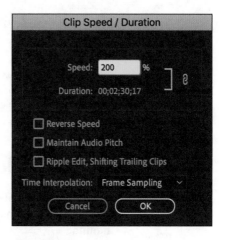

FIGURE 17-14:
Change aspect ratio.

Twitter video is meant to be short

With more than 200 million monetizable daily active users worldwide, Twitter is a big player when it comes to showing your movie to a wide audience. While it's not an ideal landing spot for a feature-length piece, it's perfect for short clips and to use as a means of promoting your movie. Just make sure that your movie is accessible to Twitter, either on your phone or through connected media.

TECHNICAL
STUFF

To upload and tweet a video, follow these steps.

1. After logging onto Twitter, click on the Plus button on the bottom right to start composing a new tweet, then click the icon to add Photos or Video near the bottom of the screen.

2. Click the All Photos button and navigate to the Videos section. Select the video you want to tweet. If the video isn't in the supported format, you will see a message. If not, proceed.

3. Edit the video. Twitter allows to change the In and Out points to trim the length. For most users, the maximum length is 140 seconds, so here's an opportunity to trim your video to conform to Twitter standards. Once satisfied, click Done in the upper right.

4. Complete your message and click Tweet to share your video.

INSTAGRAM DURATION

Like family visits and trips to the DMV, Instagram videos are meant to be short. How short? A regular post exceeding 60 seconds and/or 4GB will not post. But there's a way around this: you can post up to ten 60-second movies that can play in order. Think of it as a ten-minute movie with ten chapters — or whatever length.

Twitter video upload requirements

TECHNICAL STUFF

When uploading videos to Twitter, you need to make sure that your video file meets the limitations of video resolution and length. Here are some notes to keep in mind:

» Videos must be 2 minutes and 20 seconds (140 seconds) or less.

» Minimum resolution for Twitter video is 32 x 32 pixels, while maximum resolution is 1920 x 1200 or 1200 x 1900 if vertical is your thing.

» Supported formats by Twitter include, MP4 and .MOV on the mobile apps. From your computer, you have also use H.264 with AAC audio.

» The maximum file size is 512MB.

TikTok

TikTok hosts short-form videos — like, really short. How short are they? Some videos are so short you turn away and miss the whoile thing. The range can be anywhere between 5 and 60 seconds long, with statistics showing that the videos that perform best have a duration of 9 to 15 seconds. And they are often in the 9:16 aspect ratio — you know, vertical video. The brevity doesn't stop there, as the description character limit makes the "old" Twitter cap of 144 characters seem epic, with a range between 12 and 120 characters. TikTok has approximately one billion active global users and continues to grow as a great place to show your short video clips.

Most of the time, you're shooting video through the app and applying the appropriate filters and effects. But sometimes you may want to show short clips edited in Premiere Pro.

TIKTOK RESOLUTION

Resolution options include 720 x 1280, 640 x 640, and 1280 x 720. The user or brand name can range from 2 to 20 characters long, and app names should be about 4 to 40 characters.

TECHNICAL STUFF

If that's your thing, here's how to upload videos to TikTok:

1. **Open up TikTok on your smartphone or tablet.** It does not work on your desktop computer.

2. **At the bottom of the navigation bar, click on the "+" icon.** This provides the choice to record a video or to upload one saved on your hard drive.

3. **Click Upload to see the video gallery on your device.** Click on the one you want and click Next.

4. **Trim the video.** Drag the red rectangles for In and Out points.

5. **Add effects.** If you want add sounds, special effects, text, and more.

6. **Finalize your video.** You can add captions and hashtags, and then click Post.

Sharing your Movie

REMEMBER

Social media and online video sites have become so prominent that we often forget you can share your movie outright — you know, not through a video or social media site. Not that it's old school, but back in the day, FedExing a VHS tape, mailing a film reel, or physically bringing it somewhere was the old way to share. The methods of delivery have become more sophisticated, and while you can mail a digital movie, it still has to be on a drive or something. That's where file-sharing apps come in.

Let's look at some of the most popular ways to share your movie.

WeTransfer

Hugely popular and easy to use, this secure file-sharing application is browser-based and lets you upload up to a 2-gigabyte file for free. After you fire up the interface, a dialog pops up, as shown in Figure 17-15. Click the "+" icon and navigate to the desired file. Fill out your email, and the email address where you want

to send the file, and click Send. If you're not registered, the program generates a code and sends it to your email; you must then input this code before sending the file. Basically, you upload the files, and the application generates an email for the user to download on the other end. If you need to send larger files, you can opt for various prorated increases at a nominal fee. To get started, go to www.wetransfer.com.

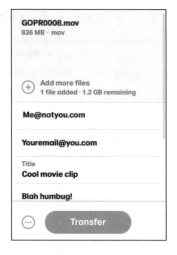

iCloud

If you're an Apple user of any sort (iPhone, Mac, iPad), then you get 5 gigabytes of storage for free and you're ready to use this unique space. Otherwise, you get 1 gigabyte, assuming you have signed up and have an Apple ID. The iCloud

FIGURE 17-15:
WeTransfer interface.

is more than a sharing site; it's a great place to store and grab video content captured on your iPhone. That is, if you enabled the Backup to iCloud function.

Log into the app from any computer by going to www.icloud.com and using your Apple ID. You can access the Photos app and navigate to the desired video or still images, export them, and then import into Premiere Pro.

iCloud Drive

TECHNICAL STUFF

While iCloud automatically backs up your data, the iCloud Drive is the place that you can do it manually. You can access it like any other drive and create folders and manually store data.

You can also store your movies in the iCloud. Just go to the iCloud icon and click on it. You see a default set of folders based on the pre-loaded Mac software, as shown in Figure 17-16. You can import directly into this space or create a folder.

1. To upload, click on the cloud icon with the up arrow and drag files from the left panel of your computer.

2. Navigate through the folders and double-click the content you want to save. You can also drag content into this space from your desktop or an open folder.

3. To download content, click on the cloud icon with the down arrow.

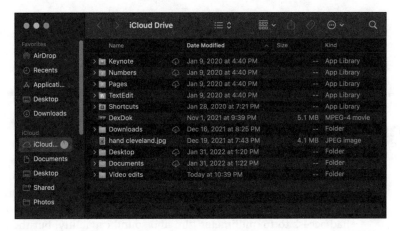

FIGURE 17-16:
iCloud Drive.

Dropbox

Dropbox probably has the distinction of being one of the most familiar file-sharing platforms. Their free account lets you store up to 2 gigabytes of files, and more space is available for both individual and business users. Basically, it's an array of folders and can share content by generating an email link. If this sounds like it will work for you, go to www.dropbox.com.

Hightail

Formerly known as YouSendIt, this cloud-based service allows you to send and receive files. Hightail offers a variety of affordable file-sharing plans, including its free Lite plan, which lets you upload files of up to 100 megabytes each, and has a storage limit of 2 gigabytes. You can find more information at www.hightail.com.

Google Drive

TECHNICAL STUFF

The Drive, as some affectionately call it, is a cloud-based data storage solution from Google that lets you save or share files and access them from anywhere online using everything from a computer to a smartphone. You can securely upload files and edit them online. At this time, Google Drive offers users 15GB of free storage, but you can get significantly more through optional pay plans.

1. **Choose who you want to share your movie with.**

2. **Go to drive.google.com to launch Google Drive.**

3. **Click on the folder you want to share.**

4. **Click Share.** Type in an email address or a Google Group you want to share with.

5. **Click Send.** An email is sent to the recipient you specified.

Going Old School

Back in the day, there was only one way to show your movie, and that was using a film projector with the only sound being the whirring fan and staccato shutter. Sound recording was generally out of reach for most users. Film students had access to 16-millimeter film and sound capability, but the cost of film stock alone was prohibitive enough to limit usage without a serious and rather generous benefactor.

On the beginner front, families would gather around the clunky projector and marvel at their likeness in silent movies. In some ways, it inspired a generation of young filmmakers to take visual storytelling more seriously. Unfortunately, 8-millimeter moviemaking wasn't really useful for more than family documentation and amateur moviemaking, the Zapruder film of the Kennedy assassination notwithstanding.

In the mid-1980s, sound came to the masses with the rise of consumer video. The VHS revolution changed the game by adding sound and the ability to record on tape. Users could immediately assemble clips together for viewing on television. While editing on the consumer level was crude, it was, at least, possible.

Today, outside of online viewing, there are many effective ways to present and share your movie.

Burning to DVD

TECHNICAL STUFF

While streaming has taken the shine away from the disc, it continues to hobble along as an entertainment option, especially with Blu-ray on the scene. While not as popular as it was a decade ago, the DVD is a great medium for physically storing and playing your movie. If you still have a built-in DVD burner, are using an external model (as shown in Figure 17-17), have decided to purchase a Blu-ray–capable model, or at the very least, have access to one, then here are some suggestions that can assure a smoother process.

>> **Use reliable media:** This one is a no-brainer. While brand-name DVDs from manufacturers like TDK, Verbatim, and Maxell (to name a few) provide

consistency from burn to burn, those discount brands by companies you never knew existed sometimes lack this consistency. That translates to repurposing those failed discs as drink coasters, and even then, the hole in the center defeats the purpose.

>> **Be sure the disc is clean:** You'd be surprised, but sometimes a smudge can corrupt the burning process and cause errors. Keep blank media in the package or case until using them, and make sure your hands are clean. Even if they are, grab the discs by the sides.

>> **Dedicate space to the processor:** Because burning a DVD requires a lot of processor work, be sure to close unused applications and windows during the process. Also, don't start typing and web surfing on the same computer during the burn. There's no reason to tie up memory and bog down the processor to check your fantasy football scores.

>> **Put some thought into it:** Don't just burn your project as a continuous-playing movie; instead, take the time to make chapter markers for different scenes. Also add some extras like behind-the-scenes chatter, outtakes, and bloopers. While you can read an entire Dummies book on making a DVD, you can also wing it because the software is usually intuitive. Anyway, you already know what a DVD should look like.

>> **Break your movie into sections, or chapters:** If you want to make your project resemble a store-bought DVD, then add some bonus material. Outtakes, interviews, and bloopers can add that extra flair.

FIGURE 17-17:
An external DVD burner comes in handy for playing old discs, or burning new ones.

DVD creation software

The death of the DVD has been greatly exaggerated. While rumors swirl regarding the end of the format, studios are still releasing titles, and players are still being sold. Although it's becoming less common to play a DVD, that doesn't negate its resilience as both a storage and self-playing format. If you want to make your own DVD, you need a burner, and software to make it.

Let's look at some of the software that's currently on the market.

>> **DVD Styler:** This is a free DVD-authoring application that works on Windows, Macintosh, or Linux. This easy-to-use application simplifies the process from the time you fire up the software. For more information, go to www.dvdstyler.org/.

>> **Wondershare DVD Creator:** This reasonably priced software offers a wide range of features including a built-in video editor, support for 150 file types, and Blu-ray capability. You can also easily create menus, make slide shows with music, and convert DVD files. For more information, go to www.wondershare.com.

>> **DVD Flick:** This free Windows-based DVD-authoring software can handle a vast assortment of file formats and video codecs. It provides tools to fully author your DVD to create chapters, perform advanced encoding, and burn the project to DVD disc. Unfortunately, it does not support Blu-ray.

Export to tape

REMEMBER

"Let's go to the videotape" was old-school sportscaster vernacular for looking at a play that just occurred. Now they say *replay*. But going to the videotape is still an option for your Premiere Pro project. It's not as common as it used to be, and not everyone has a videotape camera or even a deck. So, if you save your movie on tape, this is possible with Premiere Pro.

DV and HDV are less likely choices, but the HDCAM SR is still used. While the SR in its name can imply *Still Relevant*, it actually stands for *Superior Resolution*, and lives up to that moniker by capturing the signal to tape as purely as possible. Another popular output choice, especially with streaming services like Netflix is the Linear Tape-Open format, or LTO; it's a magnetic tape storage option that remains the industry standard for archiving media. So, at this point, the death of tap, has been greatly exaggerated.

TECHNICAL
STUFF

Record a sequence directly to videotape on either a camcorder or video recorder using the following steps.

1. **Connect the camera or deck to your computer.** Many models have a USB connection, though some older models may use Firewire. Because that technology has not been used for generations of computers, you will need an adapter.

2. **Check the settings.** If you're using a DV or HDV camcorder, make sure it's set to the VTR mode, and not camera. Also, is the deck or camera on? If not, turn it on now.

3. **Make sure the deck is set to record.** Cue the tape to the point you want to begin recording. You can hit Play and Record and pause it until you're ready.

4. **Select the sequence.** Either click on the timeline or set In and Out points to the sequence you want to record.

5. **Play the sequence.** This is to make sure that it's going to your device.

6. **Give the deck a head start.** Even if you hot-record on the deck and play on the timeline, you will miss something. Instead, add 30 seconds, or longer, in the timeline. You can add color bars and a title card of your company or name (animated, if you have one) or just move the movie up in the timeline and reproduce black.

7. Go to File ⇨ Export ⇨ Tape (DV/HDV).

Color bars

Color bars precede video content, acting as a test pattern for calibrating chroma and luminance values on video monitors. Commonly used back in the days of analog NTSC video, they are still used today.

The latest version of Premiere (v22) offers an improved Bars & Tone menu, providing both HD and HDR bars, along with a unified tone interface.

You can generate color and tone in Premiere Pro by doing the following:

Go to New ⇨ Bars and Tone. You can also click on the New Item icon on the bottom of the Project panel, as shown in Figure 17-18. When the dialog pops up, change the setting to match the

FIGURE 17-18:
Selecting Bars and Tone using the New Item icon.

sequence, if necessary, and click OK. By default, the duration is short. You can extend it by dragging to make it 15 to 30 seconds.

Adding a good leader

TIP

For good measure, a lead-in time of one minute provides enough leader for your movie, whether it's outputted to tape or not.

Here's an effective way to add a lead-in time.

1. **For color bars, lead off your edit with 15 to 30 seconds of color bars, as shown in Figure 17-19.** For black and white, lead off with 5 to 10 seconds of black.

2. **Add your title card.** You've shown these before at the start of a movie. The MGM lion qualifies, though you may want to settle for a simple animation with your name or production company.

3. **Let it run for 10-25 seconds.** Do this after you've completed the title card or animated title sequence.

FIGURE 17-19:
Color bars.

5

The Part of Tens

Chapter **18**

Ten Ideas for Making Fantastic Movies

After assembling your movie and having some idea of the narrative, it's time to "tighten" it up. Maybe you have some idea of what you want to do, or maybe you're just not sure how to take it to the next level. Let's exercise those creative muscles by checking out some of these ideas that can work for your movie.

It's always a good idea to think about your favorite films, television shows, or even YouTube videos, and the definitive techniques used in each. Maybe it was the narration in *Joker*, the subtitles in *Squid Game*, or suspense built through montage editing in a classic film like Sergei Eisenstein's *Battleship Potemkin*. Many of these techniques were added after the movie was shot and before or during editing. So, in no particular order, let's examine some ideas that can make your movie sing.

Making Your Own *Brady Bunch* Opening (Or Something Like It)

Here's the story of nine different layers that all play independently to produce a very lovely opening. Actually, it's one of the most iconic television sitcom openings of all time. While too complex back in the 1970s to create at home, now it's not only possible, but relatively doable to make this sequence yourself. While more details are available in Chapter 11, essentially, you would take nine different video clips, or whatever number you feel comfortable using, and translate them into your own composite sequence, as shown in Figure 18-1.

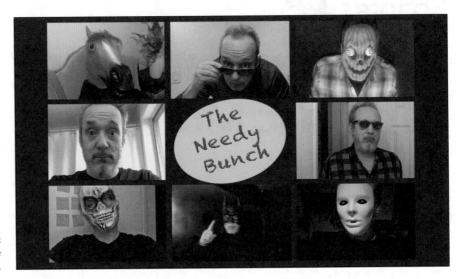

FIGURE 18-1:
Multi-image composite.

You will need to do the following.

>> **Add tracks:** Depending on the number of tracks, you should add them before starting the edit. Go to Sequence⇨Add Track, and when the dialog pops up, type in the number in the Add field, as shown in Figure 18-2.

>> **Make sure the color and tones match:** There's nothing worse than color differing in similar shots that will be seen together.

>> **Name your assets:** Each clip should have a distinct name, and you should probably the add the track number.

>> **Do the math:** Most likely, you're using a 16:9 aspect ratio, so make sure than you calculate the actual size for each asset.

>> **Use the Crop tool:** It provides the most control, and you can see a detailed explanation of this tool in Chapter 12.

>> **Use only video and aim for the right track:** Drag each video asset into a separate track by using Target each track.

>> **Turn off Audio targeting:** This way, when you drag the clip, it doesn't include audio tracks, which will only get in the way and make your timeline higher than longer.

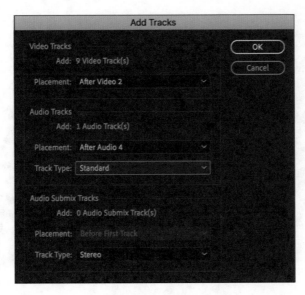

FIGURE 18-2: Adding tracks to accommodate clips.

Exploiting Montage Editing

Nearly a century ago, Russian filmmaker Sergei Eisenstein changed the game of moviemaking forever with his concept of montage editing to build suspense. His *Battleship Potemkin* steps scene has often been replicated, including an homage by Brian De Palma in *The Untouchables*. The idea is to construct the scene using quick cuts from different angles, patched together to make the scene more interesting.

Here are some tips for creating a montage.

>> **Have a great establishing shot:** Montage editing includes a lot of detail shots. So, it's important to set the tone with a strong opening, as shown in Figure 18-3.

- » **Start off strong:** Don't hold back; dazzle from the start.

- » **Alternate shots:** Go from wide to tight, change angles, include camera moves, and anything else that makes your audience focus on the action, like a cat looks at a bird or a string.

- » **Use cutaways to help with pacing:** Showing different parts of the scene can help the pace of the action by allowing you to cheat time as you return to the main action.

FIGURE 18-3:
Establishing a shot for a montage edit.

Showing Restraint While Using Plug-ins

Sometimes you want to take that extra piece of cake, and that voice in your head says, "Really?" The same idea applies to using plug-ins, or more accurately, over-using them.

With hundreds, maybe more, of plug-ins available for Premiere Pro, it's like a smorgasbord of choices, and like that big buffet, sometimes people tend to take more than necessary. Plug-ins provide an endless number of special effects, graphics, transitions, and correction tools. And while using them on a case-by-case basis can certainly improve the look of your movie, think of it as a salt-shaker: something to use sparingly. When strategically used, plug-ins can take your movie to the next level. But overusing them can diminish the quality of your movie and make it look amateurish, so choose wisely.

Transforming Your Movie to Film Noir

The great films in the film noir genre include *Sunset Boulevard* and *D.O.A.* You can emulate the look of film noir, providing the content works for it.

Identified by high-contrast black and white, this iconic style can add a retro sensibility to your movie. The word *film noir* translates from French as "black cinema" and describes a certain Hollywood style that used high-contrast black and white cinematography with ominous themes.

Here are some tips for lending your movie a film noir look.

>> **Convert to black and white:** Create an adjustment layer by going to File ⇨ New ⇨ Adjustment Layer. Size it to cover the entire timeline. Then go to the Video Effects folder and navigate to Image Control ⇨ Black and White. Drag the icon onto the adjustment layer (or you can double-click Black and White to apply the effect).

>> **Boost the contrast:** To get that noir-ish look, just go to Video Effects ⇨ Color, as shown in Figure 18-4. Go to Correction ⇨ Brightness Contrast and drag it onto the adjustment layer. Give the contrast a boost by going to Effect Controls, navigating down to Brightness and Contrast, and dragging the Contrast slider a few points to the right.

>> **Use ominous shots:** If you know your intention is to pay homage to film noir, look for shots with shadows, harsh lighting, and some element of danger.

>> **Narrate it:** A lot of classic film noir contains a narration by either the subject or an observer to fill in details of the story.

FIGURE 18-4: Boosting contrast.

Making Still Images Move (The Ken Burns Effect)

The concept of animating still photos with narration to make a compelling documentary has become an essential part of filmmaking. And while Ken Burns had little choice for doing it with his epic *The Civil War*, because, umm, there wasn't any film or video in the 1860s, that's not the case today. Still, this technique of animating still photos, as described in Chapter 12, has its place as a component in your movie.

Here are a few aspects to consider.

» **Make sure every move has its intention:** You want to show the viewer some key aspect, like a facial expression or detail.

» **Use transitions:** Here's a place where over-the-top transitions like a Cross Zoom or Page Peel can shine.

» **Alternate shots:** Try not to place similar shots next to each other. For example, if you show the same wide view that slowly zooms in, instead of pairing it with a similar shot, try the opposite, and start at a detail and slowly zoom out.

» **Vertical photos:** This is not smartphone photography, so don't place a vertical in the horizontal frame. Instead, enlarge the image so the edges fill the frame, and then tilt up or down with your settings.

Adding a voiceover

Can you imagine watching *The Shawshank Redemption* without hearing Morgan Freeman carry you through the story, or the authority in Sir David Attenborough's voice telling us how the natural world is changing? Maybe TV sitcoms are your thing, and it's Jim Parsons taking you through episodes of *The Big Bang Theory* spinoff, *Young Sheldon,* that you find comforting. Whatever your poison, it's hard to imagine the absence of the narrator, no matter how unreliable thousands of college essays may suggest that they are.

Voiceover plays a big part in everything from a TikTok video to an epic film. So, it's certainly a device on the table for your project, too. And the beauty of it is that you can do it after your edit is assembled.

Here are tips for making a voiceover for your movie.

>> **Adapt to the subject matter:** If you're doing a movie, you should speak in character, as if you were an actor.

>> **Speak clearly:** The audience should hear what you have to say in a clear and natural manner.

>> **Have a natural delivery:** While this can apply to the first two tips, it also means that it should not sound like you're reading off a script, or sound monotone or like a robot.

>> **Rehearse:** Sounding natural comes from being familiar with the script.

>> **Record in a quiet place:** A small room and some blankets to absorb sound should suffice.

>> **Take the best parts:** Like the lady that stands over the apples at Trader Joe's, pick the best take of the voiceover when editing. You can edit the audio track in Premiere Pro, as shown in Figure 18-5.

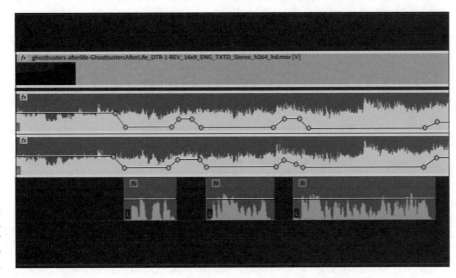

FIGURE 18-5:
Cut pieces of voiceover arranged in the timeline.

Producing Your Own News Segment

Whether you're looking to create a news report as an element of your movie or providing some serious information for a YouTube or social media video, the end result remains the same if you want to replicate a news report.

Creating your own news report depends on having all the pieces and putting them together. Most reports last around two minutes, so you need to get to the point quickly.

Here are the elements that you need, and some tips for capturing footage.

>> **Narration:** Will the subject be live or do you plan on a voiceover? Most news reports consist of both, and you can do the standup, as it's known, in front of the camera, and still use the sound with the scene you are talking about on top of it. If this is the case, the reporter should look into the camera.

>> **Interviews:** People who are being interviewed should follow the rule of thirds, meaning they should be off center and looking into the open space. Also, subjects should look off-camera, usually at the reporter. The only person that looks directly into the camera is the anchor or reporter.

>> **B-roll:** Provide adequate footage to show while the narration takes place, and allow for "breathing" room. That means, let the viewer hear natural sound before the narration continues.

>> **Lower thirds:** These are the titles beneath each person who speaks on camera, and are explained in Chapter 14.

Using Transitions to Help Tell the Story

When it comes to visual communication, it's the scene that must tell the story by how you frame the shot, choose the scenes for your sequence, and how you transition from one shot to the next. While there's an entire chapter dedicated to Premiere Pro transitions, here are a few tips to make them an effective part of your storytelling.

>> **Don't overuse transitions:** Make sure you use them only when you need them.

>> **Use clip handles:** Most transitions require extra frames to sample. If have few, or none, it's not possible to make the transition work.

>> **Think about why:** Are you looking to show a passage of time, to mark the close of a scene, or to take the viewer to another location? Maybe it's to "soften" the transition of clips. Those are all good reasons. Using it because it's a cool effect? Probably not a good idea.

Applying a Filter Over Your Movie

Perhaps you want to stylize your movie and make some blanket changes to color, density, sharpness, or some other factor. Rather than make the adjustment to every clip in your timeline, you can make a blanket adjustment by creating an adjustment layer, and dragging it to the top video track. See Chapter 10 for more info on making an adjustment layer.

Here are a few ideas.

>> **Black and white:** Transform your color edit into a black-and-white movie with a simple action.

>> **High-contrast color:** Intensify the color and tones to provide a stylized look to the footage.

>> **Color cast:** Maybe you want to warm up the look of your movie, cool it down, or lend a slight color tint, as shown in the video still in Figure 18-6.

>> **Dreamlike:** Combine color cast, lower contrast, and perhaps a slight blur to create a dreamlike image.

>> **Sepia:** In the early, pre-color days of cinema, movies were often tinted in a sepia tone to provide a more pleasing look.

FIGURE 18-6:
The style choice for this one used cool undertones.

Having Fun by Reversing Motion

Reversing motion can help you do everything from making a statement with your movie to entertaining the kids. This special effect plays back the capture by showing it backward. Reasons for using this technique include for comedic effect, or as an effect to retrace the action.

Showing a reverse of diving into a pool, or a wide shot of pedestrians during rush hour certainly draws interest, and can keep the viewer engaged and help visually tell your story. The technique is simple, and can be found in Chapter 7.

Here are some ideas.

>> **Pouring iced tea from a pitcher:** Or any other liquid going back into the container.

>> **Frying an egg:** From cooked to back in the shell.

>> **Blow-drying your hair:** A finished hairstyle that gets wetter as the scene progresses.

>> **Uncrumple a piece of paper:** It's funny to watch it uncrumple.

There are so many others — just have fun and use them at the right moment.

» Letting your still images sing

» Making up for a lack of makeup

» Producing pro-quality effects

Chapter **19**

Ten Essential Premiere Pro Plug-Ins

P remiere Pro plug-ins can enhance your experience with moviemaking. These software additions customize your movie with powerful tools that nicely dress it up. While varying in functionality, these program add-ins enrich the moviemaking experience by allowing you to take your expression to new levels with some extra pizazz. Maybe you want a cool transition that looks nothing like your father's dissolves and wipes. Perhaps you're looking to easily correct a common problem like an unflattering skin tone. Done and done.

With an addition for every problem you can think about solving, and so many more that you could not have imagined, these mini-apps really change the game. They offer amazing creative choices, and functionality, and many of them will match your needs and, more importantly, your budget. They range in cost from free to expensive, with some trial runs and a few subscription-based choices thrown in.

HOW TO LOAD PLUG-INS

If you're new to Premiere Pro, chances are you're also new to installing plug-ins, so here's a brief tutorial for putting them to work after you download them.

1. Go to the Effects panel.

2. Click on the 'hamburger' menu (that's the three-lined menu button).

3. Select Import Presets.

4. Navigate to the downloaded preset and click Open. It installs in Premiere Pro.

5. You can find the plug-in in the presets bin, or type its name in the search field.

Knocking Out Your Movie with the Cine Punch Bundle

Massive and *diverse* understate the number of tools in this bundle when it comes to adding a little zip here, some zest there, and a whole lot of pizazz. This immense collection of effects, presets, transitions, and sound can help further translate your vision into impressive movie effects. Maybe you want to "soften" the look of your scene with a "haze" overlay, imitate the appearance of a vintage projected image, or try out one of the numerous transitions. All in all, there are thousands of choices in the bundle — too many pieces to describe in this blurb. Rest assured, there will be something that works for you in this affordable bundle.

To check out what each tool can do, and for more information, go to `https://videohive.net/item/cinepunch-video-creation-suite/21485487`.

Roll with Motion Array Premiere Pro Transitions

Focusing on transitions, this hefty set of add-ins begs the question, Why would you conform to the few transition choices in Premiere Pro when you can find the perfect one for a scene? This unique set helps you create some interesting transitioning, from the distortion of Bad Signal to the fresh look of Paint Splat, letting you can take your movie to the next level. There are so many choices, but you can

look through them on the Motion Array website to find the right one. Just go to www.motionarray.com/plugins/PremierePro for more information.

Making Your Still Photo "Pop" Using Photo Montage 2

Maybe you want to include a selection of photos in your movie. Better yet, you want to make a compelling movie with photos and text that doesn't look like a slide show. This unique addition to Premiere Pro goes beyond the humdrum methods of showing still images. You can easily create some tight presentations, replete with specialized transitions, streamlined pacing, animated images, and strong titling that can make an impressive movie with a small number of stills. More information can be found at www.fxfactory.com/info/photomontage/.

Producing the Look of Film Stock with Film Convert Nitrate

Back in the day, film emulsions gave movies their distinct charm. This evocative appearance of a film look can work for your movie, and you can emulate the texture of filmstock with this unique plug-in and its numerous emulsion profiles, replete with grain, which was created at ultra-high resolution. This helpful add-in provides the look of different film stocks. You can even load 3D LUTs (look-up tables) to share with others working on your film. A full description of LUTs is covered in Chapter 10.

Just go to www.filmconvert.com for more information.

Emulating *Star Wars* Opening Titles with the Free Star Titler

Now you can easily replicate the *Star Wars* iconic opening crawl with this unique plug-in from FxFactory. While not appropriate for every situation, it's the perfect plug-in if you need the force to be with you.

Just go to https://fxfactory.com/info/startitler/ for more information.

Sweetening Up Audio with Accusonus ERA 5 Bundle

Audio problems are common when making movies, so it's nice to have a substantial set of tools that goes beyond the effects in Premiere Pro, and simplifies the process at the same time. Whether for noise reduction, voice compression, and reducing pop from plosive sounds, this set of tools can make you feel like an audio engineer without knowing much about the job.

More information can be found at `https://accusonus.com/products/audio-repair/era-bundle`.

Prettying Up Your Subject's Skin Tones with Make Up Artist 3

This plug-in lets you put on some makeup, literally. This Digital Anarchy plug-in acts as digital makeup application that lets you match skin tones, smooth wrinkles, and reduce shine. Your actors and subjects will probably appreciate your efforts. FX Factory has hundreds of versions of plugins for Premiere Pro. For more information, go to `https://fxfactory.com/info/makeupartist3/`.

Adding Pizazz between Shots with Andy's Swish Transitions

Bored of the dissolve and tired of the wipe? This set of tools can up your transition game. Appropriately titled, this unique set of transitions provides a blurred motion feel for your movie. It's not for every edit, but these transitions work well with anything that involves action.

For more information, you can go `www.fxfactory.com`.

Making Seamless Time-Lapse and Slow-Motion Video with Flicker Free

If you're an advocate of capturing time-lapse or slow-motion scenes, then this one is a must-have. More of a specialized plug-in, it corrects the flicker that's common when capturing a scene with unusual time. That's because time exposure often captures different exposures, creating a flicker. Flicker Free helps normalize exposure throughout the capture, and removes or reduces flicker. It can also fix issues with slow-motion capture.

Just go to `https://digitalanarchy.com/Flicker/main.html` for more information.

Simulating Beams of Light Coming through Portals with Light Rays

This is a relatively small set of presets that can lend your scenes a modern, stylish look with colorful rays of light. Much like the Star Titler, this one has some really limited uses, but when you need it, it's the perfect addition. For more information, just go to `www.motionarray.com`.

Chapter **20**

Ten Tips for Making Video Easier to Edit

Film director David Fincher once said, "People will say, 'There are a million ways to shoot a scene,' but I don't think so. I think there're two, maybe. And the other one is wrong."

The director of *Fight Club* and *The Social Network* has a reputation for shooting every scene until it's just right. But striving for perfection in your own movie shouldn't require dozens of takes. I'm looking at you, Mr. Fincher. But it's hard to argue the perfection of his films and how every scene moves the story.

The same dedication can hopefully work for you, not just with the shooting of your movie, but also when it comes to post-production. This includes everything from shooting the scenes just right and having great audio to checking quality control with a broadcast monitor and creating a master file. So, to maximize the editing potential of your movie, it's important to consider a slew of factors that contribute positively to your masterpiece.

Shooting Movies "Horizontally" with Your Smartphone

TIP

The hotly contested issue of the orientation you choose when shooting with your smartphone pits the vertical video camp (sometimes called portrait mode) against the more traditional horizontal shooters (or landscape mode). Not too long ago, holding your smartphone vertically and recording in the portrait view, as shown in Figure 20-1, was the signature of an amateur. That criticism has softened over the years, with vertical orientation not affecting social media views. So, it's hard to argue when users accept a new normal.

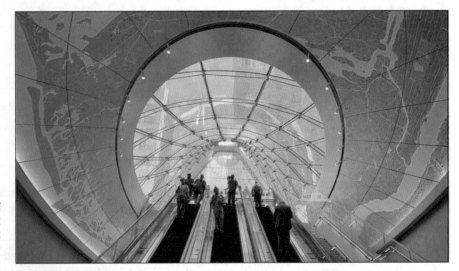

FIGURE 20-1: Screengrab of video being captured using landscape orientation.

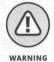

WARNING

While that works for Twitter, Instagram, and other social media sites that people incessantly view on their phones, it's less effective when shooting scenes for your movie with an iPhone. In this scenario, horizontal alignment, as shown in Figure 20-2, works well with our vision. C'mon, our eyes are designed for viewing the world on a horizontal plane. That's why movies and TV have always looked that way. Besides the physiological reasons, traditional perspective also makes more sense. For example, if you have more than one person in the scene, are you going to stack them on top of one another?

There are no hard-and-fast rules here. Both orientations can coexist in the same movie, but only if it adds to the story. One method, known as video device framing, allows the viewer to see the capture on a smartphone in the scene.

Producing Better Video to Edit by Keeping It Steady

"Keep the camera steady, Eddie. . .or Betty!" When I was a kid, I would help my dad work on oil burners. At eight years old, I was regularly given the job of holding the flashlight. Numerous requests of "hold it steady" rang out through what seemed like an eternity, although it was more like two-and-half minutes. But the reality is that it's not possible to hold a flashlight on target for long periods of time, just as it's not possible to effectively handhold a camera when making movies.

FIGURE 20-2:
Screengrab of video being captured using portrait orientation.

WARNING

Home videos are rarely taken with any stabilization, so the footage sometimes appears as if it were taken from a rowboat swaying with the tide. The most practical way to take care of the issue of unsteadiness is mounting the camera on a tripod. Not only does it keep the picture steady, but it also helps with framing the scene. Using a tripod is a good first step, but it's not always practical, either for the situation or for the idea of lugging it out.

REMEMBER

For those times when a tripod doesn't work, there are a host of solutions that can help facilitate a steady shot.

Here are a few ideas to make it work:

>> **Use a monopod.** Three legs are good, but there are times when one leg is best. Enter the monopod to help you balance your camera or camcorder and keep it steady. Some sophisticated models include stabilization now, such as the Steadicam Air 25.

>> **Consider a stabilization device.** You can try an affordable Steadicam or perhaps a *gimbal* — that's a device that keeps handheld footage looking normal and uses the same principle as keeping video from a helicopter shot steady. Basically, this hand-held device uses sophisticated motion detecting that differentiates between intentional movements and unwanted camera shake.

>> **Rest the camera on a firm surface.** It's funny how a window ledge, park bench, or curb works when you don't have a choice. When crouching, kneeling, or lying down, rest your elbow on a solid place to reduce motion while shooting, as shown in Figure 20-3.

>> **The poor man's stabilizer.** You can use a piece of string to hold the camera steady when shooting your movie. Tie a string around your camera and let it drape to the floor. Put tension on it with your foot and pull upward to create tension while shooting.

FIGURE 20-3: Resting the camera on a railing helped keep the scene steady.

Shooting to Edit for Quicker Turnaround

While great films are made in post-production, the process begins with shooting each scene quickly and efficiently. One method that news crews use to get a story out quickly is known as *shoot to edit*. That means you shoot the segment in order with variations. This helps with putting the segment together. Next time you're watching a movie, notice the shot structure, and keep in mind that it's not done haphazardly.

REMEMBER

For every shot, try to shoot several variations of the angle or background that give you some choices when it's time to edit. Also keep in mind that using a wide, medium, and telephoto sequence, as shown in Figure 20-4, can add some much-needed flair before going to a speaking person.

FIGURE 20-4:
This composite image shows a wide, normal, and telephoto view of the same scene.

Here's a breakdown of the different shot types:

» **Establishing shot:** Generally, a wide-angle shot that lets the viewer get a sense of the landscape, place, or logistics of a scene. This is usually the opening shot of a movie, but it can also be used when the location or time changes in the movie.

» **Wide angle:** An expansive view of the scene that shows the subject in relation to their environment.

» **Normal:** Debated forever, the concept of 'normal' is continually in question. But when it comes to perspective, the answer is a little simpler. It's the perspective at which our eyes typically see.

» **Telephoto:** A magnified view of the scene that brings distant objects closer. At other times, it's used to create a close-up. Sometimes you may opt to control depth-of-field to differentiate the subject from the background.

» **Pan:** Sweeping motion of the scene that goes from side to side. This is useful as an ending shot, or to transition from one subject to another.

» **Tilt:** An up-and-down motion of the scene, or the reverse, used to make a great segue or introduction.

» **Zoom:** The technique of using the focal length to draw the subjects closer or move them further away while shooting the scene.

Taking Advantage of Natural Light

Mirror, mirror, on the wall, what is the greatest light source of all? The big yellow one in the sky clearly wins that distinction.

WARNING

Nobody argues this point because sunlight is bright, diverse, and complementary. Not just because it flatters the subject with illumination, but also because its cost is gratis. No equipment purchase, power, or maintenance is required here. So, what's the catch? The same one that makes your beach vacation less than perfect. Because sunlight is a passive light form, it offers you no control. But that doesn't mean you can't take advantage of direction, shadow, quality, and background to suit your needs, as shown in Figure 20-5.

Consider the following.

>> **Try to use sunlight from a lower angle:** This creates the most flattering illumination, and it's generally warmer, too, as shown in Figure 20-5.

>> **Avoid overhead light:** When the sun is beating straight down on the subject, it's not flattering and creates harsh shadows.

>> **Take advantage of an overcast day:** Direct sunlight is sometimes harsh on the subject because it skims across the face and creates shadow and texture. As a result, most people don't like it. Enter the clouds, as they come between the sun and the subject. By acting as a giant diffuser, they present the subject in a more flattering illumination. Just watch out for white patches of sky.

FIGURE 20-5:
Late-afternoon light allows the crowd and outdoor stage to pop with color.

Handling Each Shot for Your Edit

TIP

While not for heavy lifting, these handles provide greater flexibility in the time-line. "Edit handles" are those few *extra frames* before and after the clip starts and stops. While handles come in — wait for it — *handy* for editing, they can apply to shooting, too. Hitting Record a few seconds earlier and leaving a little more at the end creates a little more to work with in the timeline. Those few extra seconds, or frames, of a clip before its In point and after its Out point do more than provide the scene with a before and after "breath."

Here's why handles are important.

>> **Transitions:** Those extra frames come in handy when applying a transition between two clips. Dissolves, wipes, fades, and any other actions between clips need extra frames for sampling. Those extra frames make the transition look smoother.

>> **Sound bites:** It's nice when there's a breath before the soundbite begins, even if it's as little as a half-second. This comes in handy when editing. And it doesn't start the clip with voice, allowing the viewer to "catch up" for a moment before the person speaks. Of course, if that's your intention, you can just trim it in the edit.

>> **Precision:** Having a little extra allows you to choose the best starting frame. This seems minor, but there are times when the first frame may be blurred due to movement, making it less than perfect when the sound starts. A few frames before it starts can ensure that the exact frame used works in the edit.

Seeing True Video Quality with a Calibrated Monitor

REMEMBER

At one time or another, we've all noticed the difference in color and tone when movies are played on a different screen. That's because the internal monitor in Premiere Pro doesn't always show the color and density of a more traditional playback device, like your HD television — and, even if it does, your TV may be calibrated differently. That's why professional editors consider a calibrated broadcast monitor an essential tool for maintaining a consistent look in their projects. With costs ranging from affordable to expensive, you can find one that fits your budget.

Adding Drives for Scratch Space

TECHNICAL STUFF

Just because *scratch disk* sounds like a hip-hop term, doesn't mean it has a beat — that is, unless you consider optimal performance something you can rap to. Instead, your Premiere Pro project must deal with various components of your ingested video clips, such as captured video and audio, conformed audio, and preview files; these take their toll on your processor and RAM, making it necessary to use hard drive space as temporary memory. Using an external drive with a lot of free space is a great solution.

Ditching the Pinhole for a Microphone

Using a real microphone can improve the quality of your video capture.

WARNING

In the spirit of the phrase, "Addition by subtraction," comes the more applicable, "The better your movie sounds, the better it looks." That's because distorted or "tinny" audio can detract from a technically perfect visual image, making the video seem inferior.

While the remedy for this problem sometimes feels complicated, using a real microphone narrows the gap. Why? If you're making movies using your smartphone, the audio quality may suffer. That's because instead of a real microphone, it uses one that's nothing more than a built-in pinhole. So, while your smartphone captures great video, its real intention is to make phone calls, send text messages, and play Candy Crush. Audio capture ranks outside an imaginary top ten list. You can use almost any microphone, including lavaliers, shotgun microphones, and hand microphones, but you will need an adapter, as shown in Figure 20-6. These range from a mini-plug-to-XLR adapter for your DSLR and camcorder, to a Lighting-to-mini-plug for your iPhone. The right microphone choice will depend on a variety of conditions. If the subject is sitting or standing in the same spot, then a lavalier (clip on microphone you see on TV) is the best choice. Subjects further away can benefit from shotgun mics, those long ones that look like a long roll of dimes with a foam sock over it.

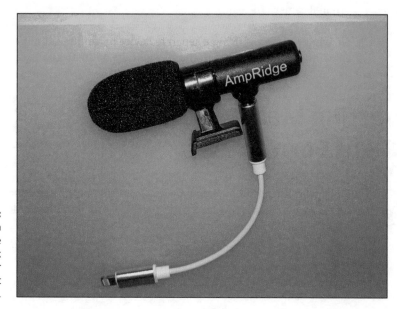

FIGURE 20-6: A mini shotgun microphone can work wonders for capturing great audio content.

Using an Audio Recorder for Great Sound

Capturing audio with a dedicated recorder allows you to fully control the sound on your shoot. That's the way they do it in Hollywood, and so can you, with an audio recorder like the one mentioned in Chapter 2.

So why do you need separate audio?

TIP

Your recording devices do a great job capturing movie footage, but they have some limitations when it comes to audio. Sometimes it's a lack of control over audio levels, other times it's a less-than-optimal microphone. Another reason for using a separate audio source is dealing with the Automatic Gain Control feature on many cameras and smartphones. This continually adjusts levels as ambient sound changes, and it does so with the best intentions. Unfortunately, it also creates the potential for fluctuating audio levels, so it's possible that your levels will be inconsistent.

Then there's the practical issue of needing the audio captured closer to the subject, though the camera may be further away. Capturing sound, independent of the camera, provides you with the most audio control for your shoot.

After capturing the video and sound from the scene, you can easily combine them in post-production by matching audio files to the camera's audio track in the timeline, and swapping out the "clean" audio before deleting, or muting, the original camera file.

So, while the idea of using a separate device to capture sound, uh, sounds complicated, the rewards outweigh the risk with its optimal-quality audio.

Converting Master Files into the Right Format

TIP

Make your life easier by using a video-conversion program, such as the included Adobe Media Encoder to create the specific format and resolution that suits your needs.

Why? Back in the day, there were two ways a movie could play: in the theater or on a television. Now, you have more than a dozen options, including YouTube, Vimeo, Instagram, DVD (yeah, still), and others. As mentioned in Chapter 16, it's simply not practical to open an active timeline every time you want to kick out a file.

You can also try the free Online Video Converter, Using an inexpensive, or free, file conversion program will let you use your master file to produce a version with a specific size, format, and compression. It also will let you convert a file from an online link. Just make sure it's something you have permission to use.

Index

frame rates, 73–74

frames

 checking size for still images in movie projects, 111

 freezing, 141–142

Free Star Titler, 347

Freeform view, 12, 63–64

freeze frames, 141–142, 290–292

G

gap insurance, 281–282

General dialog, 58

General tab (Project Settings), 89

gimbal, 354

Google Drive, sharing movies on, 327–328

GoPro cameras, 39

GPU acceleration, 30

GPU speed, 51

graphics card, 29

Graphics dialog, 59

Graphics workspace, 48

green screen, 199, 201–202

H

H264, 298

Hand tool (toolbar), 20

handout material, downloading clips from, 107

hard drives

 about, 30–31

 adding for scratch space, 358

 comparing, 32

 conventional, 31

 ingesting media using, 102

 scratch disks, 32

 solid-state, 31, 32

Hard Light Blend mode, 189

Hard Mix Blend mode, 190

HDV decks, 40–41

height, changing for audio/video tracks, 97

high definition (HD), 71

high-contrast color, 343

Hightail, sharing movies on, 327

History panel, 17

home theaters, showing movies on, 312–313

horizontal shooting, 352–353

HSL category, for Blend modes, 190–191

Hue Blend mode, 191

I

iCloud, sharing movies on, 326

iCloud Drive, sharing movies on, 326–327

Icon view, 12, 63

icons, explained, 3–4

iMac, 23

image masks, creating, 195

Immersive Video transition bin, 153

importing

 defined, 105

 media into movie projects, 101–116

In and Out points, 123–127, 129

Info panel, 17

ingesting media, 102

Insert After option (Program panel), 137

Insert Before option (Program panel), 137

Insert option (Program panel), 137

Instagram, sharing movies on, 321–323, 324

installing software, 46

integer data type, 115

intellectual property, 313–314

interface, 9

intermediate users, 42

internal drives, 31

Internet clips, downloading, 107

interviews, 342

iPads

 casting movies on, 313

 setting up as a monitor, 53

 using as a second monitor, 52

iPhones, casting movies on, 313

Iris transition bin, 153, 154

About the Author

John Carucci is not a celebrity, though he certainly brushes up against the stars of stage and screen on a regular basis in his role as an entertainment TV producer with the Associated Press. Along with hobnobbing with actors and musicians, John is also author of *Digital SLR Video & Filmmaking For Dummies* and two editions of *GoPro Cameras For Dummies*.

Dedication

Dedicated to the people that make the world a better place, especially the pair that I had a part in creating.

Author's Acknowledgments

I remembered joking about that proverbial phrase, "No man is an island," by adding "unless he's a giant lying in a shallow stream." The truth of the matter is that while this project was created through experience and perspective, it would be nearly impossible to accomplish without an army of helpers, both past and present — not to mention, I am of average height.

So, I would like to thank all of those friends, colleagues, and fellow producers who had a role in shaping this massive task. Borne out of lockdown, this idea started out as something completely different, but by bouncing ideas around I found a cohesive voice. There are so many people to mention that I'm afraid to start naming names, due to fear of forgetting someone. But if you work with me in New York, Los Angeles, Nashville, or London, then you know who you are and I want to thank you and express my appreciation without any sarcasm or bravado. Don't worry, it's still the same me.

I want to thank the folks at Wiley Publishing, starting with executive editor Steve Hayes for continuing to provide challenges, and for having the patience to shape the plan to accommodate my busy schedule. Thanks to my editor, Thomas Hill, for piecing this ever-evolving set of words and pictures together in a cohesive form and always being so pleasant. Please tell me your secret, I'd like to try it!

I would also like to extend a great deal of gratitude to the folks at Adobe.

A great big thanks to my agent, Carol Jelen, for continuing to find great projects for me. I appreciate all your help.

And once again, thanks to Jillian, Anthony, Stella, Cosmo, Bruno, and Alice for the necessary grounding.

Publisher's Acknowledgments

Senior Acquisitions Editor: Steve Hayes

Managing Editor: Kristie Pyles

Development Editor: Thomas Hill

Copy Editor: Marylouise Wiack

Technical Editor: Larry Jordan

Production Editor: Saikarthick Kumarasamy

Photographer: John Carucci

Cover Photo: © David MG/Shutterstock; Product screen shot courtesy of John Carucci

Take dummies with you everywhere you go!

Whether you are excited about e-books, want more from the web, must have your mobile apps, or are swept up in social media, dummies makes everything easier.

Find us online!

dummies.com

dummies
A Wiley Brand

Leverage the powe

Dummies is the global leader in the reference category and one of the most trusted and highly regarded brands in the world. No longer just focused on books, customers now have access to the dummies content they need in the format they want. Together we'll craft a solution that engages your customers, stands out from the competition, and helps you meet your goals.

Advertising & Sponsorships

Connect with an engaged audience on a powerful multimedia site, and position your message alongside expert how-to content. Dummies.com is a one-stop shop for free, online information and know-how curated by a team of experts.

- Targeted ads
- Video
- Email Marketing
- Microsites
- Sweepstakes sponsorship

20 MILLION PAGE VIEWS
EVERY SINGLE MONTH

15 MILLION UNIQUE
VISITORS PER MONTH

43% OF ALL VISITORS ACCESS THE SITE
VIA THEIR MOBILE DEVICES

700,000 NEWSLETTER SUBSCRIPTIONS
TO THE INBOXES OF
300,000 UNIQUE INDIVIDUALS EVERY WEEK

of dummies

Custom Publishing

Reach a global audience in any language by creating a solution that will differentiate you from competitors, amplify your message, and encourage customers to make a buying decision.

- Apps
- Books
- eBooks
- Video
- Audio
- Webinars

Brand Licensing & Content

Leverage the strength of the world's most popular reference brand to reach new audiences and channels of distribution.

For more information, visit **dummies.com/biz**

PERSONAL ENRICHMENT

Staying Sharp

9781119187790
USA $26.00
CAN $31.99
UK £19.99

Facebook

Carolyn Abram

9781119179030
USA $21.99
CAN $25.99
UK £16.99

Guitar

Mark Phillips
Jon Chappell

9781119293354
USA $24.99
CAN $29.99
UK £17.99

Investing

Eric Tyson, MBA

9781119293347
USA $22.99
CAN $27.99
UK £16.99

Beekeeping

9781119310068
USA $22.99
CAN $27.99
UK £16.99

Digital Photography

Julie Adair King

9781119235606
USA $24.99
CAN $29.99
UK £17.99

Meditation

Stephan Bodian

9781119251163
USA $24.99
CAN $29.99
UK £17.99

Pregnancy

9781119235491
USA $26.99
CAN $31.99
UK £19.99

Samsung Galaxy S7

Bill Hughes

9781119279952
USA $24.99
CAN $29.99
UK £17.99

iPhone

Edward C. Baig
Bob "Dr. Mac" LeVitus

9781119283133
USA $24.99
CAN $29.99
UK £17.99

Crocheting

Karen Manthey
Susan Brittain

9781119287117
USA $24.99
CAN $29.99
UK £16.99

Nutrition

Carol Ann Rinzler

9781119130246
USA $22.99
CAN $27.99
UK £16.99

PROFESSIONAL DEVELOPMENT

Windows 10

Andy Rathbone

9781119311041
USA $24.99
CAN $29.99
UK £17.99

AutoCAD

Bill Fane

9781119255796
USA $39.99
CAN $47.99
UK £27.99

Excel 2016

Greg Harvey, PhD

9781119293439
USA $26.99
CAN $31.99
UK £19.99

QuickBooks 2017

9781119281467
USA $26.99
CAN $31.99
UK £19.99

macOS Sierra

Bob "Dr. Mac" LeVitus

9781119280651
USA $29.99
CAN $35.99
UK £21.99

LinkedIn

Joel Elad, MBA

9781119251132
USA $24.99
CAN $29.99
UK £17.99

Windows 10

Woody Leonhard

9781119310563
USA $34.00
CAN $41.99
UK £24.99

SharePoint 2016

Rosemarie Withee
Ken Withee

9781119181705
USA $29.99
CAN $35.99
UK £21.99

Fundamental Analysis

Matt Krantz

9781119263593
USA $26.99
CAN $31.99
UK £19.99

Networking

Doug Lowe

9781119257769
USA $29.99
CAN $35.99
UK £21.99

Office 2016

Wallace Wang

9781119293477
USA $26.99
CAN $31.99
UK £19.99

Office 365

Rosemarie Withee
Ken Withee
Jennifer Reed

9781119265313
USA $24.99
CAN $29.99
UK £17.99

Salesforce.com

Liz Kao
Jon Paz

9781119239314
USA $29.99
CAN $35.99
UK £21.99

Coding

Nikhil Abraham

9781119293323
USA $29.99
CAN $35.99
UK £21.99

dummies.com

dummies®
A Wiley Brand

Learning Made Easy

ACADEMIC

9781119293576
USA $19.99
CAN $23.99
UK £15.99

9781119293637
USA $19.99
CAN $23.99
UK £15.99

9781119293491
USA $19.99
CAN $23.99
UK £15.99

9781119293460
USA $19.99
CAN $23.99
UK £15.99

9781119293590
USA $19.99
CAN $23.99
UK £15.99

9781119215844
USA $26.99
CAN $31.99
UK £19.99

9781119293378
USA $22.99
CAN $27.99
UK £16.99

9781119293521
USA $19.99
CAN $23.99
UK £15.99

9781119239178
USA $18.99
CAN $22.99
UK £14.99

9781119263883
USA $26.99
CAN $31.99
UK £19.99

Available Everywhere Books Are Sold

dummies.com

JUL 2 1 2022

Small books for big imaginations

GETTING STARTED WITH Coding
Get Creative with Code!

9781119177173
USA $9.99
CAN $9.99
UK £8.99

MODDING Minecraft™
Build Your Own Minecraft Mods!

9781119177272
USA $9.99
CAN $9.99
UK £8.99

MAKING YouTube VIDEOS
Star in Your Own Video!

9781119177241
USA $9.99
CAN $9.99
UK £8.99

DESIGNING Digital Games
Create Games with Scratch™!

9781119177210
USA $9.99
CAN $9.99
UK £8.99

GETTING STARTED WITH Raspberry Pi™
Program Your Raspberry Pi™

9781119262657
USA $9.99
CAN $9.99
UK £6.99

EXPERIMENTING WITH Science
Think, Test, and Learn!

9781119291336
USA $9.99
CAN $9.99
UK £6.99

CREATING Digital Animations
Animate Stories with Scratch™!

9781119233527
USA $9.99
CAN $9.99
UK £6.99

GETTING STARTED WITH Engineering
Think Like an Engineer!

9781119291220
USA $9.99
CAN $9.99
UK £6.99

WRITING Computer Code
Learn the Language of Computers!

9781119177302
USA $9.99
CAN $9.99
UK £8.99

Unleash Their Creativity

dummies.com